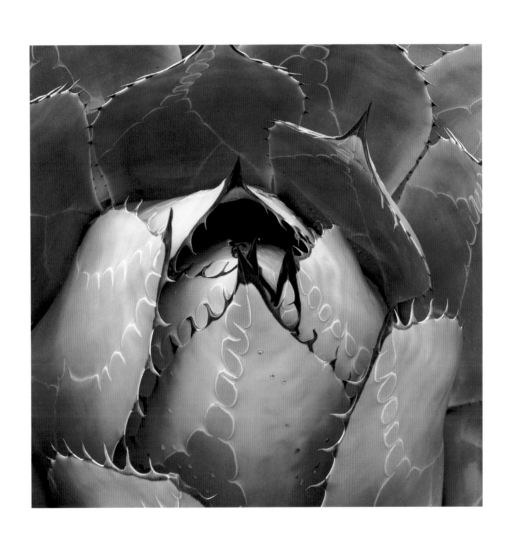

Wildlife Photographer of the Year Portfolio 17

Wildlife
Photographer
of the Year
Portfolio 17

BOOKS

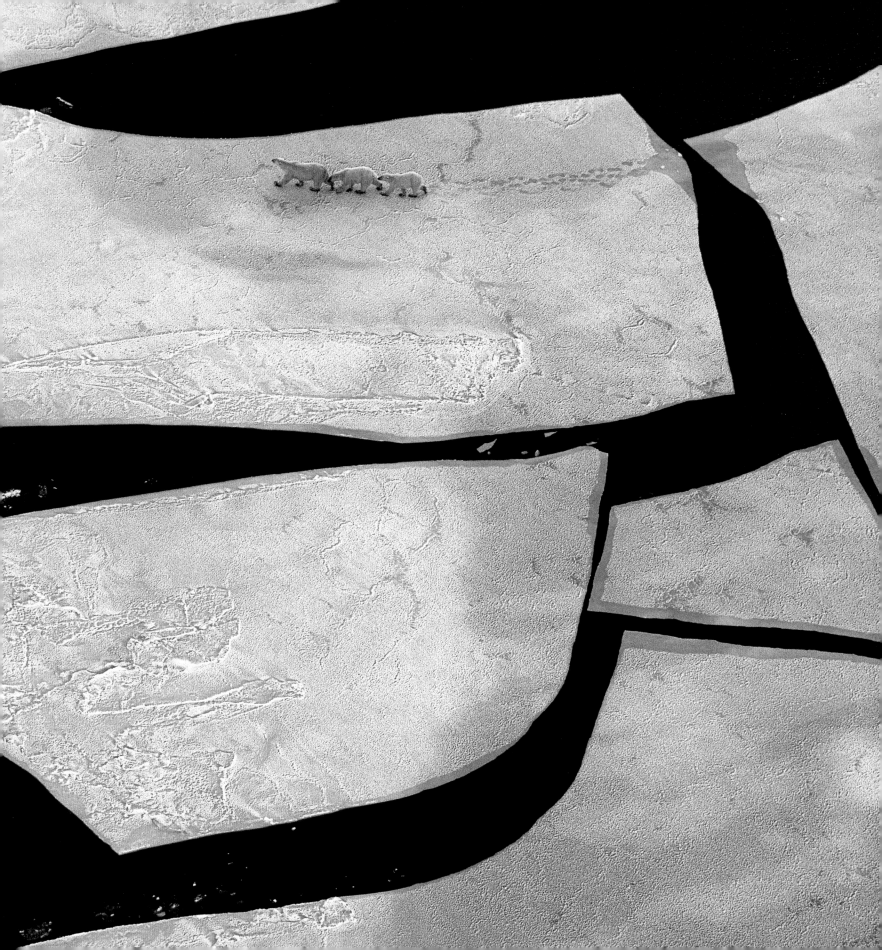

10 9 8 7 6 5 4 3 2 1

Published in 2007 by BBC Books,
an imprint of Ebury Publishing.
A Random House Group
Company

The Random House Group Limited
Reg. No. 954009
Addresses for companies within the
Random House Group can be found
at www.randomhouse.co.uk

A CIP catalogue record for this book
is available from the British Library

ISBN 978 1 846 07317 5

The Random House Group Limited
supports The Forest Stewardship
Council (FSC), the leading international
forest certification organisation.
All our titles that are printed on
Greenpeace approved FSC certified
paper carry the FSC logo. Our paper
procurement policy can be found at
www.rbooks.co.uk/environment

Colour origination and printing
by Butler & Tanner, Frome, UK

Commissioning Editor
Shirley Patton
Project Editor
Rosamund Kidman Cox
Designer
Bobby&Co Design
Caption writers
Rachel Ashton
and Tamsin Constable
Production
David Brimble
Competition Manager
Deborah Sage
Competition Officer
Gemma Webster

Contents

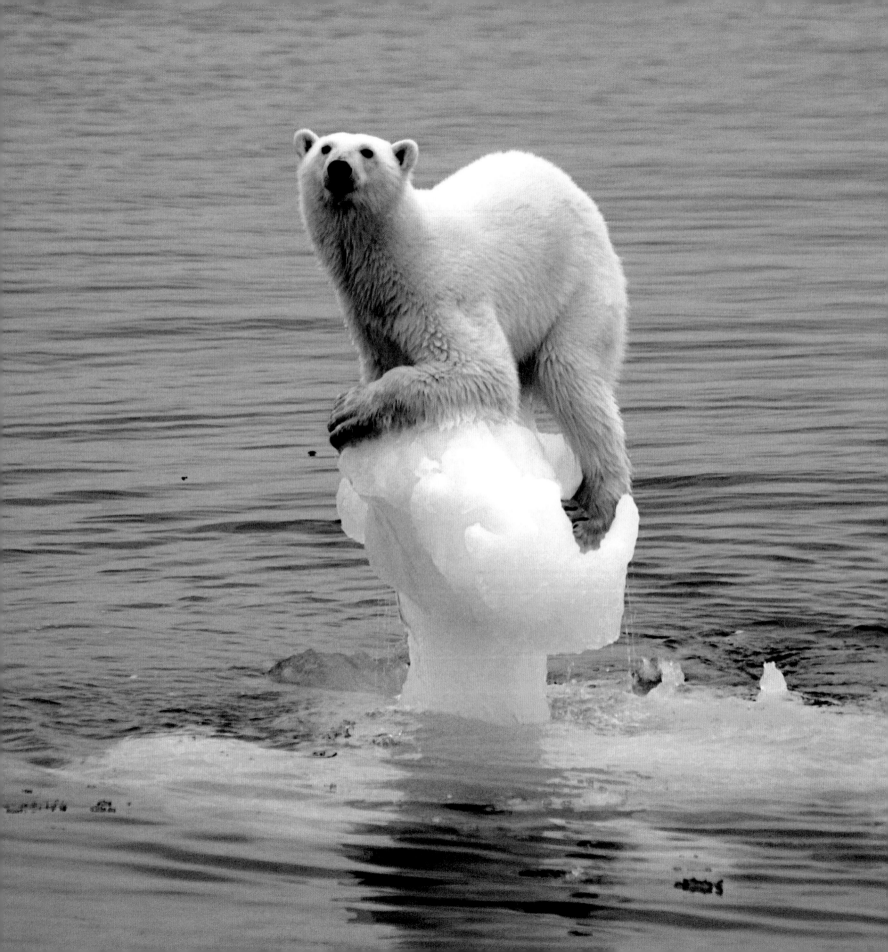

Foreword

Photographers and photographs that have changed environmental policies and perceptions was my intended theme for this foreword. I would reflect on the importance of nature photography and its role in helping protect the natural world. The remarkable images in this volume would be placed in context with those that came before them. Straightforward, I thought.

I searched for the icons, starting with the very first images made with primitive cameras 180 years ago. I sifted through the decades, expecting to find extraordinary images and efforts that helped change our destructive ways. The trail was fascinating but not dotted with billboards of dramatic images. Instead, an impressive and complex tapestry of efforts spoke of plights, large and small, around the globe.

Some efforts spoke more loudly than others. Some images have been forgotten. But the combined legacy stands tall. Now the stakes are higher, and environmental soldiers armed with cameras are marching in greater numbers. (I have yet to meet a nature photographer who did not have deep feelings about the environment and a responsibility towards it, often obsessively so.) Technology has improved the weaponry, and there have been heroic stands, but in general, it is a painful, if not chaotic, march.

William Henry Jackson, an accomplished landscape painter, and his mule-driven wagonload of photographic glass-plate negatives bounced around the American West in the mid-1800s. His photographic proof of the wonder of the west survived unbroken, and on his evidence, Congress made Yellowstone the world's first national park. Today, there can be few places that attract more long lenses. And as we grow impatient waiting for our 8-gigabyte flash cards to download, think about the challenge of developing 18 x 22 glass-plate negatives in cold mountain streams.

A hundred years after Jackson, Ansel Adams ascended a pinnacle of legendary aesthetic and environmental photographic achievement that may never be matched. In the 1930s, the path-finding British bird photographer Eric Hosking changed the world of bird photography with his dogged determination and travels to European wonders such as Doñana, now a World Heritage Site, which few had seen. In 1996, Michio Hoshino – truly the samurai warrior of modern-day nature photographers – gave his life to a bear in Siberia in his efforts to document the region's natural riches.

A powerful but nearly invisible vigour imbedded in the tradition of nature photography is the quiet influence that has allowed us to stand on the shoulders of our predecessors. Ernst Haas, an Austrian virtuoso, played an extremely influential role in my own development, though he is not considered a nature photographer per se. His landmark book was *The Creation*, published in 1971, full of inspirational images produced with lyricism and uncommon intelligence. Many of us were transformed after seeing it. 'Only time will tell,' he remarked in his musical Viennese accent. 'I don't want to be only tasteful enough to be appreciated today. I want to be appreciated a little later . . . I want to be remembered much more by a total vision than a few perfect pictures.' He makes the point. Like a general, he inspired the troops. So goes the battle.

The quintessential nature photograph that sticks in our collective psyche is probably the 'blue marble' – the first photograph of the Earth made from the *Apollo 8* spacecraft in 1968. How ironic that there is no visible sign of humans in that picture.

I expect this book has an image that will imbed itself into one's mind and eye. It has already happened to me. The bewildered-looking polar bear clinging to the nearly melted ice chunk haunts me. Here then, is the latest sentence in a long but unfinished narrative from a tribe urgently trying to give voice to the Earth.

Jim Brandenburg

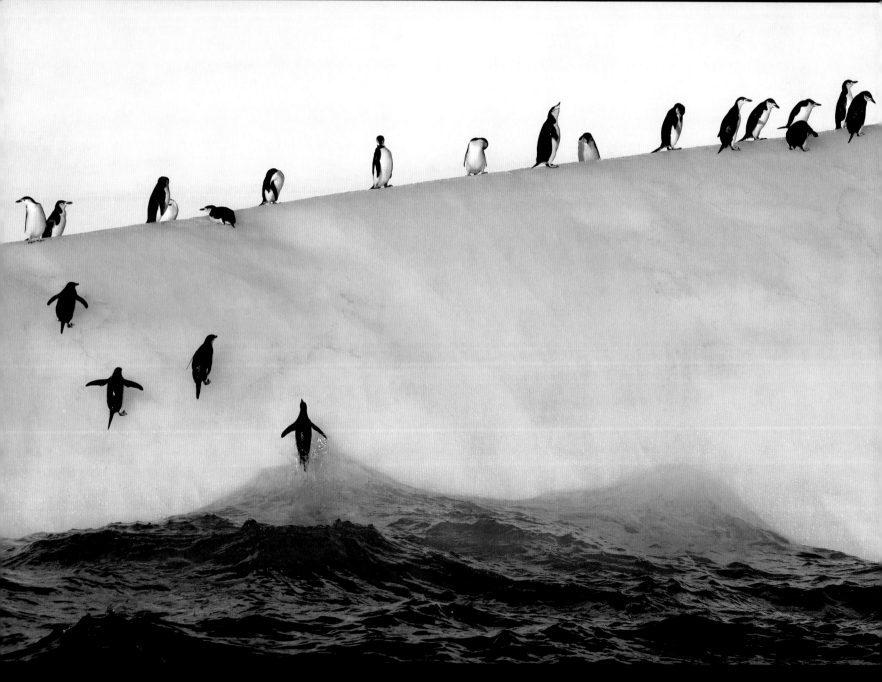

The Competition

Judges

Jim Brandenburg
nature photographer

Ysbrand Brouwers
director,
Artists for Nature Foundation

Mark Carwardine
(chair) zoologist, writer
and photographer

David Doubilet
underwater photographer

Rosamund Kidman Cox
editor and writer

Paul Kitcatt
creative director, Kitcatt Nohr
Alexander Shaw (KNAS)

Klaus Nigge
photographer

Milán Radisics
graphic designer
and nature photographer

Sophie Stafford
editor, *BBC Wildlife Magazine*

Pal Steffanson
picture editor, *Iceland Review*
and travel photographer

early-selection judges

Emma Dearden
senior account handler, Photolibrary
Group Ltd

Paul Lund
Natural History Museum, Image
Resources Photographic Unit

Jamie Owen
Natural History Museum, Image
Resources Photographic Unit

Mishka Westell
deputy art editor,
BBC Wildlife Magazine

All the pictures gathered here are prize-winning or commended images from this year's Shell Wildlife Photographer of the Year Competition – an international showcase for the very best photography featuring natural subjects. The competition is owned by two UK institutions that pride themselves on revealing and championing the diversity of life on Earth – the Natural History Museum and *BBC Wildlife Magazine*.

Being placed in this competition is something that wildlife photographers, worldwide, aspire to. Professionals win many of the prizes, but amateurs succeed, too. And that's because achieving the perfect picture is down to a mixture of vision, camera literacy, knowledge of nature – and luck. And such a mixture doesn't always require an armoury of equipment and global travel, as the pictures by young photographers reveal.

The origins of the competition go back as far as 1964, when the magazine was called *Animals* and there were just 3 categories and about 600 entries. But even then it was the leading event of its kind for nature photographers. It grew in stature over the years, and in 1984, *BBC Wildlife Magazine* and the Natural History Museum joined forces to create the competition as it is today, with most of the categories and awards you see in this book.

Now there are upwards of 30,000 entries (this year, more than 32,000), a major exhibition at the Natural History Museum and exhibitions touring throughout the year, not only in the UK but also worldwide, from the Americas through Europe and across to China, Japan and Australasia. The winning and commended pictures appear in *BBC Wildlife Magazine* and publications worldwide. As a result, the photographs are now seen by millions of people.

The aims of the competition are
- to use its collection of inspirational photographs to make people worldwide wonder at the splendour, drama and variety of life on Earth;
- to be the world's most respected forum for wildlife photographic art, showcasing the very best photographic images of nature to a worldwide audience;
- to inspire a new generation of photographic artists to produce visionary and expressive interpretations of nature;
- to raise the status of wildlife photography into that of mainstream art.

The judges, who change from year to year and represent artists and professionals from other media as well as photography, put aesthetic criteria above all others. But at the same time, they place great emphasis on photographs taken in wild and free conditions, considering that the welfare of the subject is paramount. They are also always looking for pictures with that extra something – creative flair that takes a picture beyond just a representation of nature.

Organizers

The competition is owned by the Natural History Museum, London, and *BBC Wildlife Magazine*, and is sponsored by Shell.

Open to visitors since 1881, the Natural History Museum looks after a world-class collection of 70 million specimens. It is also a leading scientific-research institution, with ground-breaking projects in more than 60 countries and 300 scientists who research the museum's valuable collections – all to better understand life on Earth, its ecosystems and the threats it faces.

Every year more than 3 million visitors, of all ages and levels of interest, are welcomed through the Museum's doors to enjoy the many galleries and exhibitions, which celebrate the beauty and meaning of the natural world and encourage visitors to see the environment around them with new eyes.

Shell Wildlife Photographer of the Year is one of the Museum's most successful and long-running exhibitions. Together with *BBC Wildlife Magazine*, the Museum has made it the most prestigious, innovative photographic competition of its kind and an international leader in the artistic representation of the natural world.

The annual exhibition of award-winning images attracts a growing audience. Visitors come to see the world's best wildlife pictures and gain an insight into the diversity of the natural world – an issue at the heart of the Museum's work.

Visit www.nhm.ac.uk
for what's on at the Museum.
You can also call +44 (0)20 7942 5000,
email information@nhm.ac.uk
or write to us at:
Information Enquiries
The Natural History Museum
Cromwell Road
London SW7 5BD

For more than 40 years, *BBC Wildlife Magazine* has showcased the wonder and beauty of our planet, its animals and wild places – and highlighted its fragility. By enabling our readers to understand, experience and enjoy nature more, we hope to inspire them to care about the fate of wildlife and take action to preserve it for future generations. Every month, we bring a world of wildlife to people's living rooms. Breathtaking images from leading wildlife photographers are complemented by informative and entertaining features on animal behaviour written by top experts, global environmental news and biological discoveries. Thought-provoking insights from columnists, such as the chairman of the judges, Mark Carwardine, are balanced by practical advice that enables our readers to get closer to the wildlife around them.

Spectacular wildlife photography is one of *BBC Wildlife*'s twin pillars. For this, we look to the photographers whose brilliance has been celebrated by Wildlife Photographer of the Year since 1964, when we first launched the competition with just three categories and a handful of pictures. Throughout the year, we showcase the photographic portfolios of these award-winning photographers, and through their eyes we see the world's wildlife afresh. In November, we publish all the winning images from the Shell Wildlife Photographer of the Year in a unique, free showguide.

Visit www.bbcwildlifemagazine.com
for more information about *BBC Wildlife*, back issues, special offers and reader photos. You can also email wildlifemagazine@bbcmagazinesbristol.com, call +44 (0)117 314 8363 or write to *BBC Wildlife*, 14th Floor, Tower House, Fairfax Street, Bristol BS1 3BN.

Subscribing to *BBC Wildlife Magazine*
To SAVE 25% on the shop price of *BBC Wildlife*, call 0844 844 0251 or email us at wildlife@servicehelpline.co.uk quoting WPOY07.

Shell is proud to sponsor the world's largest and longest-running wildlife photography competition.

The production of energy must go together with protection of the environment and conservation of biodiversity. This is an area of considerable importance to Shell and one to which we are keenly committed, demonstrated by our partnerships with, for example, the World Conservation Union (IUCN), The Nature Conservancy, the Smithsonian Institution and Wetlands International.

We hope you enjoy this book and the wonderful display of biodiversity within it.

James Smith
Chairman
Shell UK Ltd

Visit www.shell.com/biodiversity
for more information about our approach to biodiversity.

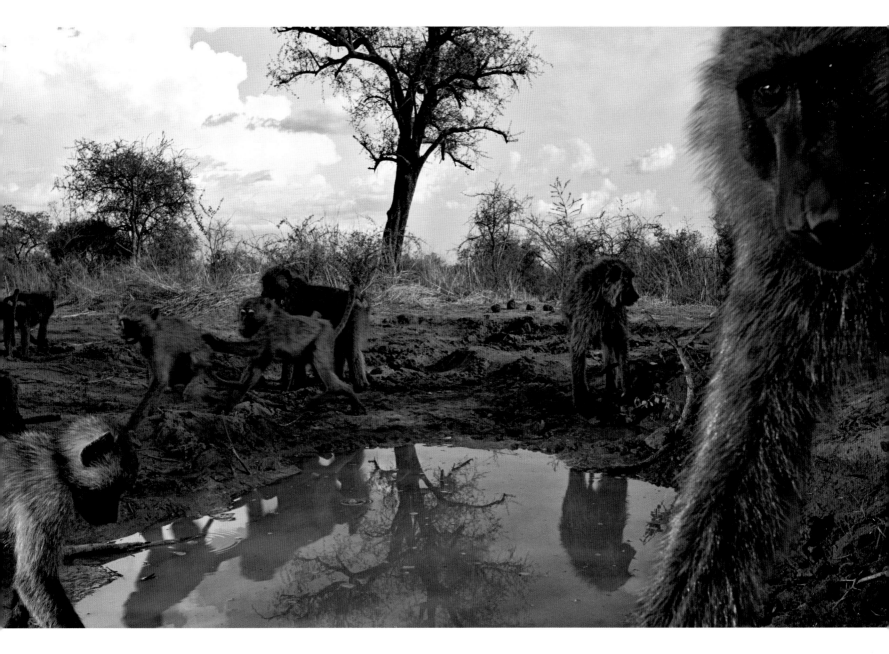

The Shell Wildlife Photographer of the Year Award

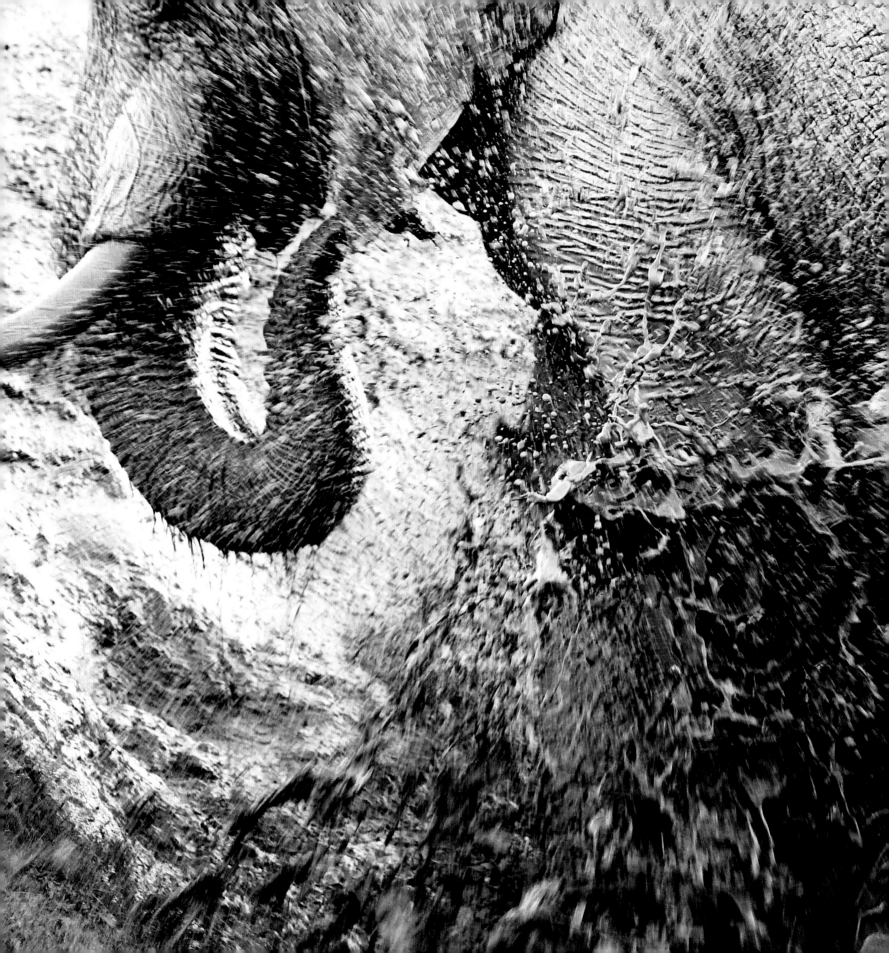

The Shell Wildlife Photographer of the Year Award goes to Ben Osborne, whose picture has been chosen as the most striking and memorable of all the competition's entries.

Ben Osborne

Ben has been a freelance photographer for the past 25 years, based in the UK and specializing in wildlife, landscapes and environmental photography. His work has been published in numerous international magazines and books, and he has worked on all seven continents, especially Antarctica, often taking editorial stills for major tv series such as *Life in the Freezer* and *Planet Earth*, as well as for tourist and government organizations. Recently he has concentrated on arts projects, collaborating with poets and musicians to create major audio-visual presentations in the UK.

Elephant creation

For three weeks in the middle of the Botswana dry season, Ben staked out a waterhole in Chobe National Park, using his vehicle as a hide while photographing the streams of thirsty elephants and other animals coming to drink. Key times were the hours after dawn and before dusk. Occasionally the waterhole overflowed, creating a muddy wallow that was a magnet for dry and dusty elephants. This huge bull was the first to indulge in a head-to-toe spa, spraying muddy water all over his body with his trunk, then kicking and stamping his feet. It was the behaviour that Ben had hoped for. Using a slow shutter speed, he focused on the centre of the action – trying to capture the drama and energy of the accelerating mud and the effect of the early morning low light reflecting off the liquid surfaces – to create an explosion of texture and colour.

Canon EOS 1D Mark II N + 70-200mm f2.8 lens (set at 135mm); 1/50 sec at f5; ISO 400; beanbag.

Creative Visions of Nature

Pictures in this category should take inspiration from nature but reveal new ways of seeing natural subjects or scenes. They can be figurative, abstract or conceptual but must provoke thought or emotional reactions, whether through their beauty or imaginative interpretation.

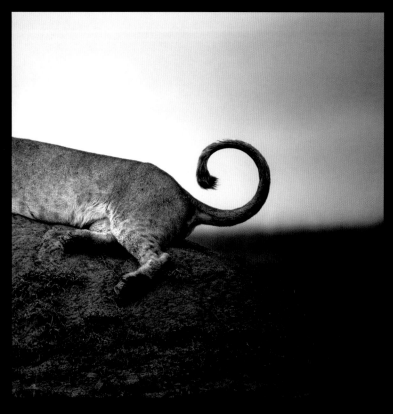

Lion's tail

SPECIALLY COMMENDED

Laurent Baheux

FRANCE

Relaxed but alert, the lioness was stretched out on a termite nest in Kenya's Masai Mara. The only part of her that moved was her tail. 'Every so often, she would roll it up and in,' says Laurent, 'a simple movement that symbolized her strength and vitality.' Lions are the only cats to have a tuft of dark hair at the tips of their tails, which may help communicate moods. Within five minutes, another lioness arrived, and the sisters strolled off together.

Canon EOS 1D Mark II + Canon EF 600mm f4 IS USM lens; 1/500 sec at f8; ISO 200

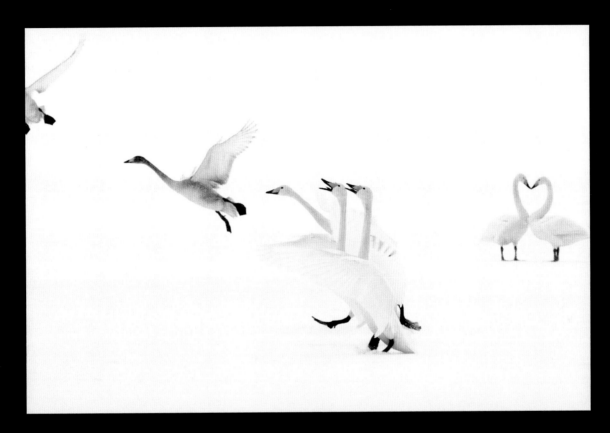

Swan lake

RUNNER-UP

Jan Vermeer

THE NETHERLANDS

One of Jan's favourite locations for swans is Hokkaido's Lake Kushiro, Japan's largest marshland, where flocks of whooper swans spend the winter. 'What I wanted was different poses in the same frame,' says Jan, 'set against the white of the ice. One swan is flying out of frame, another is taking off, three are having a discussion and two are courting – nearly perfect. I always look for such pictures – simple in colour, strong in composition.'

Nikon D2X + 70-200mm lens and 1.4 extender; 1/640 sec at f7.1; Gitzo tripod.

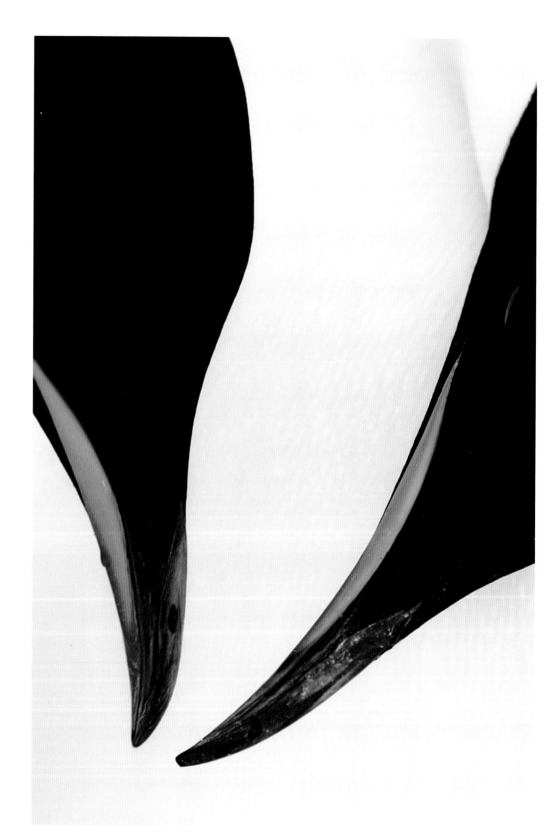

Emperor elegance

HIGHLY COMMENDED

Jan Vermeer

THE NETHERLANDS

Jan has visited emperor penguins on many occasions, and on this trip he knew exactly what he wanted to do: sit in one place and watch. 'The idea was to create pictures using just one long lens, so as to focus intently on the intimate behaviour of the penguins and get very close without disturbing them.' It was November, and the rookery on Snow Hill Island was full of the noise of some 4000 breeding pairs, each incubating a single chick. While one adult babysits, the other leaves to feed at sea on fish and squid, returning to regurgitate some of its catch to the hungry chick. As the adults reunite before swapping duties, there is a brief greeting. This was 'the elegant moment' Jan waited to catch.

Nikon D2X + 500mm f4 lens; 1/350 sec at f8; Gitzo tripod.

Great foot

SPECIALLY COMMENDED
Kurt Jay Bertels
SOUTH AFRICA

'My aim was to photograph elephants in a fresh way,' says Kurt, who spent several weeks in South Africa's Greater Kruger National Park on this assignment. 'I focused on the heavy movements of the feet', he says, 'and tried to show the effort the elephant has to put into each step.' Using his vehicle as a hide, he moved the camera along with the foot, and the long exposure gives an impression of both speed and weight, largeness – as befits the world's largest land animal – and yet relative nimbleness. Even though the sole looks as tough as old boots through years of wandering across hard, hot earth and scrub, research shows that an elephant's foot is surprisingly sensitive – elephants can 'hear' slight vibrations through the ground and so can communicate with each other through their feet.

Canon 20D + Canon 100-400mm lens; 1/20 sec at f9 (-1 exposure compensation).

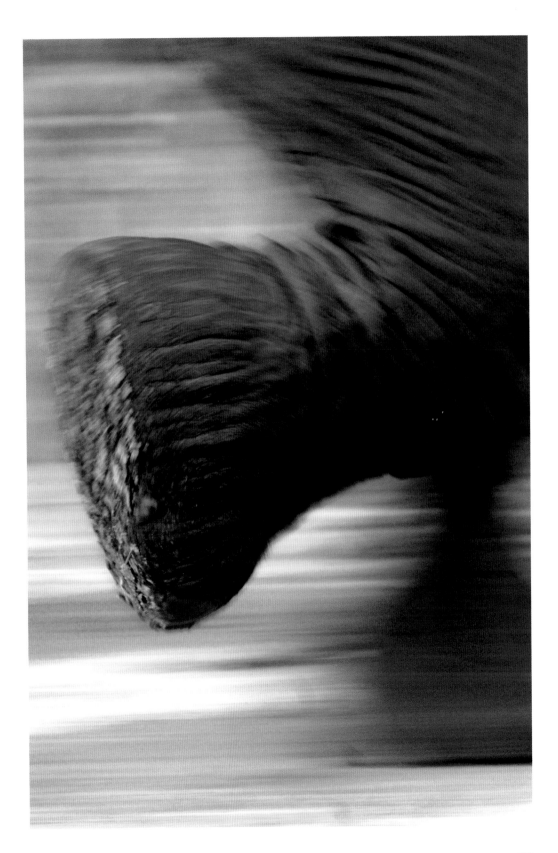

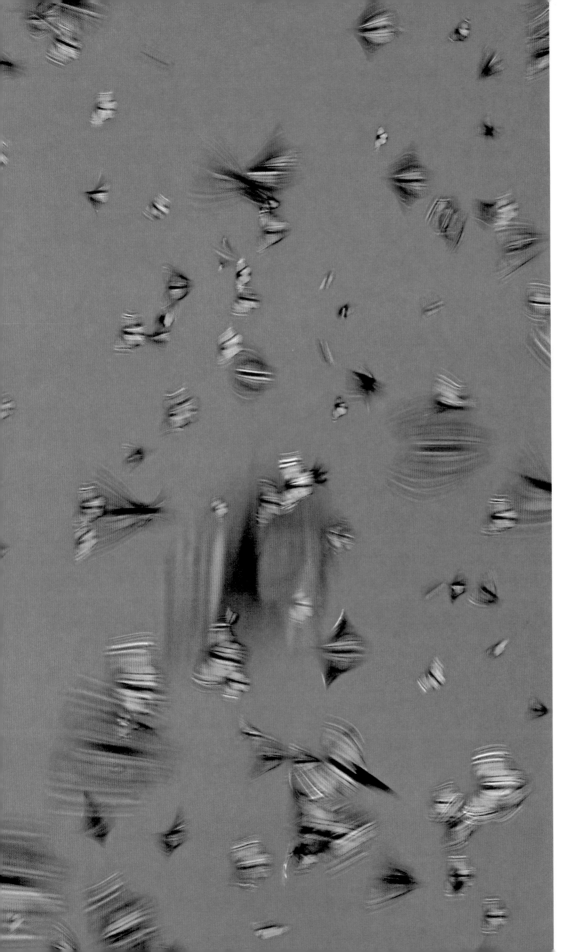

Flight of the butterflies

HIGHLY COMMENDED

Ingo Arndt

GERMANY

Ingo travelled to Michoacán in Mexico to catch the start of one of the world's most famous wildlife migrations. Every year in early spring, about 400 million monarch butterflies leave their overwintering site in the Sierra Madre mountains to fly to North America – a journey of more than 3000 kilometres (1860 miles) – where they lay their eggs on milkweed plants. As the butterflies begin to stir from their winter snooze, the trees pulsate orange and black, with the insects wings whirring audibly. Ingo positioned himself in a small clearing, where he could photograph the clouds of monarchs passing overhead. 'I used a long exposure to get a dynamic image of movement,' says Ingo, 'but there was just one day when the sun shone into the clearing, and the sky provided the brilliant blue backdrop I was after.' The descendants of these butterflies will head back to Mexico, breeding and dying as they go, in a generational relay, arriving as the great, great grandchildren to start the cycle once again.

Canon EOS 5D + Canon 70-200mm f2.8 IS USM lens; 1/45 sec at f32; ISO 100; tripod.

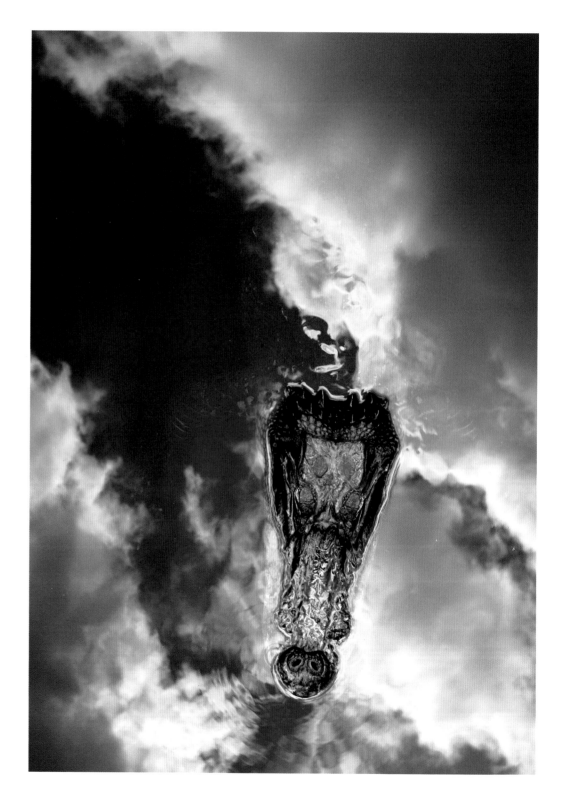

Head in the clouds

HIGHLY COMMENDED

Adam Butler

UK

It was a hot, sticky, breezeless day. And when the skipper turned the boat's engine off, calm descended over the Everglades. All Adam could hear were bird calls and the gentle splash of oars – oh, and the buzz of a thousand mosquitoes. They paddled slowly through the swampy water, getting closer and closer to the alligator until they were right next to it. The 2.5-metre (8-foot) reptile remained motionless, even when Adam leaned out of the boat and bent down over it. So clear was the reflection of the sky that the alligator appeared to be drifting through the clouds.

Canon EOS 20D + 16-35mm f2.8 lens; 1/200 sec at f7.1; ASA 200.

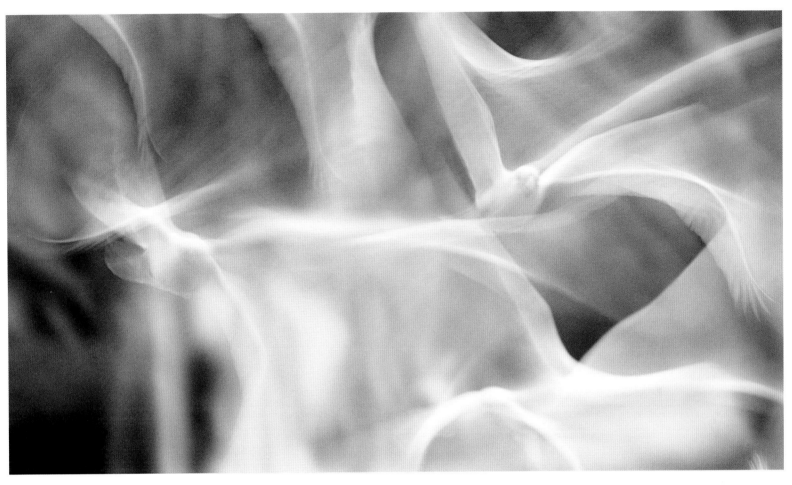

A confusion of corellas

HIGHLY COMMENDED

Elaine Argaet

AUSTRALIA

Elaine was experimenting with a new camera, photographing a flock of long-billed corellas feeding on the ground in a park in Port Stephens, in New South Wales, when something spooked them. The white cockatoos lifted up in unison, screeching in alarm. Elaine had time, though, to take one shot that captured both a sense of the confusion and the cacophony of the scene, lit by the soft, late-afternoon sun.

Nikon D200 + 80-400mm f4.5-5.6 lens; 1/6 sec at f11; ISO 640.

Seascape

HIGHLY COMMENDED

Gary Steer

AUSTRALIA

It was a beautiful clear night, and as the full moon began to rise over the Pacific, this seascape emerged. It was, of course, an image created partly by the skill of the photographer – bands of sky, ocean, surf and sand creating a composition in soft moonlight exposed in just the right way. Its painterly nature belies the fact that it was taken just minutes from the centre of Sydney at Coogee Beach – a popular and busy surf spot.

Canon EOS 5D + Canon EF 35-350mm lens; 21 sec at f9.9; Manfrotto tripod.

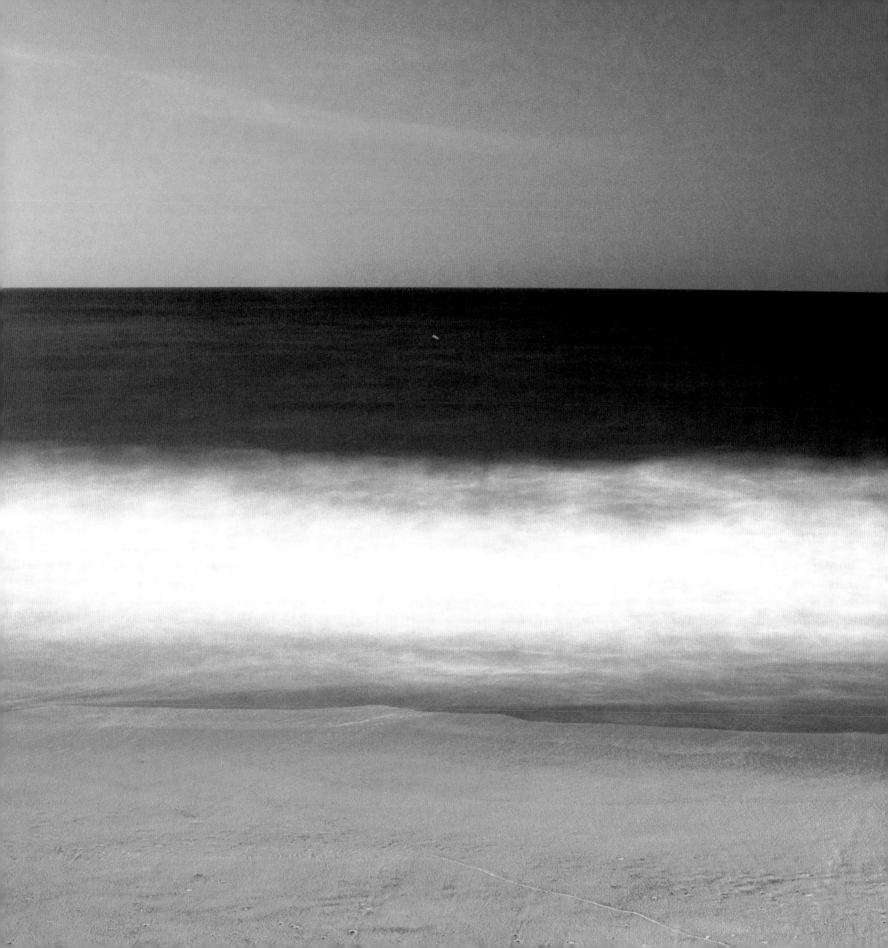

Behaviour
Birds

Birds are among the most popular subjects for photographers entering the competition. But the challenge here is to take a picture with aesthetic appeal that also shows active or interesting behaviour.

Snowy owl stoop

WINNER

Louis-Marie Preau

FRANCE

In winter, when lemmings become scarce, snowy owls leave the inhospitable Arctic tundra of northern Canada and head south to feed on the open fields just north of Quebec. One afternoon, in temperatures of -15°C (5°F) and with a metre of ice-encrusted snow on the ground, Louis-Marie waited for this snowy owl to begin hunting. From its nearby perch, it scrutinized its surroundings for any sign of movement that might betray the presence of a small mammal. Hours went by, the sun began to drop, and nothing happened. 'Then, just as the sun fell behind the horizon, sending flames of colour across the sky,' says Louis-Marie, 'the owl took off' and flew just metres away from where he was lying on the snow. 'The magic lasted an instant, but the emotion was intense.'

Canon EOS 1Ds Mark II + Canon 300mm IS f2.8 lens; 1/800 sec at f3.5; tripod.

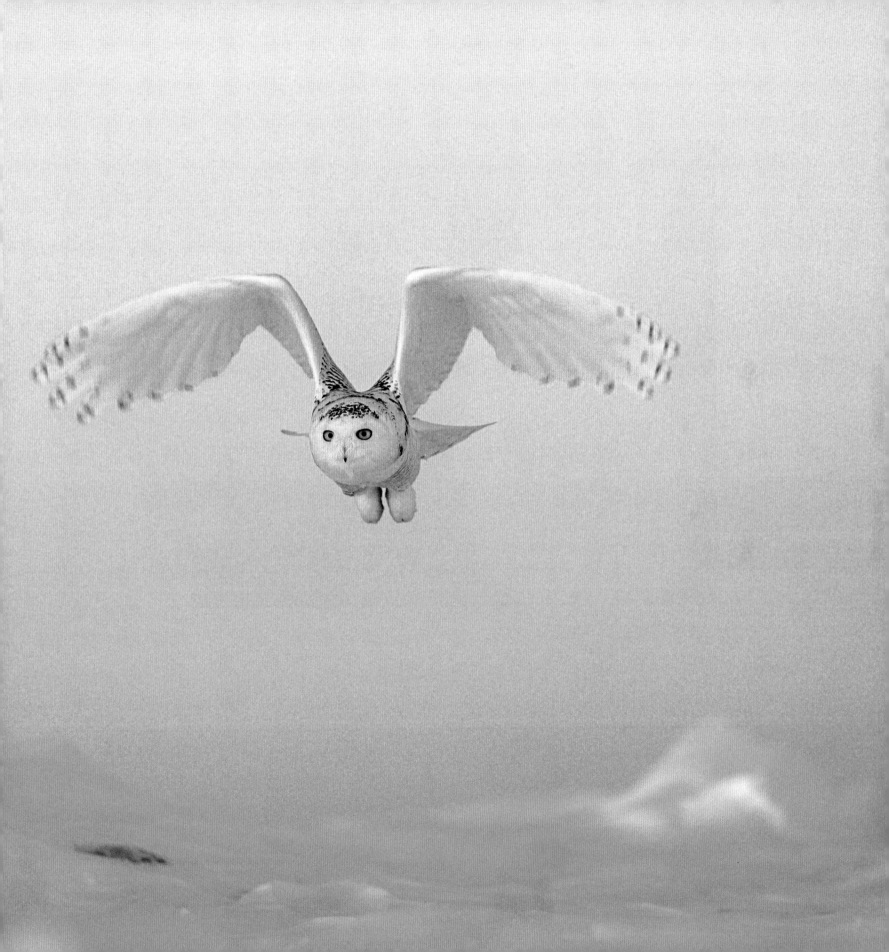

Battling blackcocks

SPECIALLY COMMENDED

David Tipling

UK

In pursuit of a black grouse picture that would convey the spirit of the bird in a new way, David spent six days lying in a hide in a frozen bog in Finland, getting into it an hour before dawn when it was -10°C (14°F). The grouse would arrive in the dark, uttering calls from cooing to explosive hisses as they started to display. 'I got countless images of them displaying and fighting,' adds David, 'but this composition was my ultimate goal.'

Nikon D2X + Nikon 300mm f2.8 lens; 1/1000 sec at f2.8; angled viewfinder.

Frozen frenzy

RUNNER-UP

Kristin McCrea

CANADA

'The Canadian winter reveals the familiar in a stark, edited way,' says Kristin, which is what took her down to photograph the ring-billed gulls on Lake Ontario on a day when temperatures had dropped to -14°C (7°F). Gulls are a challenge. 'By feeding them,' she says, 'I have partial control over the composition. The bravest hover, landing as I back away, on my knees in the snow, shooting as I go' – giving just enough time to frame the mêlée.

Canon EOS 10D + 70-300mm IS lens at 300mm; 1/1000 sec at f10.8; ISO 400.

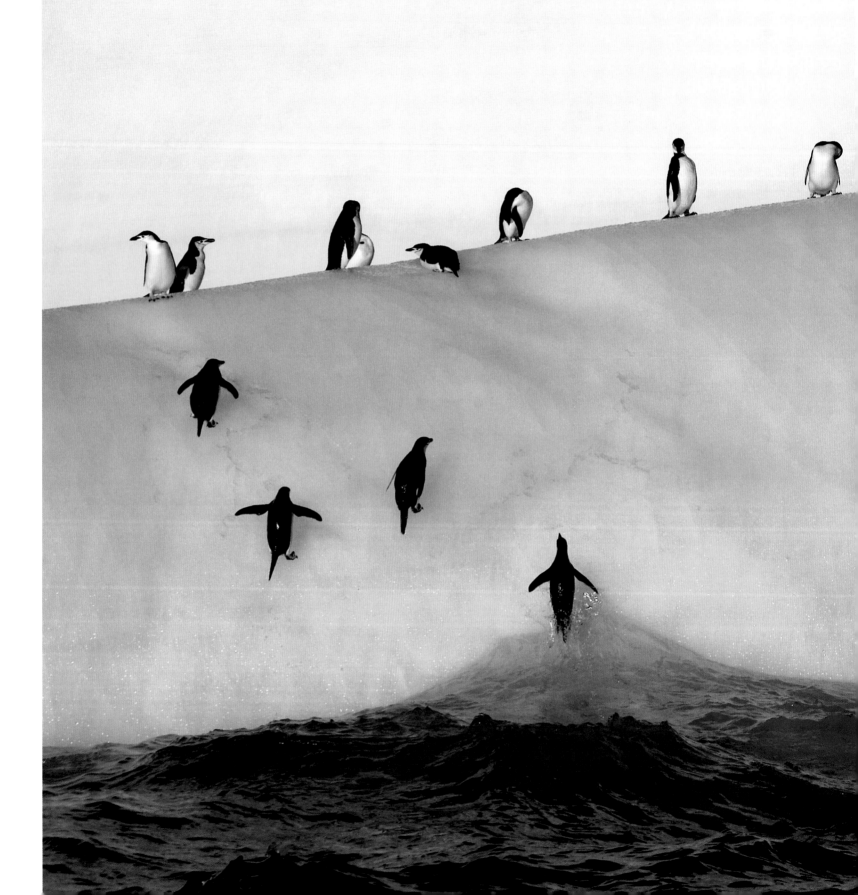

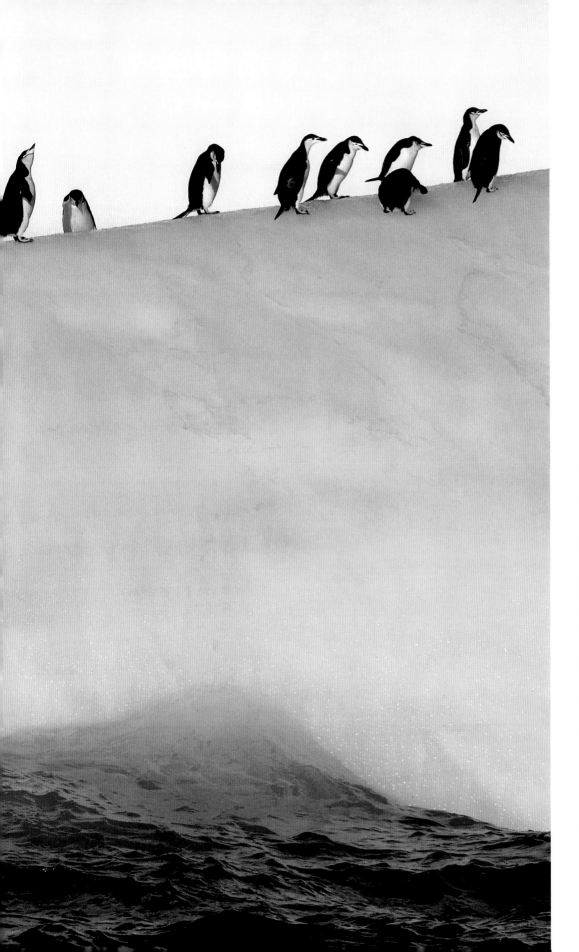

The ice-hoppers

HIGHLY COMMENDED

Maria Stenzel

USA

Maria took this shot while on assignment in one of the world's most remote regions – the South Sandwich Islands – photographing the world's largest colony of chinstrap penguins. 'I was shooting from the yacht', says Maria, 'on an unusually calm, sunny morning off the island of Zavodovski. Weaving among the icebergs, we could see chinstraps everywhere, many of them perched on the ice, resting from feeding or, in the case of juveniles, probably just hanging out.' Maria describes the penguins as 'incredible athletes, able to scale the steepest of slopes, digging into the ice with their crampon-like claws'. Every austral summer, 2 million or so pairs of chinstraps arrive on Zavodovski, which is some 1600km (1000 miles) off the coast of Antarctica. They immediately start mating and laying eggs, the imperative being to raise their chicks in time for them to fatten up in the krill-rich water before winter sets in again and the ocean freezes over.

Canon EOS 1D Mark II N + zoom lens at 115mm; 1/4000 sec at f8; ISO 400.

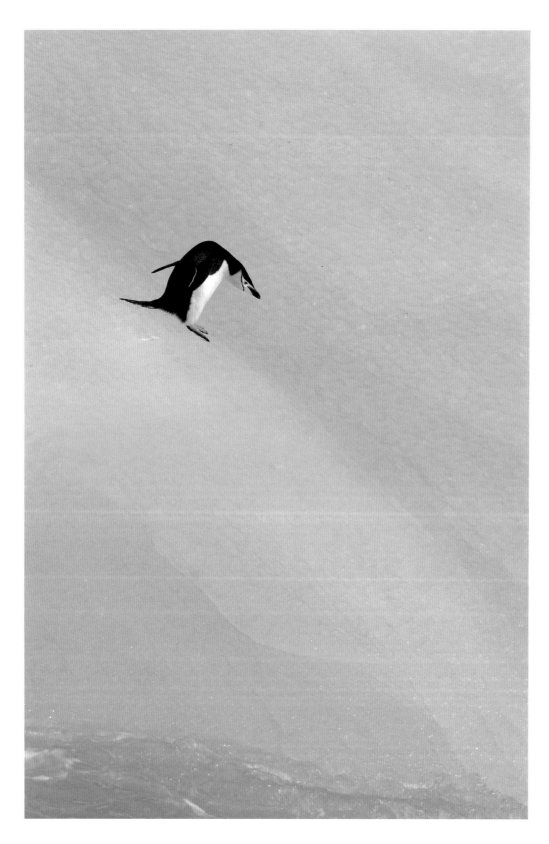

Chinstrap slide

HIGHLY COMMENDED

Chris Gomersall

UK

Chris was leading a photographic expedition to South Georgia and Antarctica on the *Grigoriy Mikheev* when he awoke to find the ship surrounded by icebergs. Floating by was a beautiful blue one with a sprinkling of chinstrap penguins. 'I concentrated on this particular penguin,' says Chris, 'which seemed intent on an icy dip.' He set up for a fast shutter-speed in anticipation of an imminent leap – or perhaps an uncontrolled slither. In the event, the penguin managed to negotiate the precarious slope and simply hop across to another block of the iceberg to join its companions.

Nikon D2Xs + Nikkor 200-400mm f4 VR lens; 1/3200 sec at f7.1; ISO 200; monopod.

Song of the corn bunting

HIGHLY COMMENDED

Gastone Pivatelli

ITALY

In spring, the repetitive, jangling, 'metallic' songs of corn buntings ring out around Gastone's home town in northern Italy, as the males sing their hearts out trying to attract as many females as possible to their territories. These buntings are bigger and plumper than other kinds, and unlike most buntings, both sexes look alike, though males are larger than females. 'I noticed that the teasel was this male's favourite song post,' says Gastone, 'and so I set up my camera early in the morning and waited for his arrival.' The air was so cold that the steam of the bunting's breath condensed into song-rings above him.

Canon EOS 1Ds Mark II + Canon EF 500mm f4 IS lens; 1/250 sec at f5.6; ISO 200; tripod.

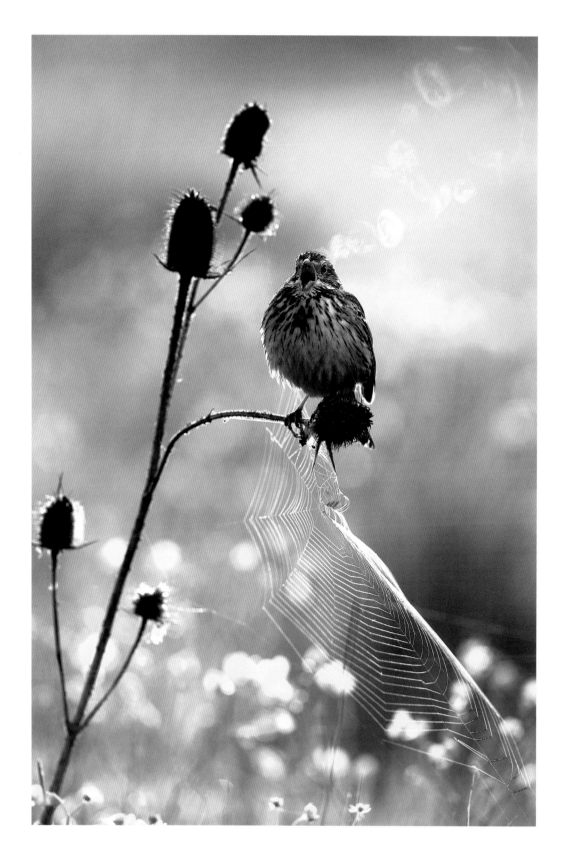

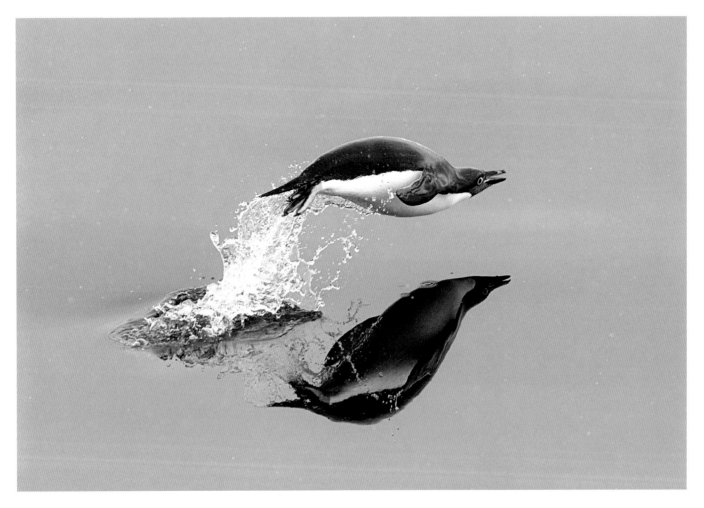

Porpoising penguin

HIGHLY COMMENDED

David Tipling

UK

'It was a particularly dull day, with snow falling gently,' recalls David, 'and when the sea became choppy, I went below deck.' But Antarctic weather can change in an instant, and within 10 minutes, David glimpsed a mirror-smooth sea through the porthole. He dashed back up just in time to see this Adélie penguin porpoising across the bow. 'The reflection was perfect,' he says, 'and I managed one good frame before the penguin disappeared and a breeze ruffled the water.'

Nikon D2X + Nikon 300mm f2.8 lens; 1/1000 sec at f5.

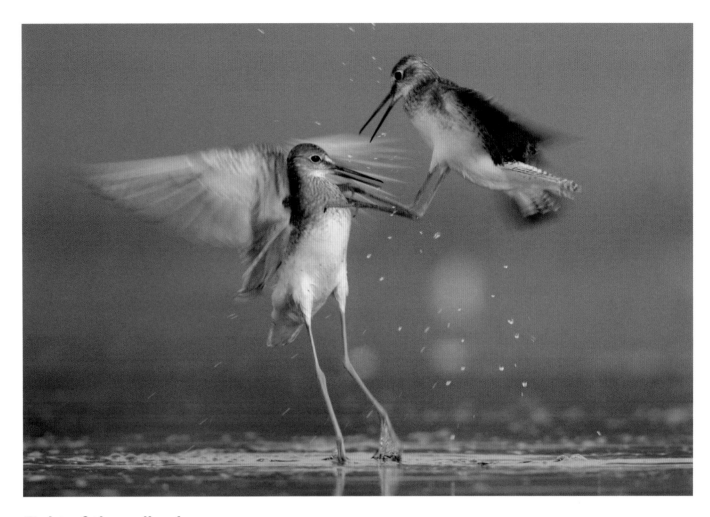

Fight of the yellowlegs

HIGHLY COMMENDED

George DeCamp

USA

On his stomach in the mud, George started to photograph a lesser yellowlegs foraging in the shallows in front of him. New York's Jamaica Bay National Wildlife Refuge pulls in huge flocks of migrants, including lesser yellowlegs, that stop off to feed on the mudflats. Suddenly, a second yellowlegs started calling nearby. 'Within seconds, the two of them went for each other, leaping and kicking like kung-fu fighters,' says George.

Nikon D2X + Nikon 500mm AF-S II lens; 1/320 sec at f4; ISO 200; Skimmer Ground Pod and Wimberley head.

Behaviour
Mammals

The pictures in this category are selected to show action and interest value as much as aesthetic appeal.

Jackal catch

WINNER

Johan J. Botha

SOUTH AFRICA

Was it the same character? Johan couldn't be sure, but given its well-practised behaviour, he had a strong suspicion that it was the same black-backed jackal he had photographed here two years before. Every morning, hundreds – perhaps thousands – of Cape turtle doves descend to drink at a waterhole in the eastern side of Namibia's Etosha National Park. And every morning, this black-backed jackal joins them for a drink – then helps itself to breakfast. 'It would trot slowly past the doves as they drank, pretending to ignore them,' Johan describes. 'Then it would suddenly jump at an unsuspecting bird, often springing through the shallows to catch it.' Thanks to this clever routine, the jackal managed to bag itself two or three Cape turtle doves every morning.

Canon EOS D1 Mark II + Canon 600mm f4 USM lens and 2x converter; 1/1000 sec at f8; own-design car-support lens bracket with Wimberley head.

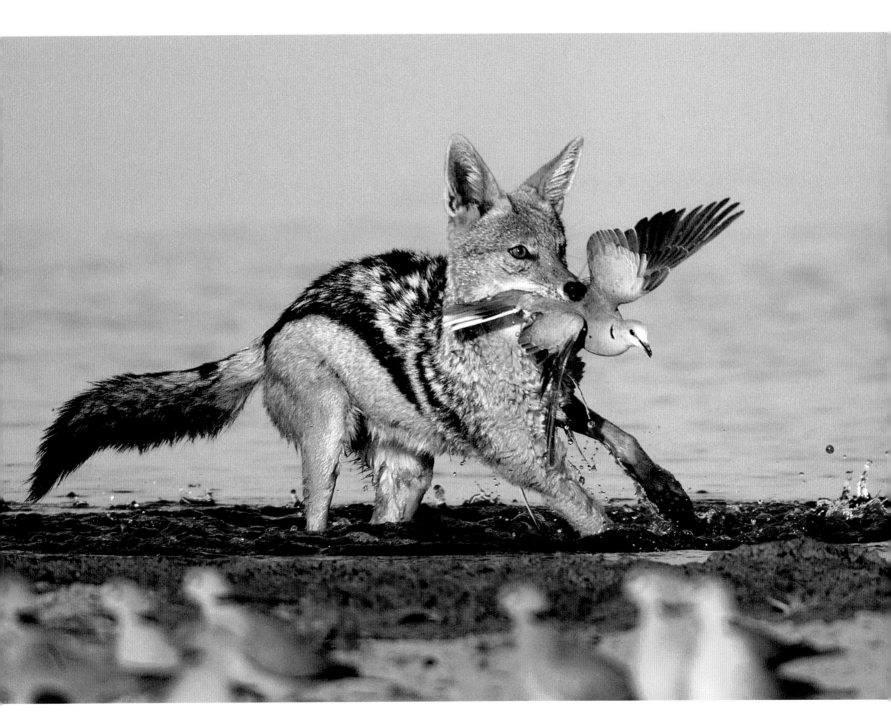

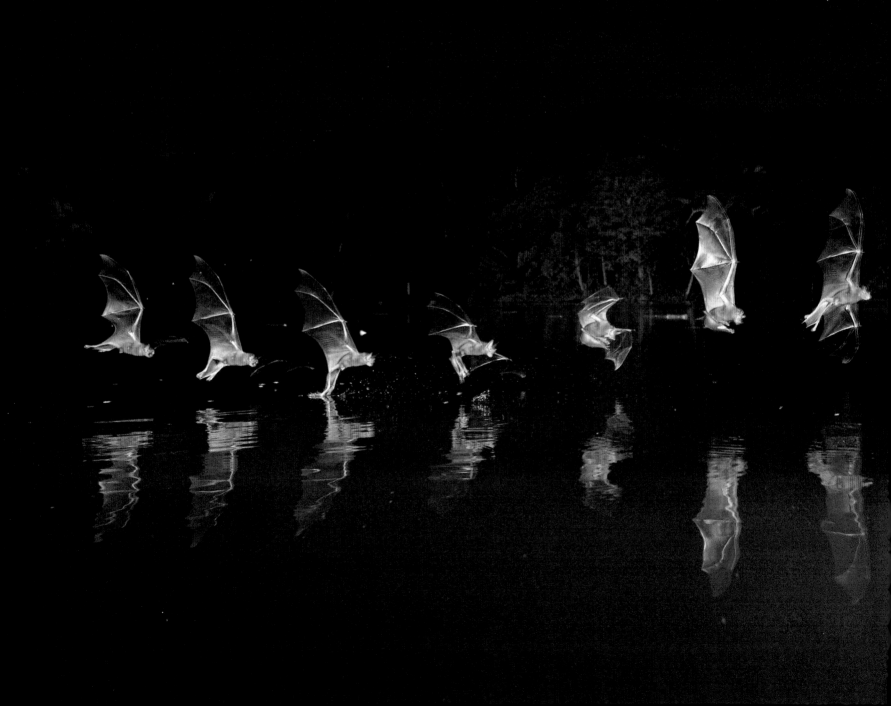

Flight of the fishing bat

RUNNER-UP

Christian Ziegler

GERMANY

It takes time to locate most rainforest species, let alone photograph their behaviour. So Christian spends much of the year in the rainforest on Barro Colorado Island, Panama, at the field station of the Smithsonian Tropical Research Institute, working with the scientists there. Bats are a particular preoccupation, none more challenging than the fishing bats. The only way to photograph a fishing bat fishing is by sitting in the lake in a boat, and lighting the lake scene requires more than one boat. Then there is a matter of fixing your tripod on a post in the right position at the right time on the right night. The background for this picture has been floodlit, and the multiple images have been created by a rapid series of flashes. In one frame you can see the swoop, the descent of the long hind limbs with their gaff-like claws, the catch and the transfer from feet to mouth. The bat detects fish by sonar and rakes its feet through the water to impale the prey, which it chews in flight and then stores it in its expandable cheek pouches so it can continue hunting.

Canon EOS 5D + 16-35mm lens at 26mm; 10 sec at f6.4; ISO 800; stroboscope flash; floodlights on boats; tripod attached to a post.

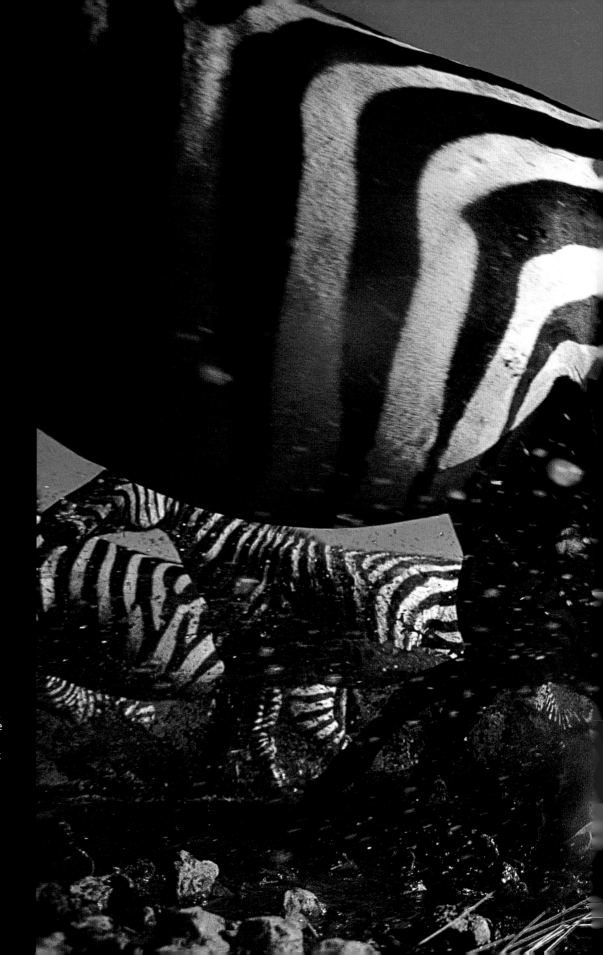

Zebra crossing

SPECIALLY COMMENDED

Anup Shah

UK

This picture took much planning and an intimate knowledge of the behaviour of the subjects – plains zebra in the Serengeti. Anup knew that the zebras would come at a certain time to drink at the waterhole. He also knew that, after not very long, 'something in their psyche would tell them this was not a place to linger at' and they would panic. The zebras behaved according to script, a mare leading in the group to drink, and then one animal sensing danger and causing the herd to charge out, kicking up mud and water – the bright light intensifying the power of the action. It was an expensive shot in terms of time (setting up the remote system) and money (the mud-soaked camera had to be serviced), but a cheap one in terms of satisfaction, creating what Anup had intended: an ant's-eye view of a large, powerful animal and a sense of the nature of the beast.

Canon EOS 1V + 20mm lens; Fujichrome Velvia 100F.

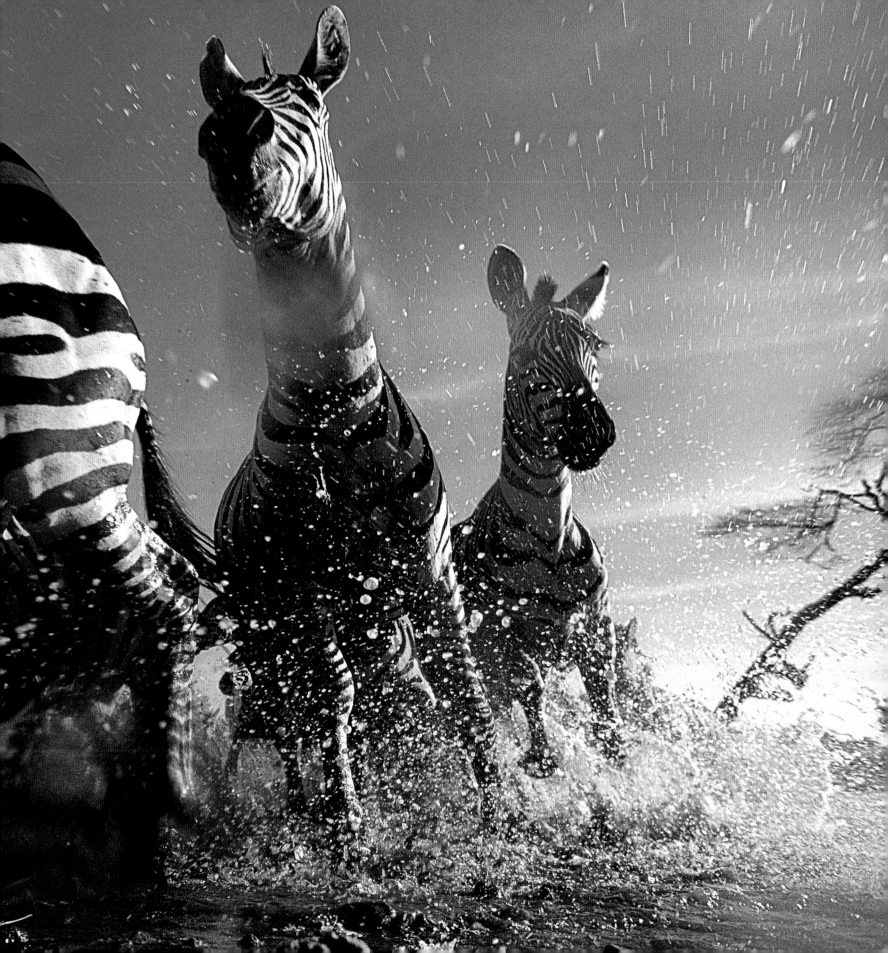

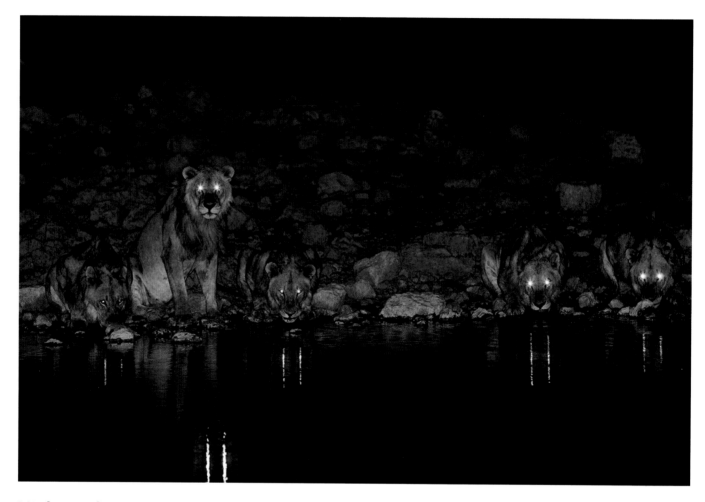

Night pride

HIGHLY COMMENDED

Cristóbal Serrano Pérez

SPAIN

In Namibia's Etosha National Park, permanent waterholes are a lifeline for wildlife in the dry season. Cristóbal spent five long, humid nights photographing the animals coming to drink at Okaukuejo. 'As this pride approached, I could hear them breathing,' he says. The camera flash is reflected back from their eyes as they glance, unfazed, at Cristóbal on the other side.

Canon EOS 1Ds Mark II + Canon EF 400mm f2.8L II USM lens and extender EF 1.4x II; 1/250 sec at f5.6; ISO 400; flash; fresnel lens, tripod.

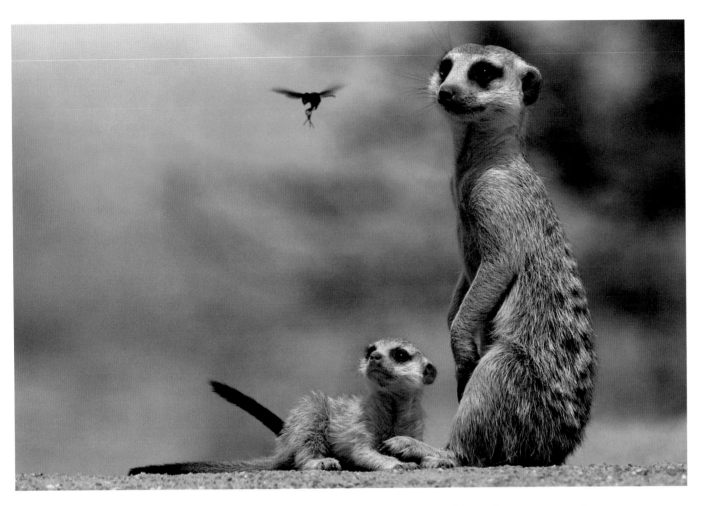

Meerkat moment

SPECIALLY COMMENDED

Shem Compion

SOUTH AFRICA

Meerkats are extremely vigilant – their lives depend on them spotting raptors flying overhead. They also live in colonies and are highly social, teaching their young, for example, how to extract stings from prey. This pup and its siblings were with an adult babysitter, in South Africa's Tswalu Kalahari reserve, when a hornet flew by. Thoughts of danger immediately turned to those of lunch, and for a moment these two were transfixed.

Nikon D200 + Nikon 200-400mm f4 VR lens; 1/320 sec at f8; ISO 100; beanbag.

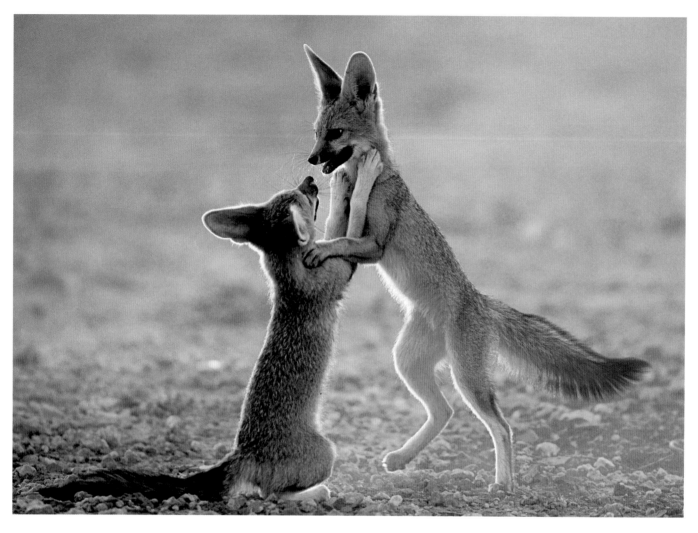

Cape fox cubs at play

HIGHLY COMMENDED

Helmut Niebuhr

SOUTH AFRICA

Having discovered a den of Cape foxes in South Africa's Kgalagadi Transfrontier Park, Helmut visited every day to observe and enjoy the family. The four cubs were most active when the light was best for photography – in the early morning (as here) and late afternoon, fighting, stalking and chasing one another while the vixen stayed close by watching for potential danger.

Canon EOS 1D Mark II + 500mm f4 lens; 1/500 sec at f4; ISO 400; beanbag.

Coyote howl

HIGHLY COMMENDED

Cathy Illg

USA

Cathy was on a landscape shoot in California's Death Valley National Park when, moments before sunset, a pack of hunting coyotes materialized. There were a lot of youngsters, whose playfulness infected the whole pack. The coyotes chased after each other to and fro across the salty, sandy ground, kicking up the dust into golden clouds and howling. Then, pausing briefly against a backdrop of mesquite trees, they did something Cathy had never witnessed before – they howled in unison.

Canon EOS 20D + Canon 100-400mm IS lens at 400mm; 1/160 sec at f10; ISO 400.

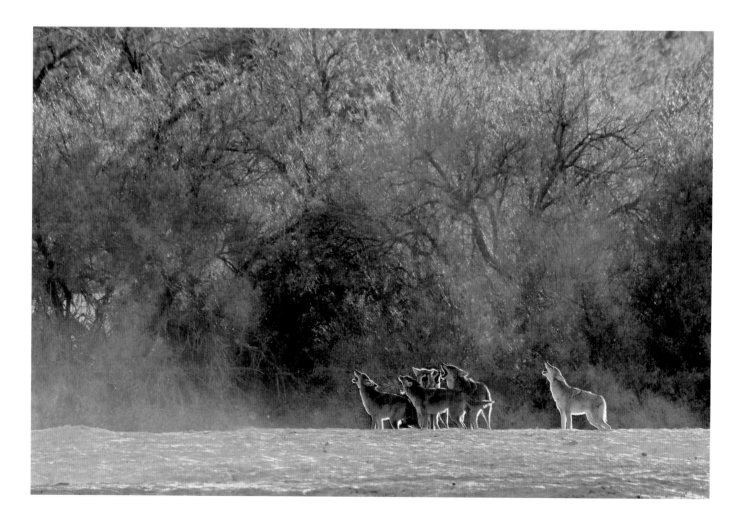

Behaviour
All Other
Animals

The majority of animals on Earth are species other than mammals and birds, and most of them behave in ways that are little known or understood. So this category offers plenty of scope for unusual behaviour and different pictures.

Great white torpedo

WINNER

Amos Nachoum

ISRAEL/USA

Determined to get the perfect great white shark breach, Amos spent two years planning and many days at sea on the floor of a small boat, suffering fumes from the outboard engine, lashing wind and spray. Together with the sharks, he patrolled the waters surrounding Seal Island in False Bay, South Africa. Known as the Ring of Death, this area is a hotspot for great white sharks to ambush seals and is the only place where they breach regularly in such a spectacular way, rising at speed from the depths. The best time for seal hunting (and therefore shark hunting) is the early morning, when the seals set off in search of food – there is just enough light to see seals' silhouettes from below, but not enough so the seals can see what's lurking below. Sometimes a shark would breach for a seal, sometimes one would do it for a rubber dummy towed behind the boat, as in this case. Always, it was unexpected and over in less than a second and a half – the fastest breach being just two thirds of a second from breaking the surface.

Nikon F5 + 70-200 f4 lens; 1/1000 sec; Fujichrome Provia 100.

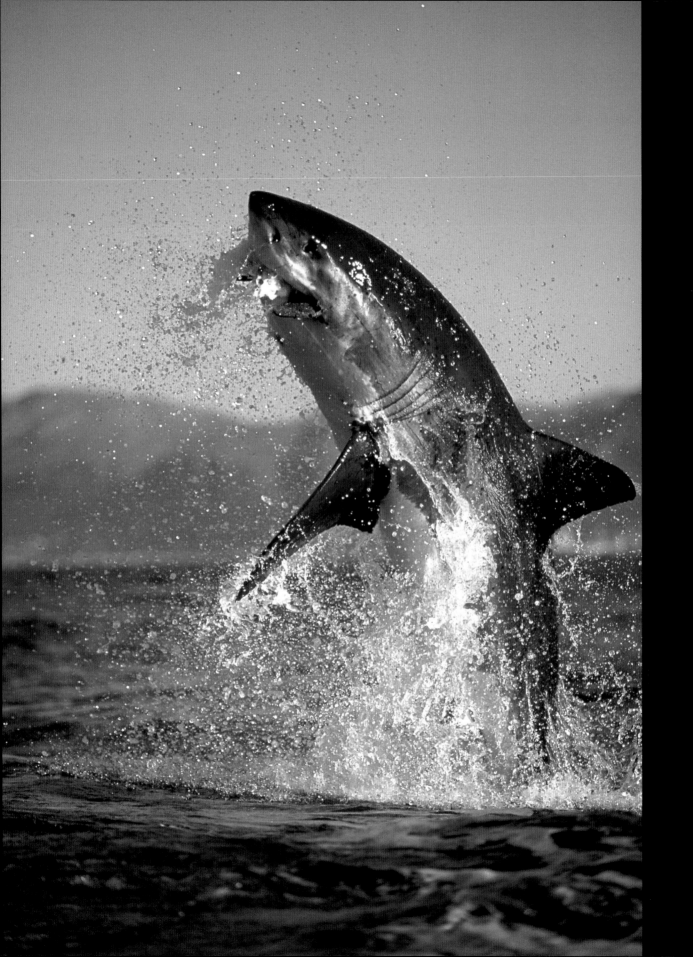

Ocean glider

RUNNER-UP

Marguerite Fewkes

UK

Marguerite was on a ship sailing between Vanuatu in the South Pacific and Fiji when, one afternoon, dozens of large flying fish appeared off the bow. Flying fish 'fly' by using their tail fins as rudders and gliding on their huge pectoral fins across the ocean surface up to an astonishing 100 metres (100 yards). Usually, they surface to flee predators such as tuna and swordfish, but this shoal was probably disturbed by the ship's bow wave. 'Their iridescent blue sheen was dazzling against the velvet-like sea,' she remembers, 'but focusing was a challenge,' as they were gliding at speed. She opted to focus on one area of sea, and the moment a flying fish appeared in the viewfinder, she quickly refocused and shot repeatedly until it submerged. This is the result.

Canon EOS 20D + Canon 75-300mm IS DO zoom lens; 1/500 sec at f7.1; ISO 200.

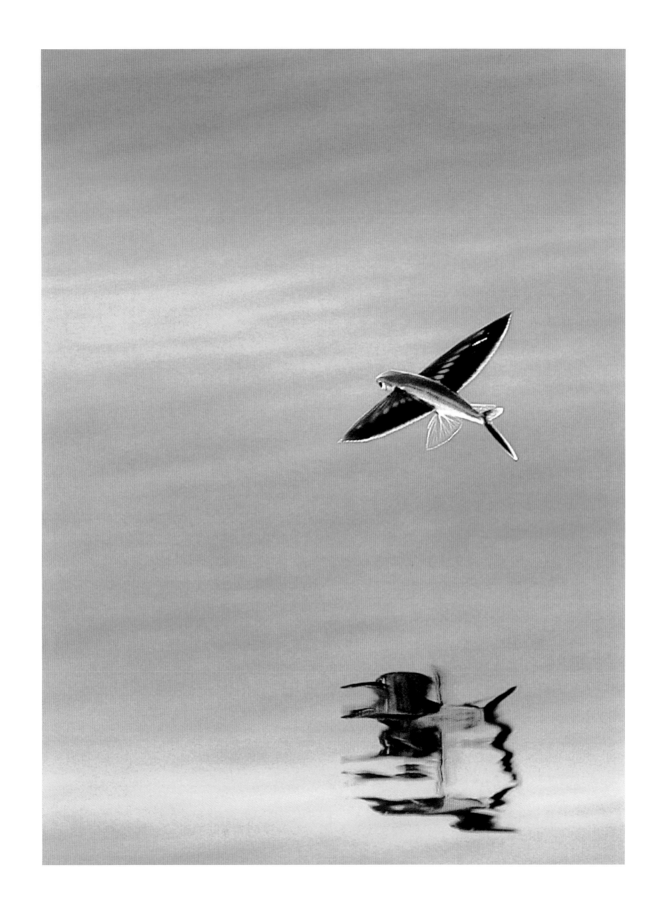

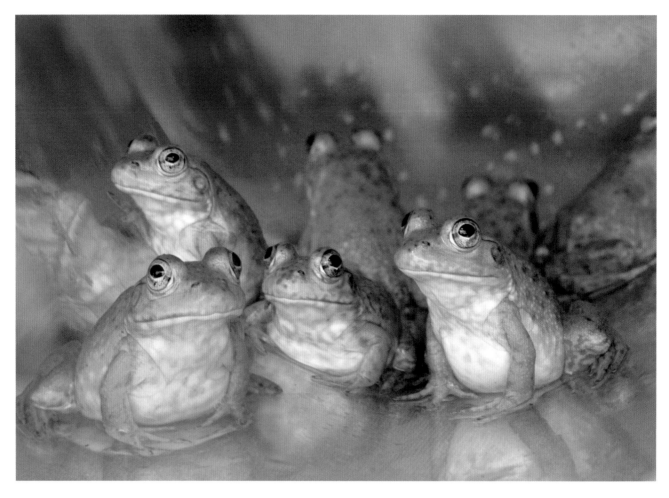

Frog refuge

HIGHLY COMMENDED

Ines Labunski Roberts

UK/USA

One winter morning, Ines discovered this huddle of young American bullfrogs in an open drainpipe. They were near a thermal pool in the foothills of California's Sierra Nevada, and, says Ines, 'some of the frogs were actually swimming in the pool.' Dead frogs near the pool could have been victims of a severe frost the previous night. So there is a possibility that the drain and the warmth from the pool saved these six from freezing to death.

Canon EOS 20D + Canon 24-85mm lens; 1/200 sec probably at f8.

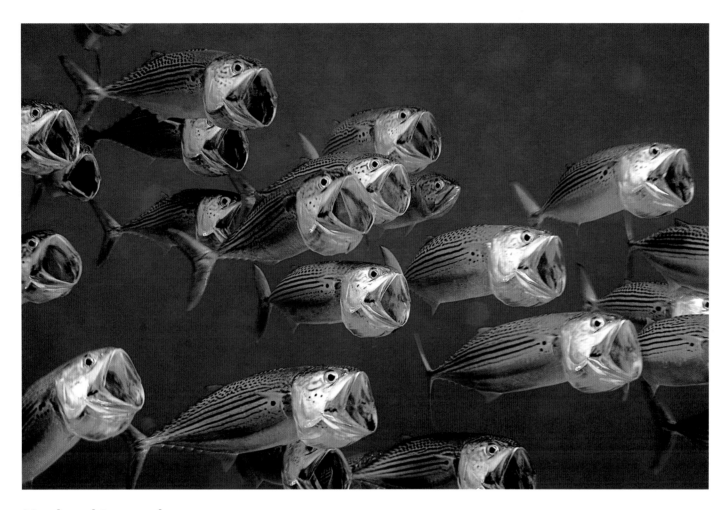

Mackerel in synchrony

HIGHLY COMMENDED

Béla Násfay

HUNGARY

Násfay encountered this huge school of striped mackerel in the Red Sea off the Egyptian coast. 'A surreal sight,' he says, 'hundreds of mouths agape, moving in synchrony as though one.' Mackerel usually occur in the open ocean, filtering plankton, but they feasted for three days, allowing Násfay to get to know their behaviour. 'If they felt disturbed,' he says, 'they'd close their mouths and change direction in a flash.'

Nikon D200 + AF Micro-Nikkor 60mm f2.8 lens; 1/125 sec at f11; ISO 100; Ikelite housing; 2x DS125 flashes.

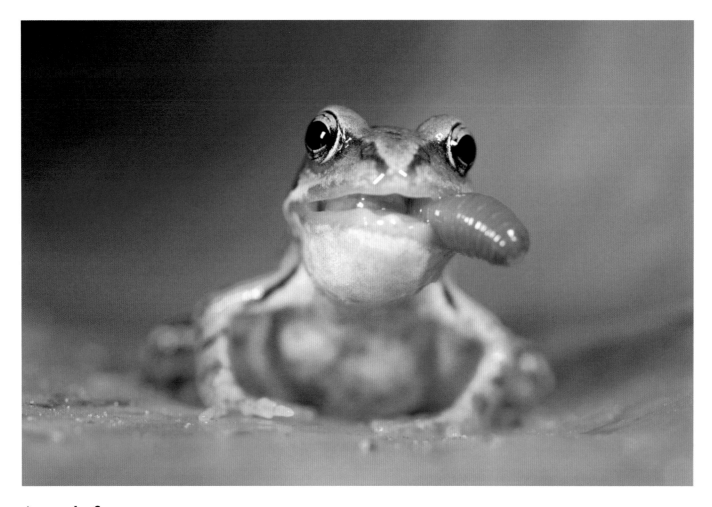

A meal of a worm

HIGHLY COMMENDED

David Maitland

UK

While photographing a year in the life of a pond at his children's school, David was delighted when he noticed common frogs eating earthworms – 'We see frogs in our gardens, but we rarely see them feeding.' Having wrestled its prey into position, this little frog was waiting for the worm to reach its stomach before sealing shut its mouth – 'a shot that captures the character of frog,' says David.

Canon EOS 1Ds + MP-E 65mm macro lens; 1/1000 sec at f8; ISO 100; macro twin flash.

Bouquet of butterflies

HIGHLY COMMENDED

Philippe Toussaint

BELGIUM

'Butterflies', says Philippe, 'are at their most charming at the end of the day – a bit like small children – once they've stopped flitting about.' Chalkhill blues and other butterflies thrive on the chalk grassland near Philippe's home in Lorraine in northeastern France. He wanted to capture their jewel-like quality when at rest, and spent a lot of time in the early morning and at the end of the day searching for a butterfly roost. Here, as the chalkhill blues (males and females) settled for the night, Philippe set up his tripod, taking advantage of the soft evening light to create what he calls his bouquet of butterflies.

Fujifilm Finepix S2 Pro + AF Micro-Nikkor 200mm 1.4D lens; 1/125 sec at f6.7; tripod.

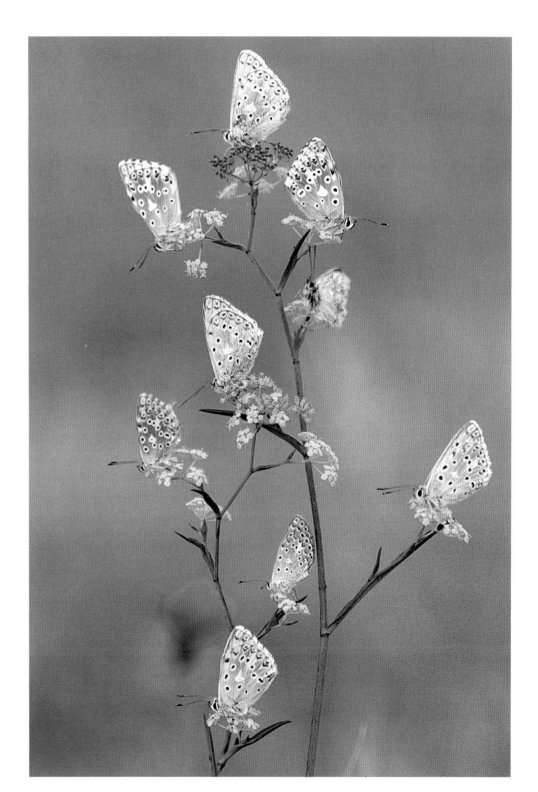

The Underwater World

Here the subjects can be marine or freshwater, but the pictures must be memorable, either because of the behaviour displayed or because of their aesthetic appeal – and ideally, both.

Giant feast

WINNER

Felipe Barrio

SPAIN

It was dawn on New Year's Eve when Felipe was woken by a huge crash against his boat. The largest fish on Earth – a 10-metre-long (33-foot) young whale shark – had just bumped into the hull. Within a few minutes, four other sharks had joined it, gathered below the school of sardines. 'We slipped into the water using snorkelling gear', says Felipe, 'so as not to disturb the sharks .' The Gulf of Tadjourah off Djibouti, in the Red Sea, is a hotspot for these giants, which congregate here from October to January to feed. And feed they did, non-stop for three hours, sucking up the surface plankton that the sardines were eating but also the sardines' excrement. Felipe has dived all over the world, but 'being under water surrounded by these giants, exchanging curious stares,' adds Felipe, 'is one of my best-ever diving experiences.'

Nikon D200 + Nikon 10.5mm lens; 1/50 sec at f4; ISO 160; Seacam housing.

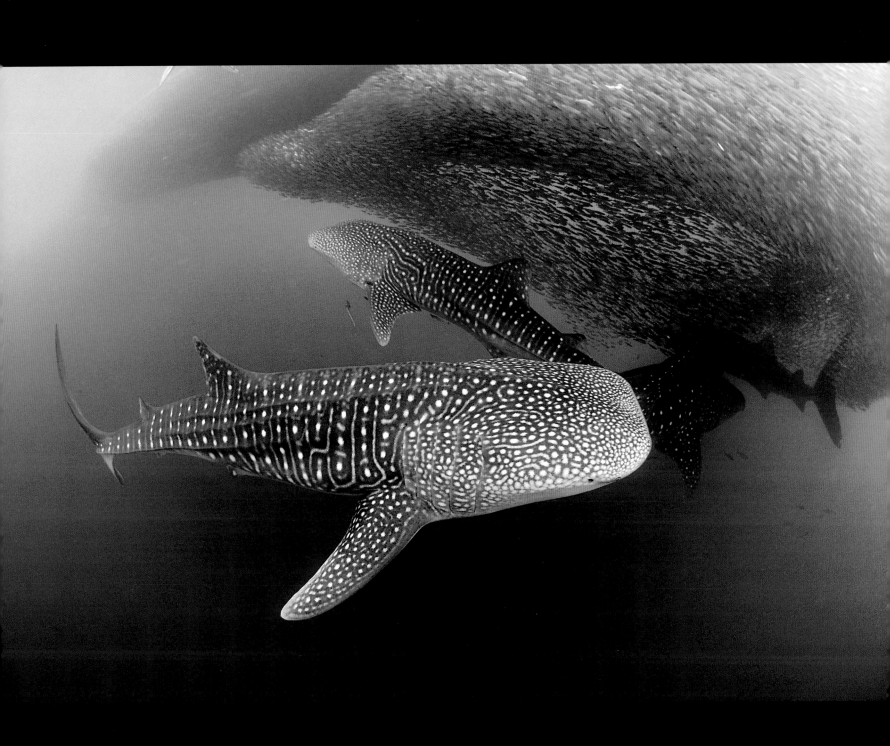

Teeth exposure

RUNNER-UP

Paul Nicklen

CANADA

'Leopard seals have always had a bad rap,' says
Paul. 'They have punctured inflatable boats and
followed people onto the ice, and in 2003, a
British scientist was attacked and drowned.' But
like all predators, they are usually judged by the
worst stories. Paul set out to find out whether the
leopard seal was a savage beast – or simply
confident, curious and misunderstood.
At Anvers Island off the Antarctic Peninsula,
he had more than 50 underwater encounters with
leopard seals. 'In almost every case,' says Paul,
'the seals approached me in the same way,
opening their mouths inches from my face –
I'm sure it's their way of communicating.'
After they had established their dominance with
this rather nerve-racking initiation ceremony, they
seemed to relax and even caught and offered
penguins to Paul. 'Leopard seals are intelligent
and highly social animals,' he concludes, 'but
like all predators, they need to be treated with
respect and as individuals.'

**Canon EOS 1Ds Mark II + 17-40mm f4 lens; 1/30 sec at
f11; Ikelite 125 digital strobes.**

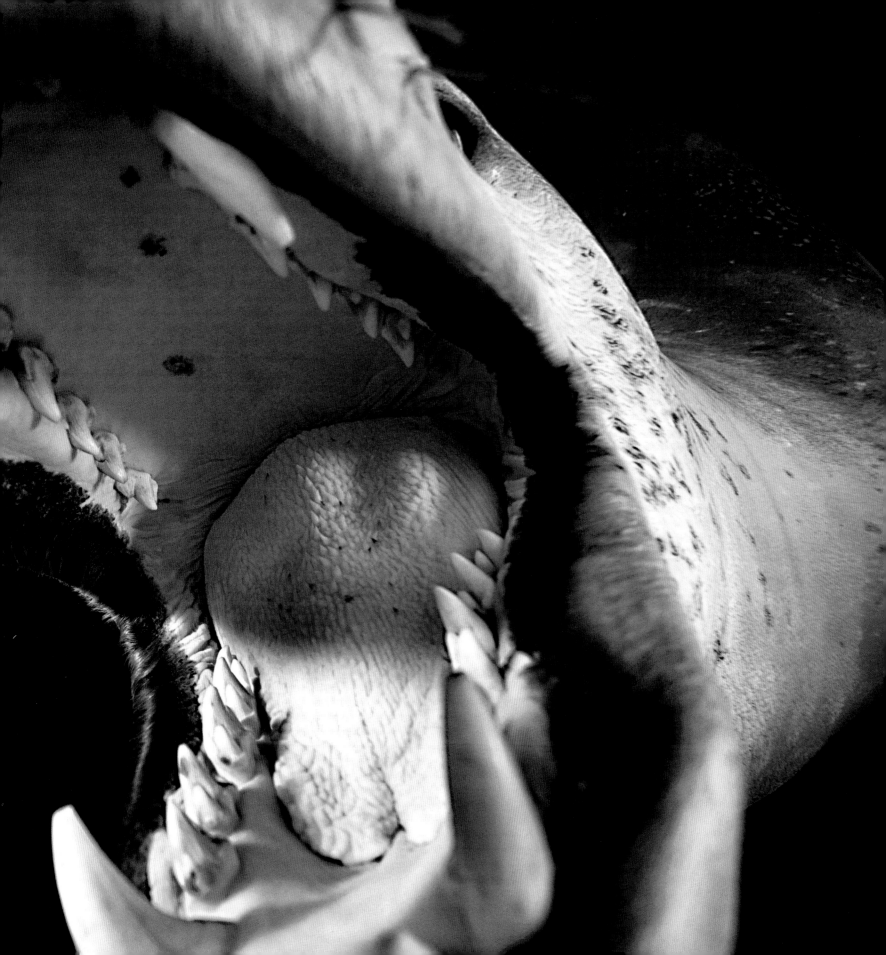

Love of a leopard seal

HIGHLY COMMENDED

Paul Nicklen

CANADA

'From the first time I got in the water with this massive female leopard seal, she attempted to communicate with me,' says Paul. Every time he saw her, he would jump in the water with her. 'I couldn't sleep at night because I was dying to interact with her. Every day, she would offer me penguins, both dead and alive [here, a chinstrap] – releasing the live ones towards me, watching my behaviour. I really believe that she felt sorry for me – a useless predator – and thought I might starve. When I kept refusing to eat her offerings, she looked agitated and would blow bubbles in my face and then go and get me another penguin.'

Canon EOS 1D Mark II + Canon 17-40mm f4 lens; 1/60 sec at f8; Seacam housing; two Ikelite ss125 strobes.

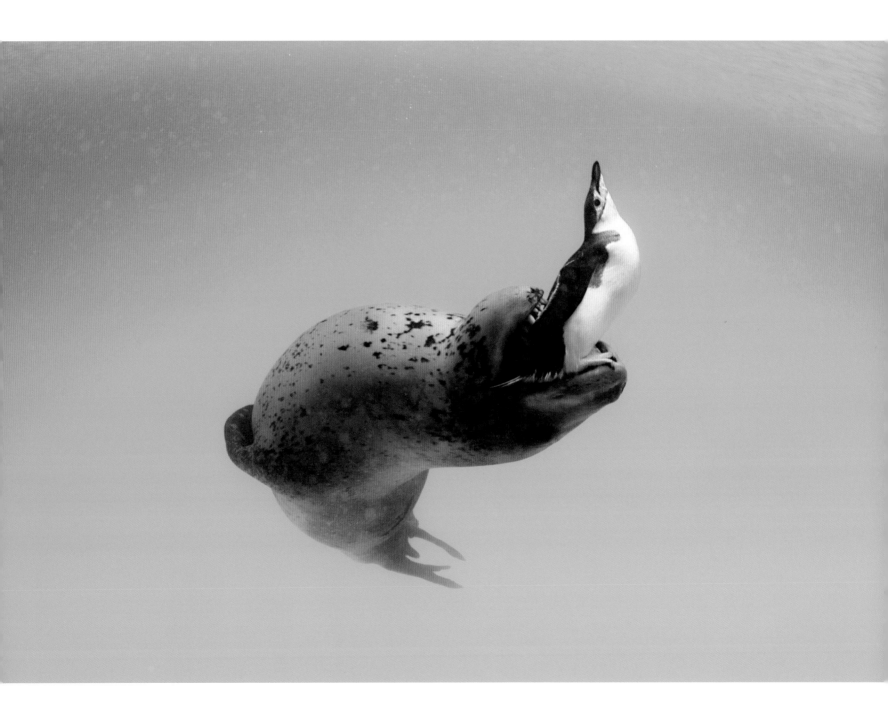

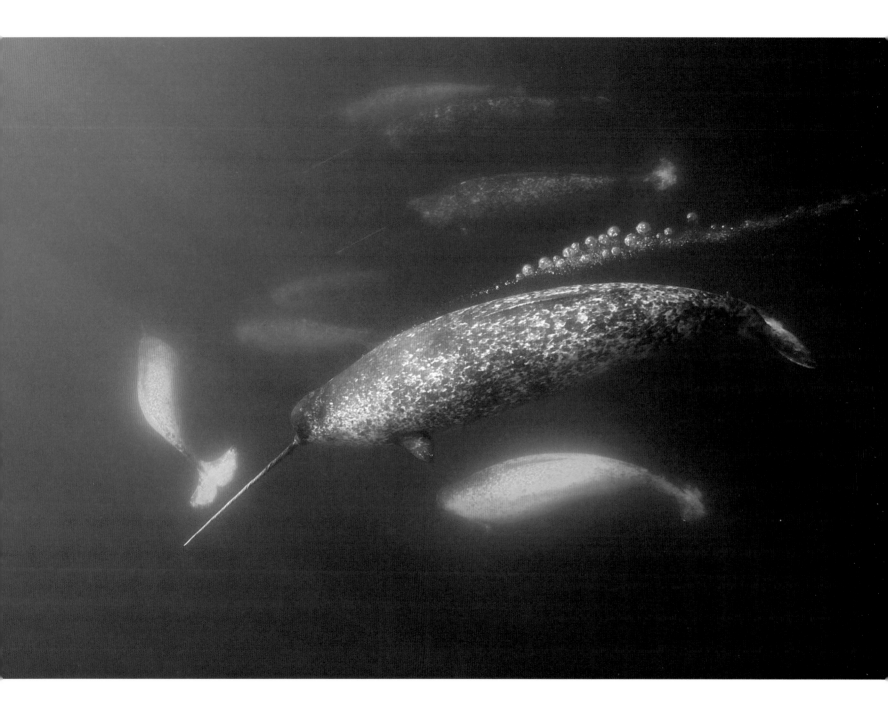

The mysterious narwhal

SPECIALLY COMMENDED

Paul Nicklen

CANADA

This group of male narwhals was photographed by Paul at the ice edge in Canada's Lancaster Sound. As one approached him, it released a stream of bubbles, possibly as some form of communication. The most puzzling thing about narwhals, though, is the function of their tusks. When a male narwhal reaches the age of about one, something bizarre happens – its left incisor starts to drill outwards. Slowly the tooth spirals anti-clockwise, emerging from its upper jaw and eventually reaching some one to two and a half metres (three to eight feet) in length. This, the world's most extraordinary tooth, may serve as a jousting weapon – females seldom have tusks – help pick up sonar pulses or even act as a sensory tool detecting water temperature, salinity or pressure. But as narwhals live mainly in Arctic waters, observations of their behaviour are few and far between, and so no one knows for sure.

Canon EOS 1Ds Mark II + Canon 16-35mm f2.8 lens; 1/60 sec at f8; Seacam underwater housing.

Big fish, little fish

HIGHLY COMMENDED

Len Deeley

UK

Despite appearances, this is not a little pilot fish about to be snapped up by a big shark. Pilot fish often swim in front of sharks, possibly to benefit from their protection, to 'bow ride' and to snap up scraps – a small one may even swim into a shark's mouth to nibble food between its teeth. Rarely will a shark eat a pilot fish. Diving in the Red Sea, Len went in search of sharks, and this silky shark came looking at him. 'Just as it made a close pass,' says Len, 'I shot its profile, the pilot fish in typical lead position, as if attached by an invisible wire.'

Nikon D70s + 60mm f2.8 lens; 1/60 sec at f5.6; ISO 200; Sea & Sea housing; two Inon flashguns.

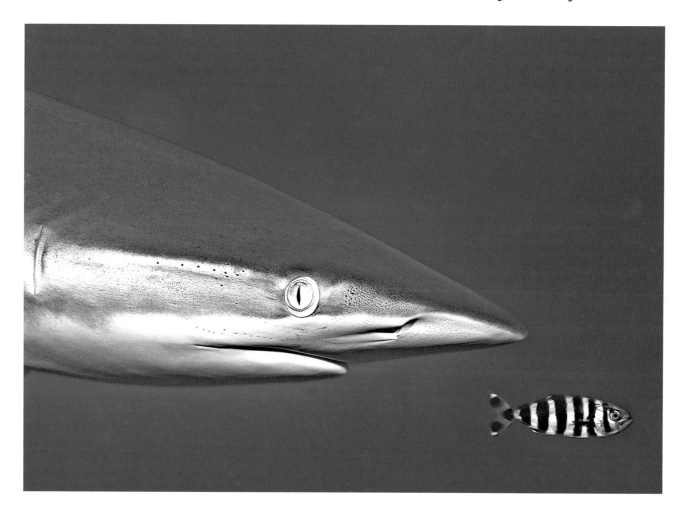

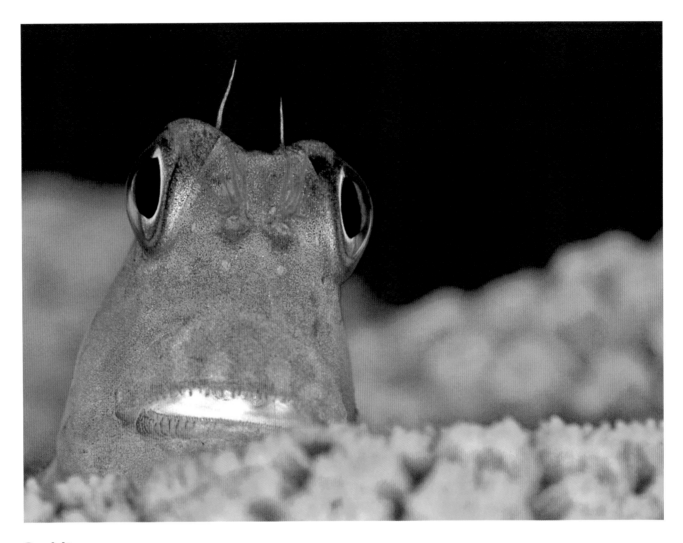

Red-lips

HIGHLY COMMENDED

Patrick Weir

UK

Colourful and curious, this red-lipped blenny exudes character. Patrick encountered it on Grand Cayman in the Caribbean. True to character, it was darting busily around its territory, making it nearly impossible to photograph. It may even have been tending eggs – male red-lips are perfect fathers. He took the shot when it paused to look at its strange pursuer. Its red lips are agape, revealing comb-like teeth – perfect for eating algae. The blenny favours sunny spots on reefs with plentiful algae, which also sets off its colour to perfection.

Nikon D2X + Sigma 28-70mm lens; 1/125 sec at f16; Subal ND2 housing.

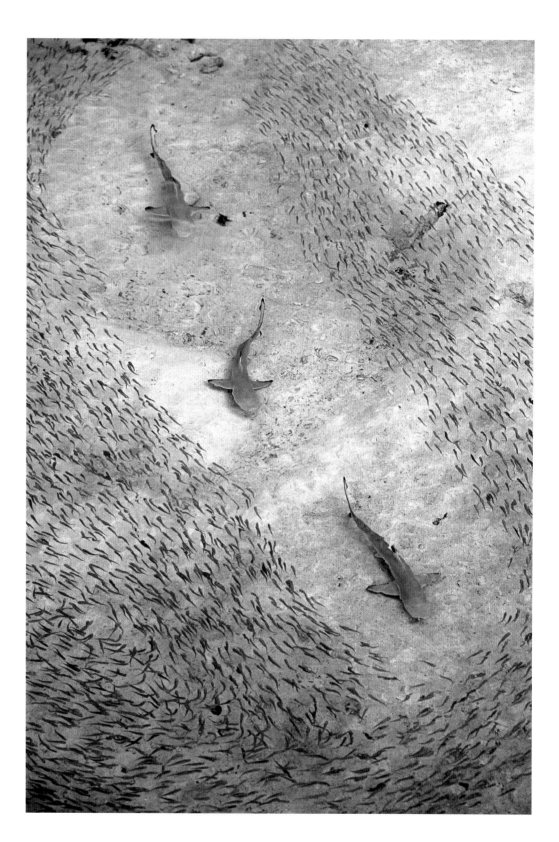

Fish round-up

HIGHLY COMMENDED

Alec Connah

UK

Alec visited Lankayan Island, off Sabah, Borneo, with the intention of photographing nesting turtles. One morning he was standing on the jetty when these young black-tip reef sharks meandered along, seemingly herding small fish into the shallows. 'I was impressed with their languid approach,' says Alec, 'and the patterns and swirls that formed as the fish took unhurried evasive action.' But every so often, a shark would lash out in a surprise attempt to feed. 'It was the only occasion I witnessed such behaviour,' says Alec, 'and I never did get the turtle shots.'

Nikon F5 + Sigma 70-200mm f2.8 lens; 1/250 sec at f5.6.

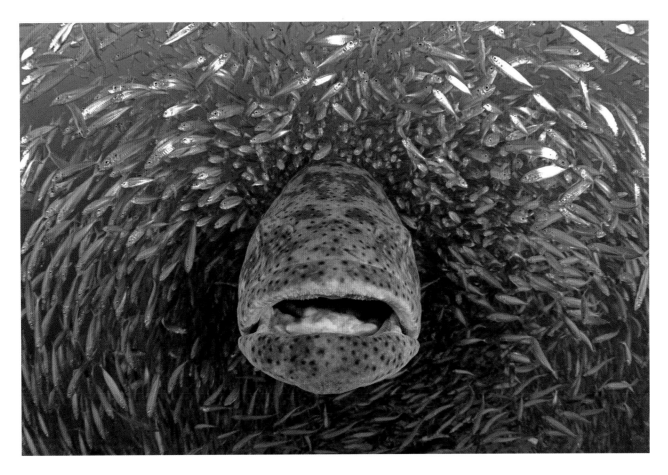

Goliath

HIGHLY COMMENDED

Douglas David Seifert

USA

This goliath grouper, with its massive mouth and swirling mane of silver fish, was discovered by Douglas lurking in a shipwreck off Jupiter, Florida. The cigar minnows are clustering around it to protect themselves from other predators such as trevally (groupers feed mainly on crustaceans such as lobsters). But being the largest reef fish in the Atlantic – at up to 2.5 metres (8.2 feet) and weighing up to 363kg (880 pounds) – has not protected the goliath grouper from being fished almost to extinction in in the Atlantic. Though the species is now protected under Florida law, large individuals such as this one are still a rarity.

Canon EOS 1Ds Mark II + 15mm fisheye lens;
1/250 sec at f8.

In Praise of Plants

The aim of this category is to showcase the beauty and importance of flowering and non-flowering plants, whether by featuring them in close-up or as part of their environment.

Heart of an agave

HIGHLY COMMENDED

Jack Dykinga

USA

While photographing the incredible biodiversity of the northeastern Mexican state of Tamaulipas, Jack spent time on the mountains of the Sierra Madre Oriental. Here the drought-resistant agave *Agave montana*, found only in this region, grows slowly but to huge proportions – up to 1.5 metres (5 feet) tall and 1.8 metres (6 feet) wide. Jack took this photograph at sunset in extremely low light 'making the greens fairly glow and revealing the patterns and indentations of each blade'. Seventy-five per cent of all agaves are found in Mexico.

Arca Swiss F-Field + Schneider Super-Symmar XL 110mm lens; 40 sec at f45; 4 x 5 format Fujichrome Velvia 50.

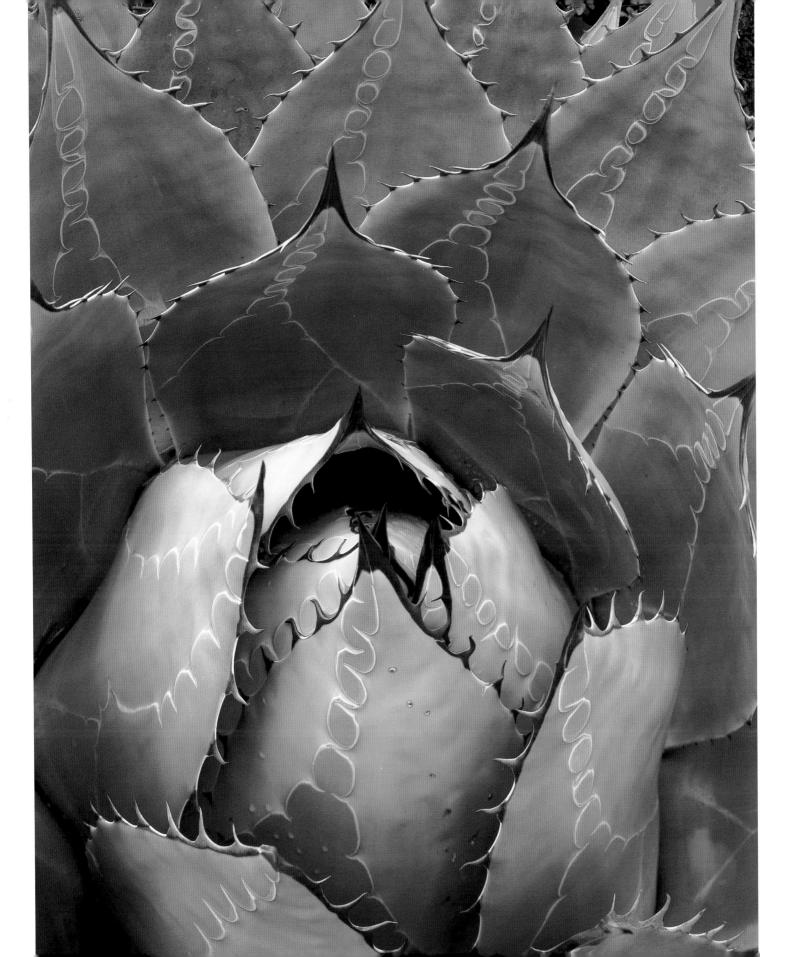

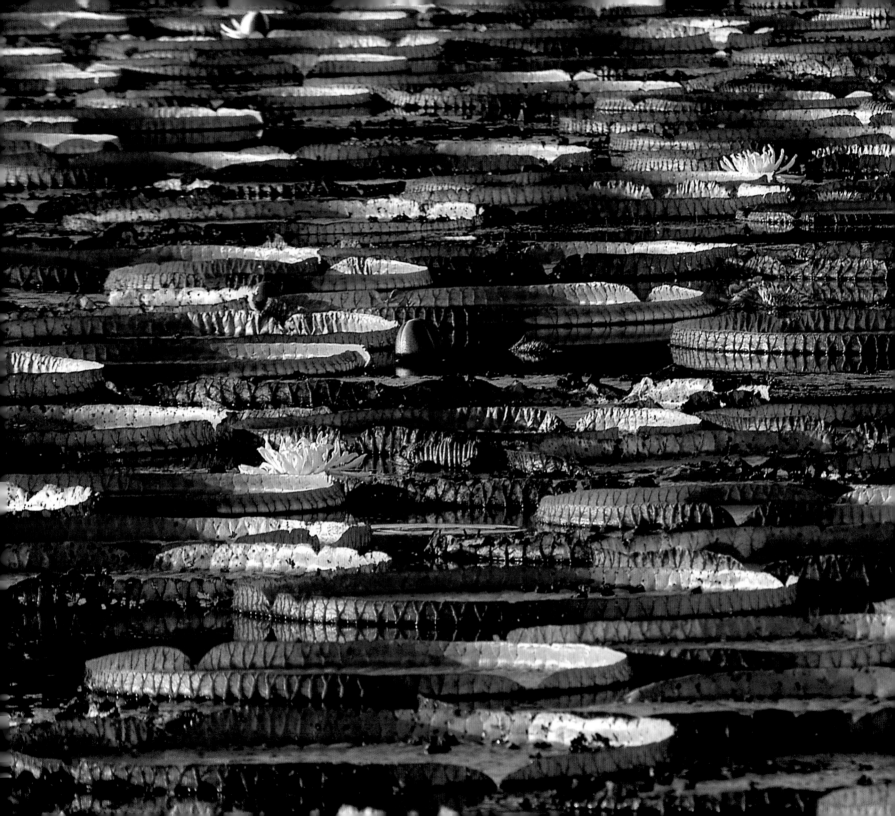

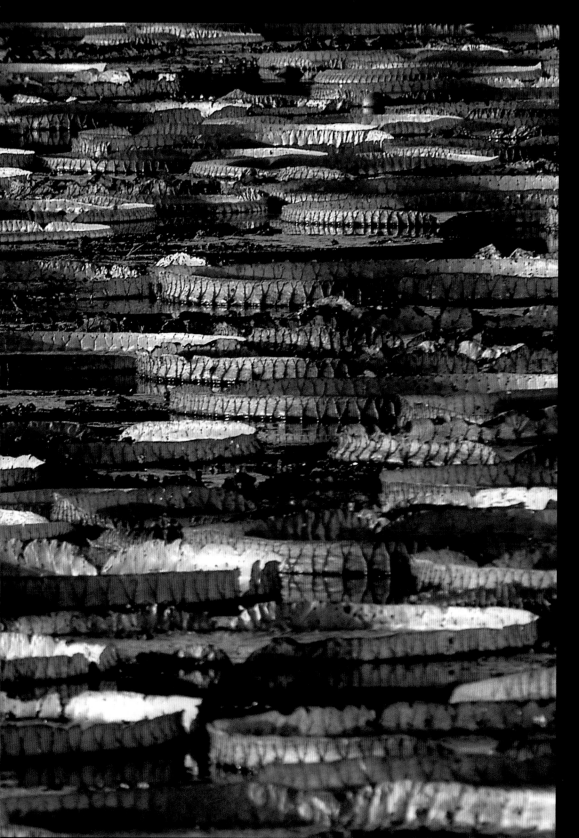

Giant Amazon display

HIGHLY COMMENDED

Charlene deJori

USA

These are the leaves of Amazon water lilies, the largest lily leaves in the world. Not only can they be nearly 3 metres (10 feet) in diameter, but their stalks can also be up to 8 metres (26 feet) long. On a quest to photograph the illusive bare-faced ibis, Charlene discovered 'an unexpected delight' – a large inland lake in Brazil's northern Pantanal covered from shore to shore with enormous lily leaves. 'Captivated by the play of light and form on the astonishingly sized leaves, lying flat and wide on the water's surface in the intense sun,' she set about trying to capture the intensity of the scene by using a panoramic format. The experience reinforced for her that the 'strongest magnet for a wildlife photographer is not just the final image but also the exhilaration of discovery.'

Nikon D200 + 75-300mm lens; 1/125 sec at f16 (-1.5 exposure compensation); ISO 1000.

The Dark Hedges

HIGHLY COMMENDED

Bob McCallion

UK

Looking like a scene out of *The Legend of Sleepy Hollow*, this glorious avenue of beech trees in County Antrim, Northern Ireland, is known locally as 'The Dark Hedges'. At least 250 years old, the overarching trees exude history and atmosphere, and a cold, misty February dawn seemed the right time to capture the spirit of the place. 'As the sun filtered through the light mist, it bathed the scene in dappled light, giving the branches form and depth,' says Bob – the perfect moment for the spectre of the road, the 'grey lady', to appear. But the light changed in a matter of minutes, and Bob had only just enough time to get the shot he wanted. The view has also changed since this picture was taken – the trees were pruned a few weeks later for safety reasons, and some felling of the ancient beeches and replanting is planned, as part of a long-term conservation plan.

Fujifilm Finepix S9600 + 28-300mm lens at 300mm and 2x converter; 1/25 sec at f11; tripod.

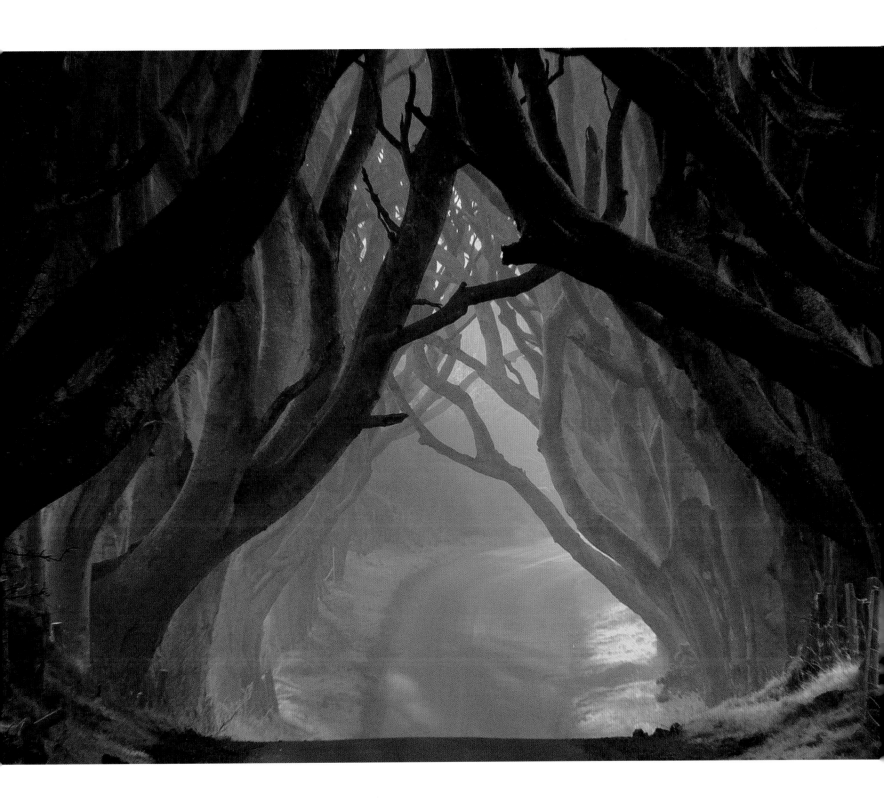

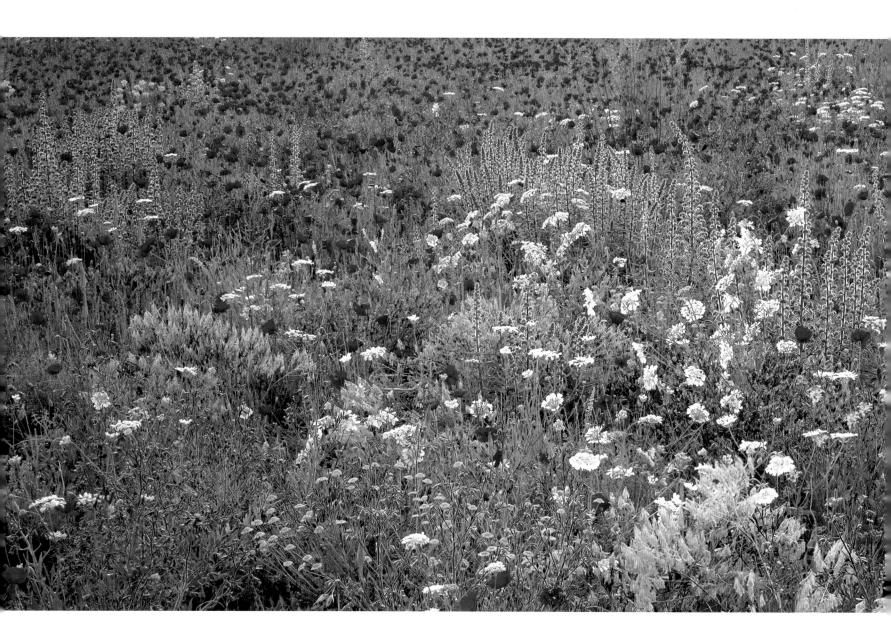

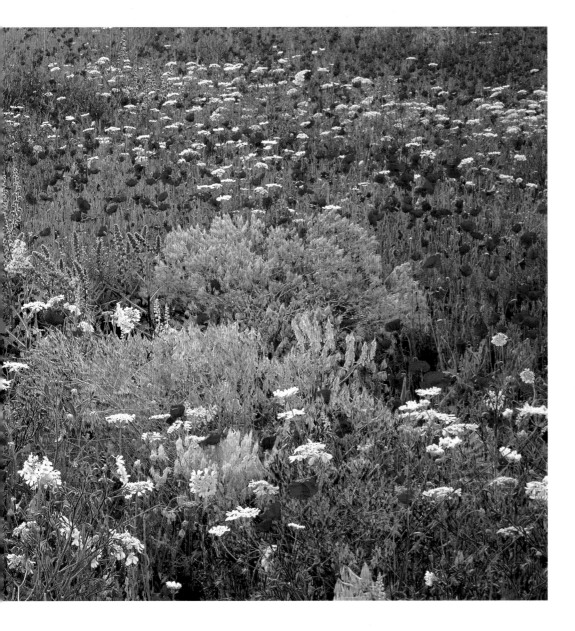

Flower colour

HIGHLY COMMENDED

Maurizio Valentini

ITALY

'Spring', says Maurizio, 'is by far my favourite season for photography.' It offers a feast of material for his ongoing study of 'light and colour' in the Abruzzo wilderness of his home region in central Italy. Last June, the highlands were in full bloom. 'When I found this magic spot with its sea of wildflowers,' says Maurizio, 'I couldn't believe my eyes. It reminded me of a letter from Pissarro (one of the founders of the Impressionism art movement) to his friend Cézanne: "Always paint using only the three primary colours – red, blue, yellow – and their shades".' Following this advice, Maurizio returned to the spot many times, waiting for the soft light of an overcast, rainy day to enhance the vibrant colours. When the conditions were right, he chose a panoramic format to create the perfect picture.

Hasselblad X Pan II + 90mm f4 lens; 2 sec at f22; Fujichrome Velvia 50; tripod; cable release.

Dawn meadow

HIGHLY COMMENDED

Rupert Heath

UK

'I tend to make most of my photographs around dawn – the most magical time to be outside,' says Rupert. 'The quality of light can be extraordinary. Though to best appreciate the richness of life in a meadow, you should walk through it in the heat of a summer's day, when the grasses and flowers are buzzing with insect life.' Many of the creatures in the meadow provide food for the birds that raise their broods in the surrounding trees and hedgerows or among the grasses. 'Skylarks still breed every year in this meadow,' he says. 'The picture's main focus is the field scabious, but the old grass species are evident, too, and there's a wonderful, thick, uncut hedgerow beyond.' The National Trust cares for this particular wildlife-rich meadow in Surrey. In the UK as a whole, though, meadowland has been reduced by 95 per cent within ten years. But as Rupert points out, habitat restoration is possible, and even part of a garden lawn can be managed as a meadow to help local wildlife.

Ebony 45S + 90mm lens; 13 sec at f32; Fujichrome Velvia 50; 0.9 & 0.3 hard-graduated neutral-density Lee filters; tripod.

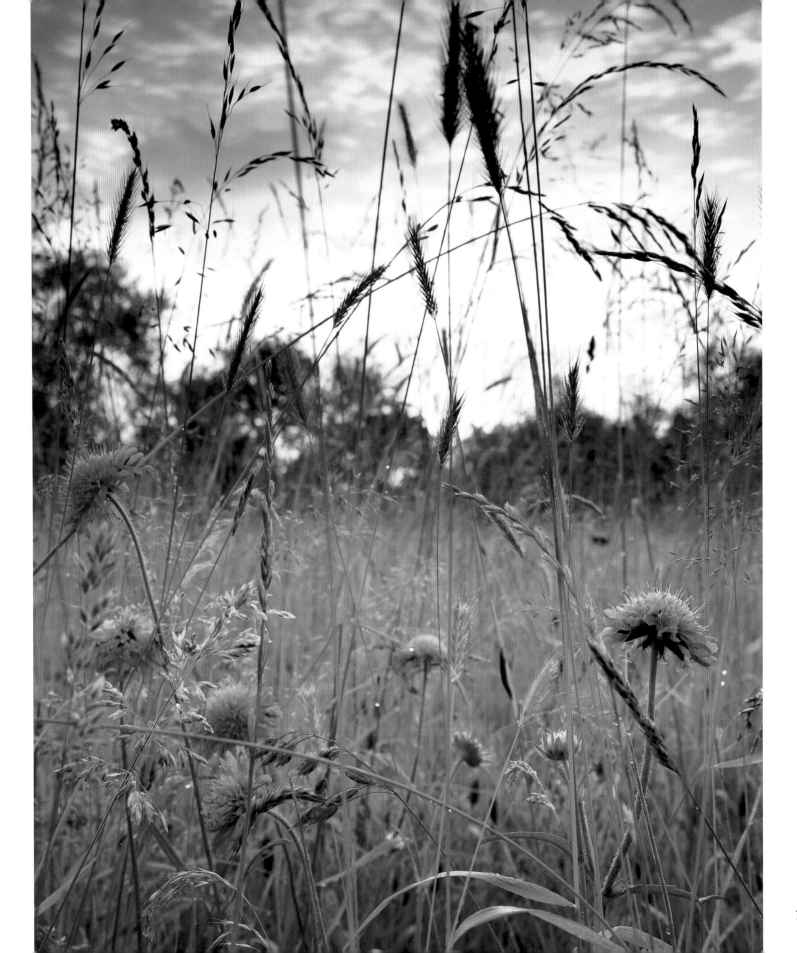

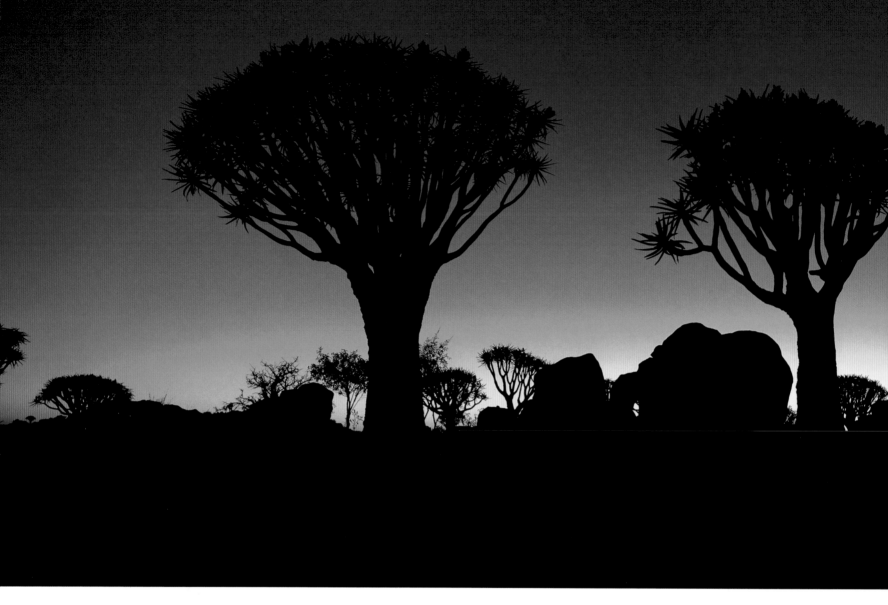

Land of the quiver trees

HIGHLY COMMENDED

Werner Van Steen

BELGIUM

'When I arrived at the Quiver Tree Forest,' says Werner, 'all I wanted to do was to take the first plane home.' He had heard so much about these surreal, Namibian plants (aloes, not trees), but they looked as dull and grey as the road running through them. But what a difference a few hours and a shift in light can make. When he returned at sunset, the world of the quiver trees was emerging. 'As the colours intensified, I was so overwhelmed by the beauty of the scene', says Werner, 'that rolls of film just flew through my camera.'

Fuji GX 617 + 90mm f5.6 lens; Fujichrome Velvia 50.

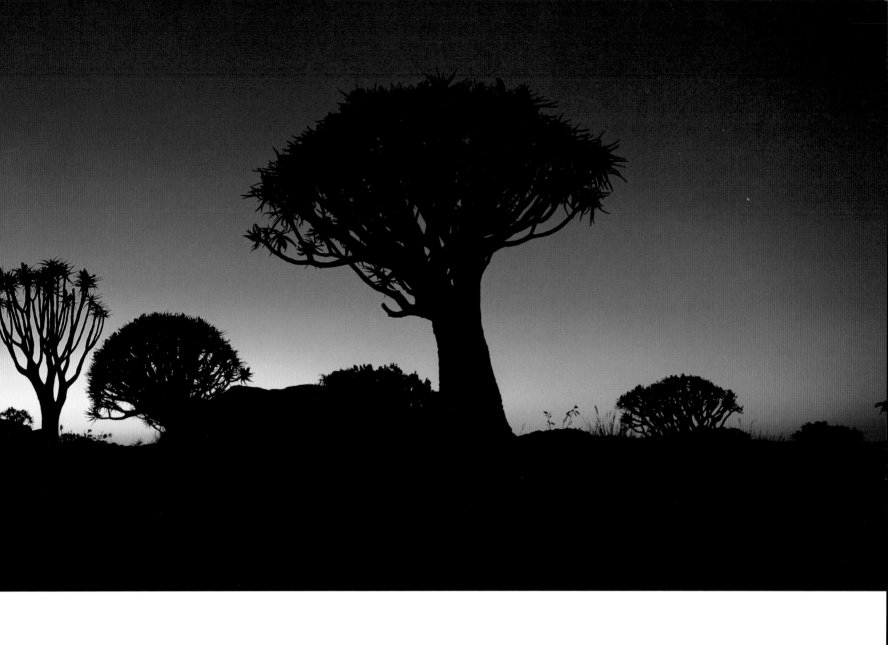

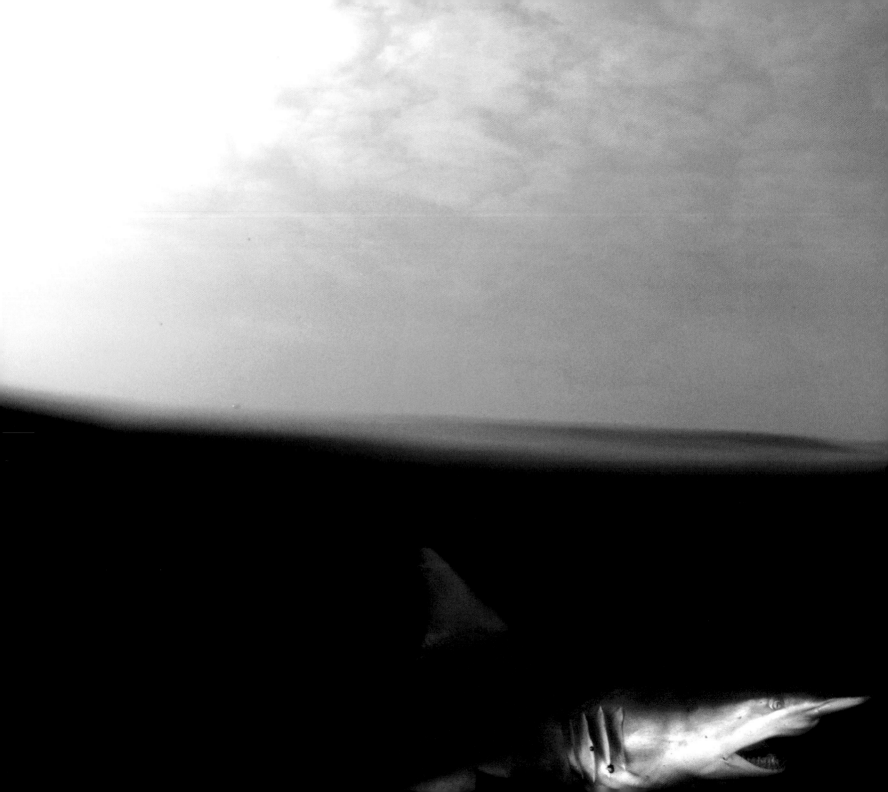

Nature in Black and White

The subject can be any wild landscape or creature, but what a picture must display is skilful and artistic use of the black and white medium.

Blacktip at dawn

WINNER

Thomas P. Peschak

SOUTH AFRICA

Divers often come across blacktip sharks at Aliwal Shoal, a subtropical rocky reef system off South Africa's KwaZulu Natal coast. But only in the early morning is the sea calm enough for split-level underwater photography of this sort, a time when little light penetrates the ocean. So Thomas used two strobes but focused light only on the shark, leaving the sea an inky black. After half an hour photographing blacktips cruising near the surface, he captured the split-second moment when one shark gaped – a mild threat display or signal to back off. Thomas knew enough about shark behaviour not to worry: 'It was directed at another shark just out of the frame, not at me,' he says.

Nikon D2X + Nikon 10.5mm f2.8 fisheye lens; 1/125 sec at f20; 2x Inon underwater strobes; Subal housing.

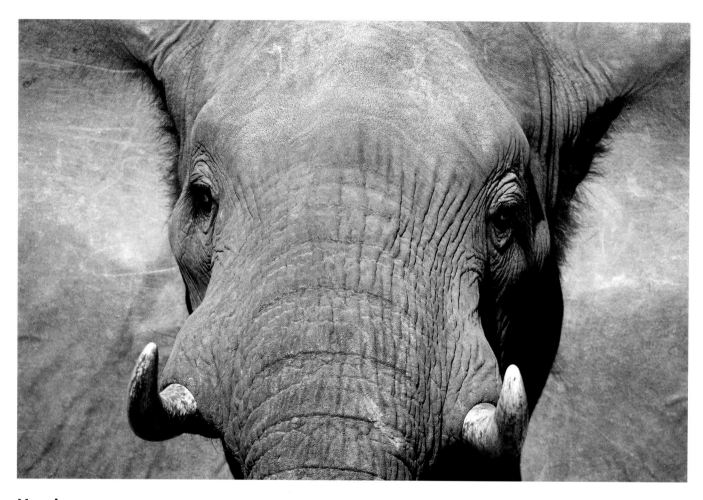

Head on

RUNNER-UP

Michel Denis-Huot

FRANCE

With its skin textures and grades of grey, an elephant is the perfect subject for black and white portraiture. When this bull in the Sabi Sands Game Reserve, South Africa, struck an intimidating pose, raising his head and spreading out his ears, Michel cropped in tight with his 500mm lens, using the ears as a frame for the face. The light that day was dull – perfect for the muted tones he required.

Canon EOS 1Ds Mark II + 500mm f4 IS USM lens; f6.3; ISO 640.

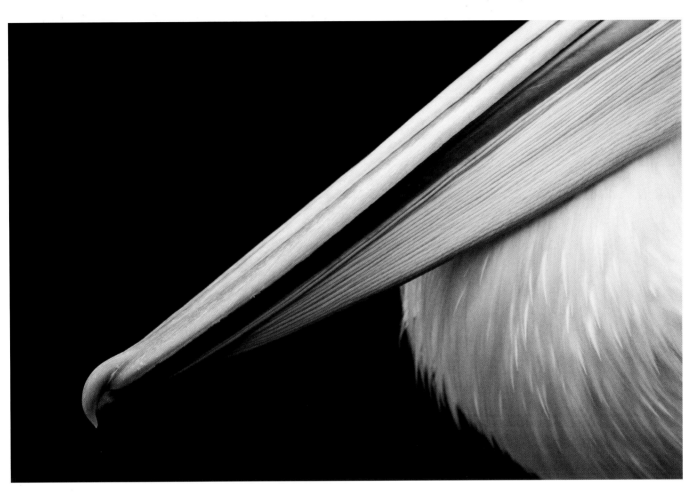

The bill

HIGHLY COMMENDED

Wesley Cooper

AUSTRALIA

Wesley was photographing birds for teaching purposes, when he became fascinated by this common Australian pelican. He watched for nearly half an hour as it cleaned itself with its beak, a process that involved turning the pouch inside out. 'A pelican has the largest bill of any bird in the world,' says Wesley, 'and by concentrating on the bill, I wanted to capture the spirit of the species.'

Canon EOS 1D Mark II N + Canon EF 300mm f4 USM IS lens; 1/3200 sec at f4; ISO 320.

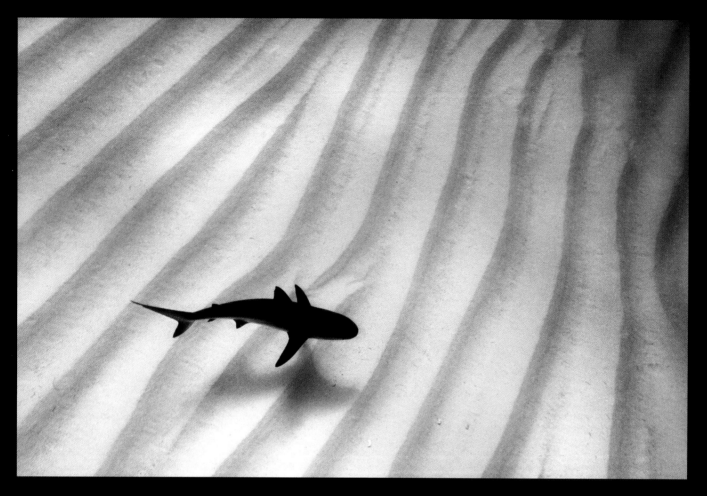

Lone shark

HIGHLY COMMENDED

Alexander Mustard

UK

'My aim was to make it look small in its habitat, to highlight just how vulnerable sharks are,' explains Alexander. He did this by opting for a minimalist composition, looking down on the Caribbean reef shark as it swam across the sand. He went to the Bahamas specifically to photograph sharks – one of the few places where numbers have not been decimated by the shark-fin-soup trade, which now pays more than $700 a kilogram for their fins.

Nikon D2X + 12-24mm f4 lens; 1/125 sec at f11; ISO 100; Subal housing.

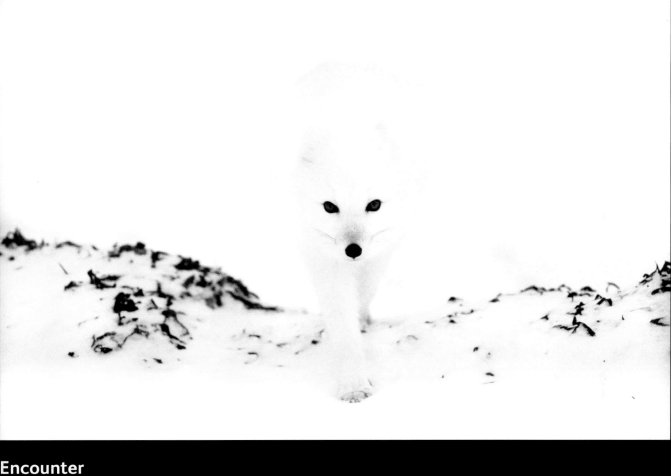

Encounter

Anna Henly

UK

Swaddled with arctic gear and wedged painfully
between rocks encrusted with salty sea-ice by
Hudson Bay, Canada, Anna watched a group of
Arctic foxes patrolling the beach in search of food.
One decided to take a closer look at her frozen
form. 'It stalked me, emerging out of the mist, and
came so close that I could have stroked its fur.'
The fox then peered straight down her lens. 'When
it made eye-contact, I was spellbound,' she says.

Animal
Portraits

This category – one of the most popular in the competition – invites portraits that capture the character or spirit of an animal and must do so in an original way.

Bear glare

WINNER

Sergey Gorshkov

RUSSIA

If you had to put a human name to this bear's expression, it would be anger, malevolence even, with eyes narrowed and nostrils flaring. This bear, of the largest race of brown bear on Earth, is telling Sergey to take his camera and get the hell off its patch. Sergey got the message – but not before getting his shot. He was there to take pictures of the thousands of spawning salmon on the Ozernaya River in southern Kamchatka, East Russia. So absorbed was he with the masses of fish that he didn't notice the bear until he surfaced. 'It was a *terrible* shock', admits Sergey 'to see this massive face glowering at me from just a metre away.' Adrenalin didn't make him bolt, however, but instead helped him concentrate on the photograph. Only later did he really appreciate just how serious the situation was.

Nikon D2X + Nikkor 12-24mm f4 G AF-S DX lens at 12mm; 1/250 sec at f10; ISO 200; Subal housing; two strobes INON D2000.

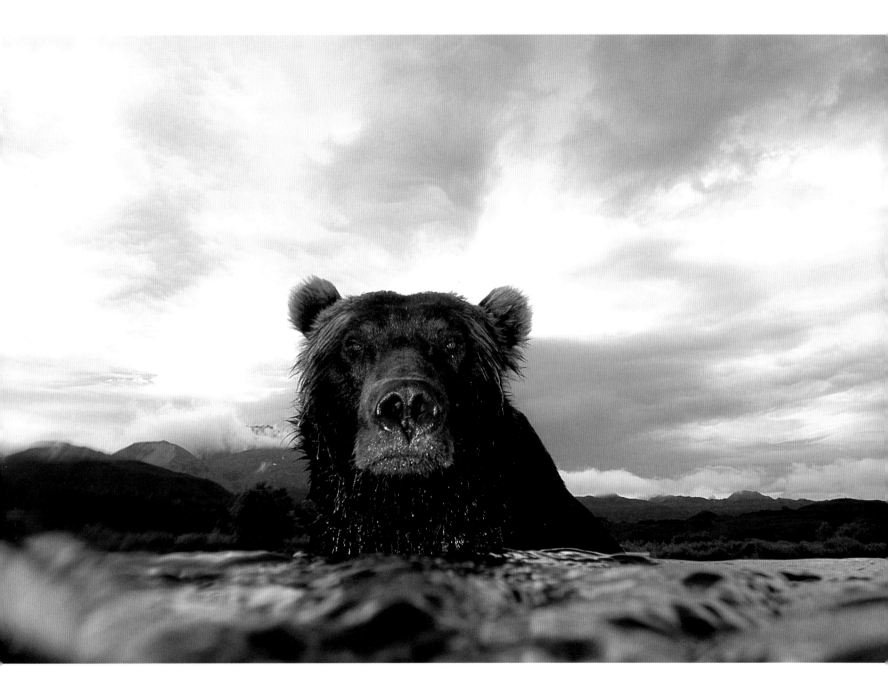

Mallard's-eye view

RUNNER-UP

Graham Eaton

UK

Graham spent several chilly, overcast October days diving and swimming in Llyn Padarn, in Llanberis, North Wales, to get the local mallards used to his presence. His aim was to take a shot of one feeding under water. This duck was particularly inquisitive. 'Whenever I dropped below the surface, he would look down at me looking up at him,' says Graham. 'It was a strange situation – the exact reverse of how people and ducks usually see each other.' Finally the conditions he had been waiting for presented themselves: clear water and a still surface, with the sky creating a strong contrast. Graham sank below the surface and waited. Sure enough, his nosy friend swam over. As the mallard poked his head down, Graham took the shot with the light behind him to create a frame of sunburst.

Nikon D200 + Nikon 12-24mm lens at 12mm; f11 at 1/125 sec; ISO 100; Sea & Sea housing; two Sea & Sea YS 90 strobes.

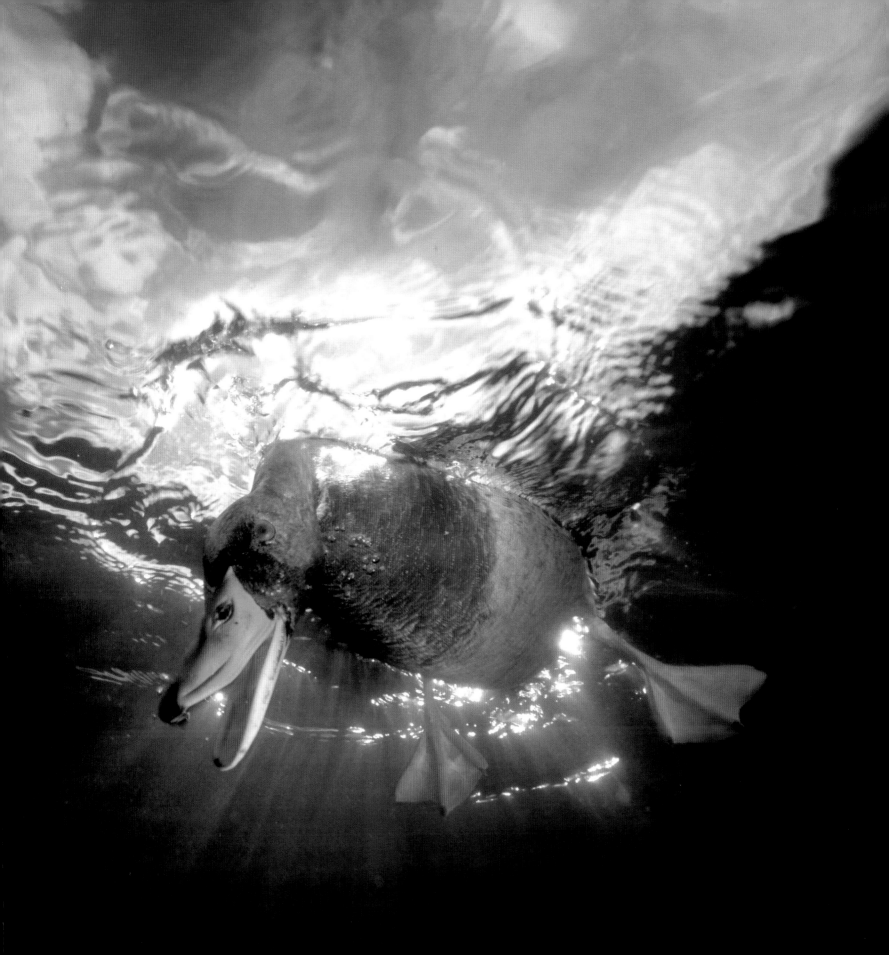

Night stalker

HIGHLY COMMENDED

Angel M. Fitor

SPAIN

It was full moon when Angel slipped into the water off San Juan, a popular tourist beach in Alicante, Spain. He had dived in the same place the previous night while taking macro-photos and had seen three smoothhound sharks, a female and a couple of males. These non-aggressive sharks are common enough in the region though not normally in such shallow waters or in a group. He decided to return with a different lens the next night in the hope they would still be there. Eight metres (26 feet) down, he found them. 'The sharks took no notice of me,' says Angel, 'I think they were more interested in courtship.' He got close enough to the female to use lighting, giving her portrait a dramatic edge against the black water below and the moonlit surface above.

Nikon D200 + AF Fisheye-Nikkor 10.5mm lens; 1/250 sec at f22; ISO 200; twin strobes.

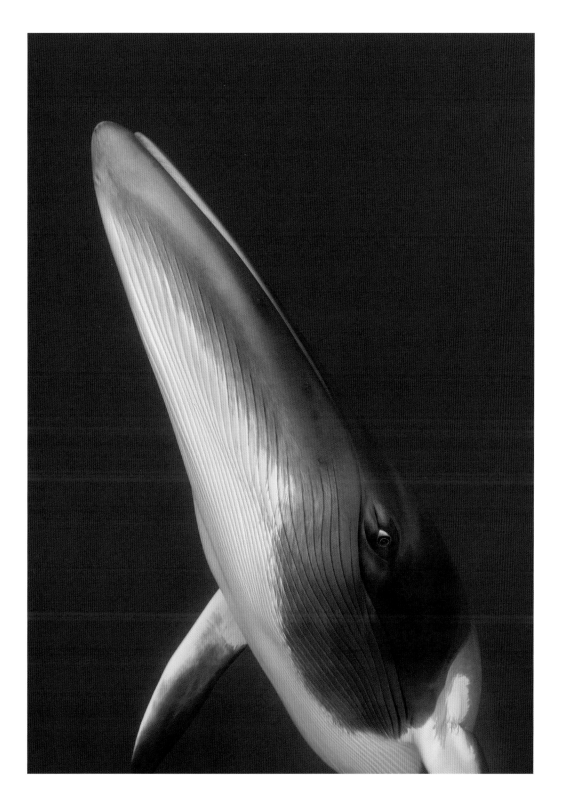

Eye of the minke

SPECIALLY COMMENDED

Jürgen Freund

AUSTRALIA

Dwarf minke whales travel to the tropical wintering grounds of the northern part of Australia's Great Barrier Reef between June and August, possibly to breed. Jürgen spent a week there in mid-July on the *Undersea Explorer*, a vessel involved in minke whale research. 'In snorkelling gear, we hung from a line attached to the boat and just drifted, which meant the whales weren't spooked and could choose when to come over. They often interacted with us for hours.' While drifting along not far from Lizard Island, this 6-7-metre (20-23-foot) dwarf minke whale turned up (currently regarded as a subspecies of the larger, northern-hemisphere minke). Christened 'Pavlova' after the Russian ballet dancer, she treated the snorkellers to lengthy, rare displays of underwater pirouetting. While performing these eloquent revolvings, she maintained eye contact. 'It was as if she was looking straight into me,' says Jürgen.

Nikon D200 + Nikkor 12-24mm f4 lens; 1/180 auto; Seacam housing.

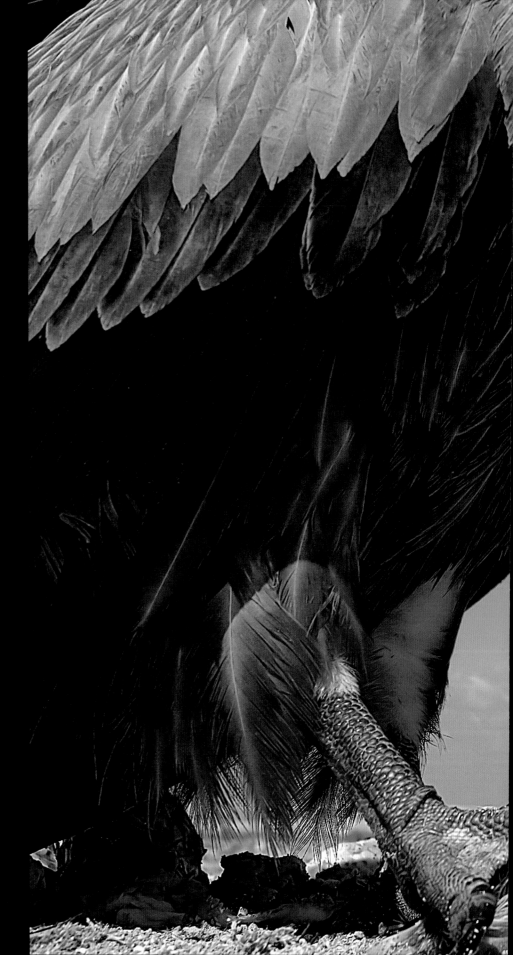

Griffon picnic

HIGHLY COMMENDED

Juan Manuel
Hernández López

SPAIN

Juan's aim was to photograph dinnertime from
a Spanish griffon vulture's perspective. At a special
feeding station, where animal carcasses are put
out for carrion-feeding birds, he set up an infrared
beam device so that the vultures would take their
own portraits. He used a wide-angle lens to get
a bird's-eye view and create an impression of size.
But it took a long time and very many attempts
before he had the picture he wanted, with the
vulture in frame and gripping the food in its claws.
In the aftermath of BSE ('mad-cow disease'), such
artificial feeding stations – here, in Segovia – were
banned in Spain, threatening the survival of the
vultures. Now a new law has been passed that,
with certain regulations, once again allows the
disposal of dead farm animals at these traditional
muladares (literally, 'mule dumps') to help boost
populations of the region's birds of prey.

**Nikon D70s + 18-35mm lens; 1/500 sec at f8; infrared
beam and cable.**

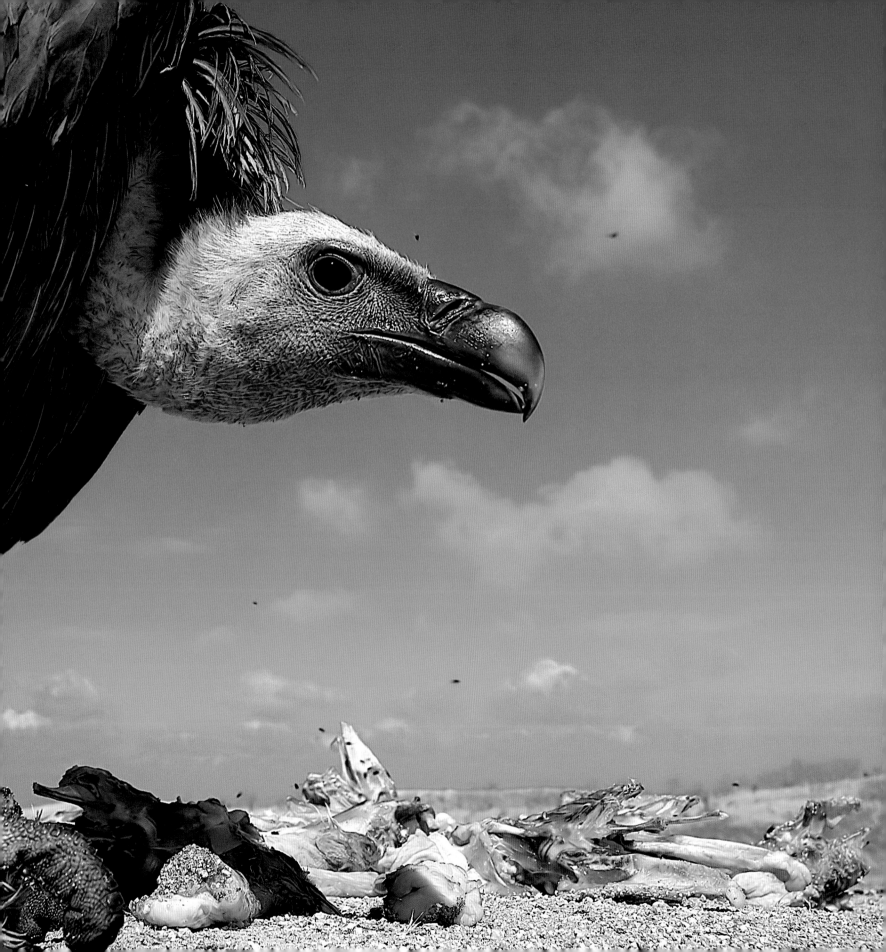

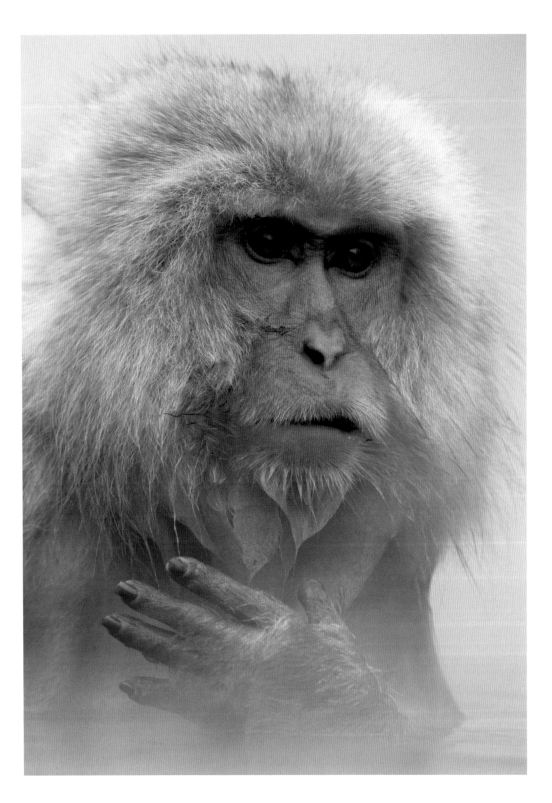

Macaque moment

HIGHLY COMMENDED

Ian Nelson

UK

Japanese macaques will soak for hours in the deliciously hot baths filled by volcanic springs in Jigokudani National Park, Honshu. This helps them cope when the winter snow lies thick and temperatures drop below -5°C. The pools remain at a constant 38-40°C, the steam in the freezing air giving the park its other name, Hell's Valley. Native to northern Japan, the macaques are the most northern-living non-human primates. Ian was able to get very close to this contemplative individual, which sat blissfully in its mineral bath, or *onsen*, intermittently examining its hand. 'What finally broke the trance', says Ian, 'was a commotion that broke out between other troop members, and it shot a worried glance in the direction of the fracas.'

Nikon D2Xs + Nikon VR 200-400mm f4G lens; 1/200 sec at f5; ISO 125.

Owl glare

HIGHLY COMMENDED

Régis Cavignaux

FRANCE

Step by cautious step, Régis crept towards long-eared owls dozing in a winter dormitory roost in wild rose bushes in Champenoux, France. The owls tolerated his presence, but occasionally glanced towards him, as though to check his progress. Whenever the owls seemed to notice him, Régis would pause, sometimes for a long while, until they closed their eyes. Like all owls, they can see and hear extremely well (though the feathery tufts above their eyes have nothing to do with hearing). An hour later, Régis was finally close enough to start taking photographs. 'When one turned to look straight at me, its eyes seemed to shine as bright as the berries,' he remembers. 'I knew then I had the shot I wanted.'

Nikon D2Xs + 400mm f2.8 lens; 1/350 sec; ISO 250; monopod.

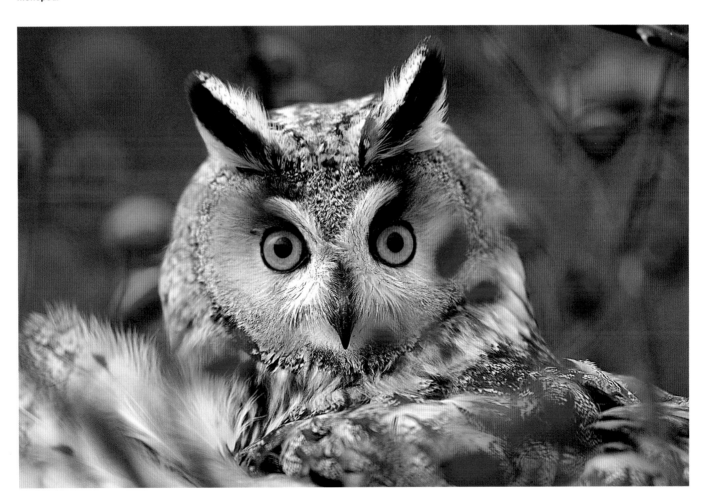

Urban and Garden Wildlife

Pictures here must be taken in urban, suburban and garden environments – and must look as if they have been.

Vole at the hole

Danny Green

UK

For the past two years, Danny has been photographing water voles on a disused canal in Derbyshire. The water vole – immortalized as Ratty in Kenneth Grahame's *The Wind in the Willows* – has suffered a drastic decline in numbers in the UK over the past 25 years. Habitat loss has been a major factor, but pollution and the introduction of the American mink have played their part. Urban canals and ponds are among the water vole's last strongholds. This particular canal is prone to flooding, and if heavy rain is predicted, the sluice gates are opened to drop the water level. 'If the rain doesn't come, the drainage pipes are exposed,' says Danny. 'I have tried many times to capture an image of a vole sitting in one of these pipes. This picture is the result of one of just two fleeting opportunities.'

Canon EOS 1D Mark II + 500mm f4 lens; 1/100 at f5.6; ISO 400; tripod.

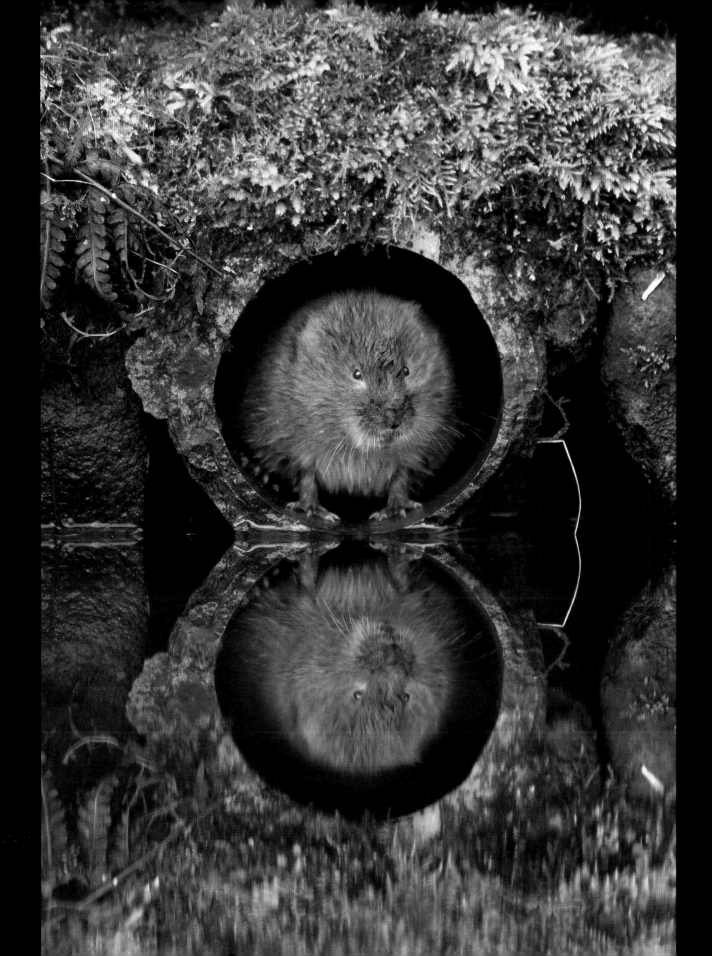

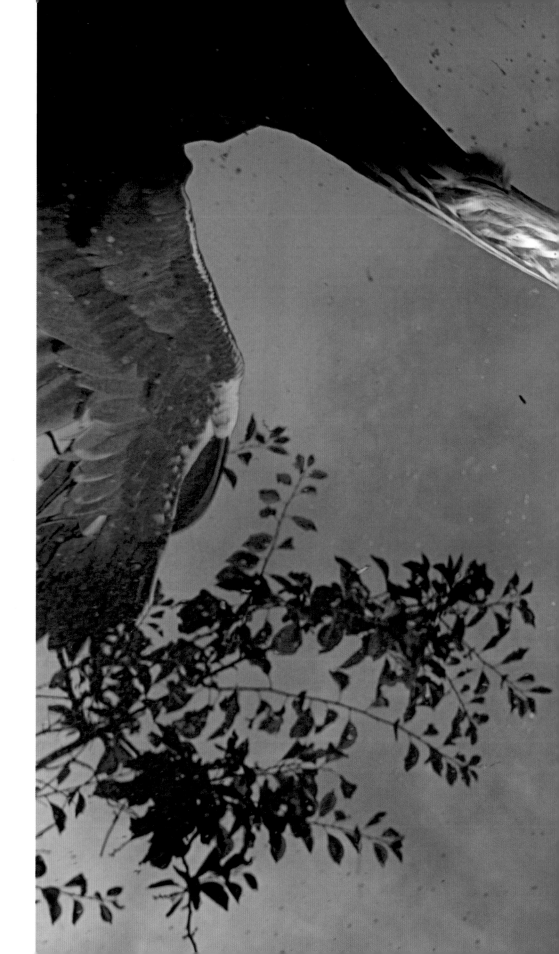

The master-fisher

RUNNER-UP

Jordi Bas Casas

SPAIN

This shot involved a great amount of planning. The setting is a large aquarium placed beside a pond. The star is a grey heron, which came daily to fish. Jordi carefully positioned his camera (upside down) and flashes under the aquarium, linked by cable to his laptop, so he could view the composition on the laptop and alter the position of the camera and flashes appropriately. Having set up a shot, he would then wait patiently in his hide several metres away until the heron arrived and then take a picture using a remote-control cable when the heron was in the right position. It took days and many missed shots before he got both the action and the composition he wanted.

Nikon D200 + 12-24mm lens at 18mm; 1/250 sec at f8; two flashes in synch; remote-control cable; laptop.

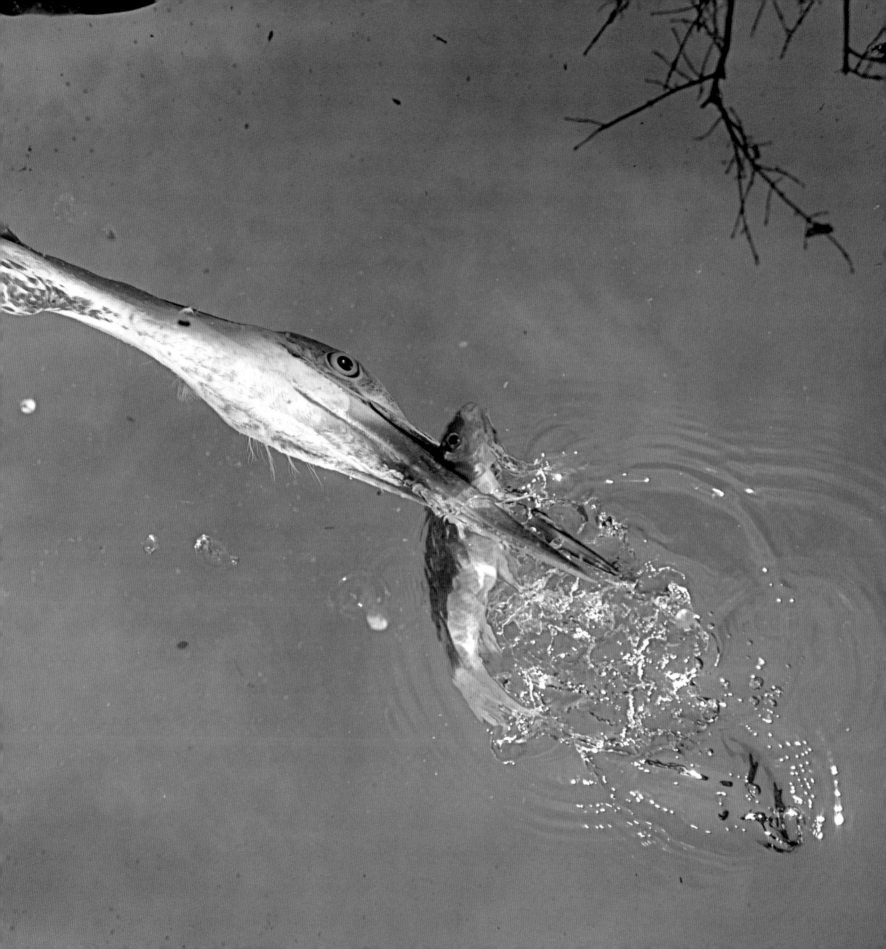

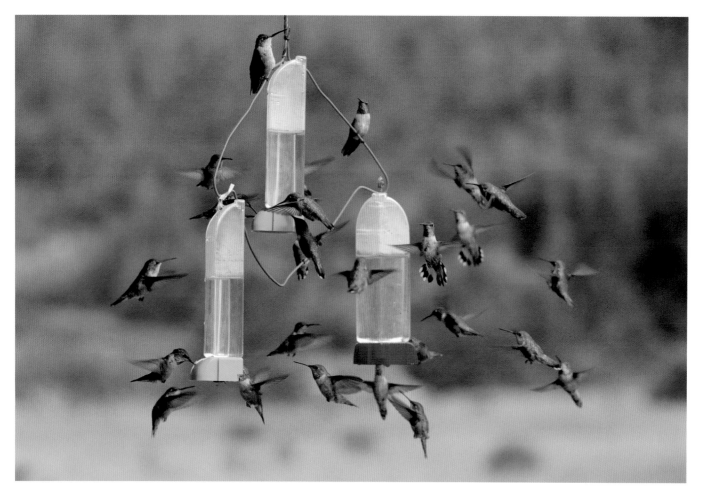

Hovering hummers

HIGHLY COMMENDED

Yuichi Takasaka

JAPAN

Rufous hummingbirds visit Yuichi's Canadian garden in spring and stay for the summer, sipping from the sugar-water feeders. Males arrive first, the dominant one trying to chase off the others, and females arrive about two weeks later, which is when Yuichi took this photo – the pose giving the appearance that all is harmony. Once the chicks have hatched, Yuichi refills the sugar water up to five times a day to cope with the hungry visitors.

Pentax *istD + Pentax SMC FA 100mm macro f2.8 lens; 1/750 sec at f4; ISO 200; flash with -1 flash exposure compensation, high-speed sync-flash mode.

Cable doves

HIGHLY COMMENDED

Mark Somogyi

HUNGARY

Mark was out walking when he heard the cooing of doves and looked up to see them sitting overhead on power lines at nearly identical intervals. 'My first interest was in the geometric, graphic effect this created,' he says, 'but when some of them flew off, their chaotic movements added a pinch of anarchy that made the picture I really liked – a picture that also illustrates how well some birds adapt to an urban environment.'

Nikon D200 + Nikkor 24mm manual lens; 1/50 sec at f8.

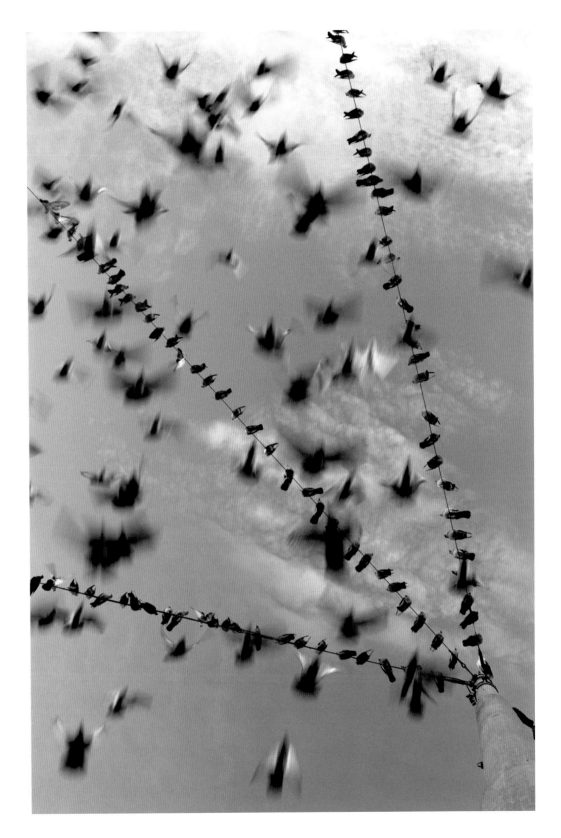

Amber thrush

HIGHLY COMMENDED

Andrew Walmsley

UK

A ready-made, heated nest site with ambient night-light – this is how one pair of mistle thrushes viewed a set of traffic lights at a busy road junction in Glasgow, Scotland, choosing the amber level as their preferred colour. Andrew didn't have to worry about disturbing the nesting pair, which totally ignored the constant traffic, but it took several hours to get a parent bird's silhouette to coincide with the brief showing of red and amber lights together. The birds' ingenuity paid off: all four of their chicks fledged, probably benefiting from the warmth from the light and the added predator deterrence provided by people and traffic. Elsewhere in the UK, mistle thrushes are not doing well, and ironically, the species now has an 'amber-level' conservation status.

Nikon D70 + Sigma 50-500mm f4-6.3 lens at 420mm; 1/1000 sec at f8; ISO 500; Manfrotto tripod.

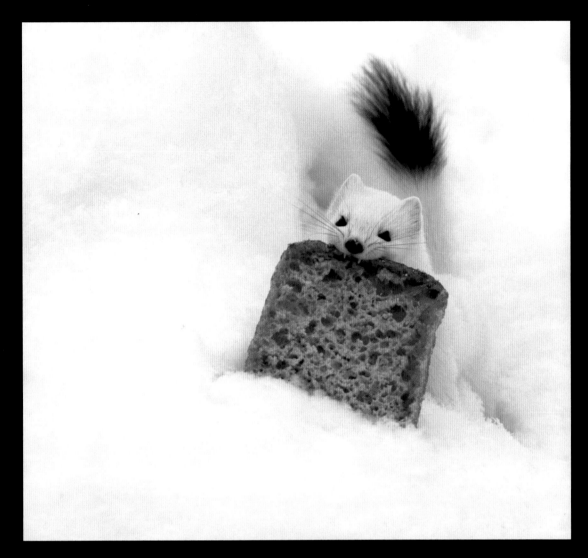

Stoat sandwich

HIGHLY COMMENDED

Ari Tervo

FINLAND

When Ari heard that a stoat in its ermine (winter) coat had taken to scavenging scraps under a friend's birdtable in the city of Kajaani, he set up watch, armed with bread. The stoat soon got the hang of retrieving slices, but she moved so fast that it took several hours and 20 slices for Ari to get his shot. Finally, she disappeared, her larder fully stocked. 'Perhaps she made sandwiches, putting mice between the slices,' ponders Ari.

Canon EOS 1D Mark II + Canon 100-400 EF f4.5-5.6 L IS lens; 1/500 sec; ISO 400 (+1/3 exposure compensation).

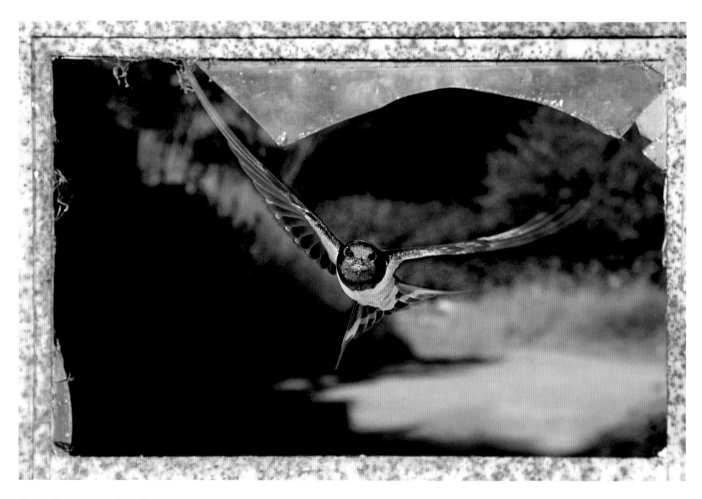

Swallow in the frame

HIGHLY COMMENDED

Stephen Powles

UK

Each summer, swallows fly from Africa to nest in Stephen's Devon garage. Last year, he set out to photograph their speed and agility. Placing an old window frame in the flight-path and setting up a trip-beam, he finally got a shot with a sense of both place and movement. 'The miracle', says Stephen, 'is that they or their offspring will return again next year to nest in my garage.'

Nikon D100 + AF-S VR-Nikkor 24-120mm lens; 1/180 sec at f13; ISO 200; Nikon speedlight SB800; X2 Vivitar flash 285; infrared beam; tripod.

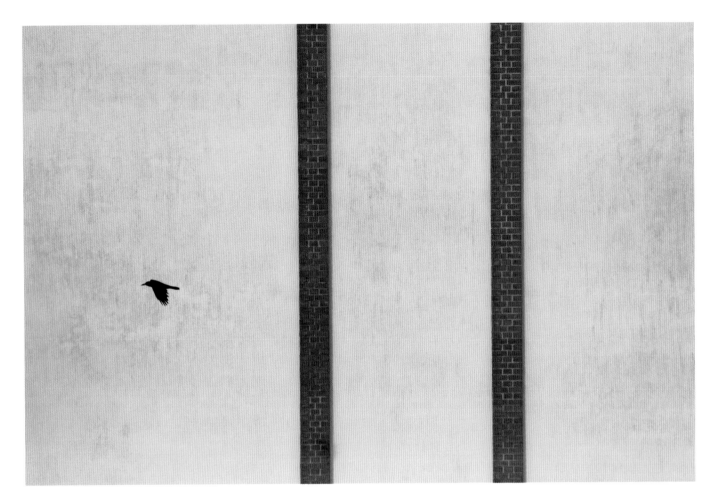

Urban rook

HIGHLY COMMENDED

Jonas Salmonsson

SWEDEN

Walking through the small town of Greifswald, in northern Germany, photographing flocks of crows against simple backgrounds of sky or tree foliage, Jonas noticed an unusual wall. As he set up his camera to photograph this stark urban canvas, a single rook flew by. 'For me the picture symbolizes how rooks and other members of the crow family have become part of our urban lives,' he says.

Canon EOS 20D + 70-300mm Sigma f4-5.6 lens; 1/2500 sec at f8; ISO 400; tripod.

Wild Places

This is a category for landscape photographs, but ones that must convey a true feeling of wildness and create a sense of awe.

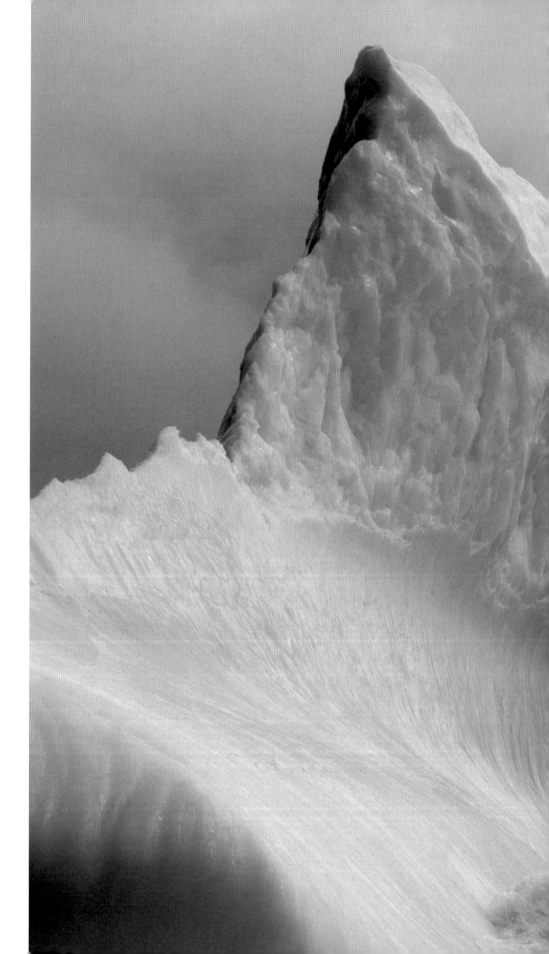

Ice creation

WINNER

Robert Knight

USA

The sea around the subantarctic island of South Georgia is full of icebergs spawned from the many glaciers that cover its surface and from the Antarctic itself. On a Zodiac, heading back to his ship in advance of an approaching storm, Robert and his fellow passengers spotted this extraordinary creation on the horizon and had to investigate. As they approached, a beautiful formation of cyan-blue pinnacles and ridges was revealed, the lower portion sculpted into wave formations that merged with the sea. 'The challenge', says Robert. 'was to capture something of the beauty and wildness of the scene, while waves buffeted the Zodiac and spray covered me.'

Canon EOS 1Ds Mark II + 70-200mm f2.8 IS lens; 1/800 sec at f13; ISO 200.

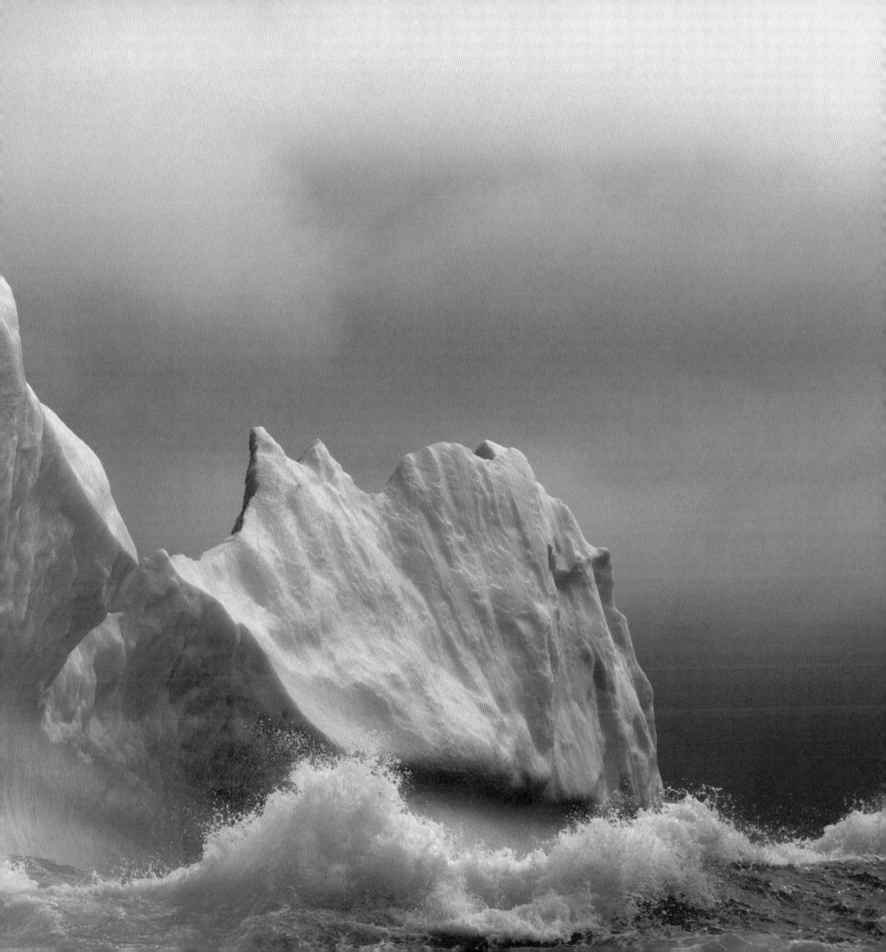

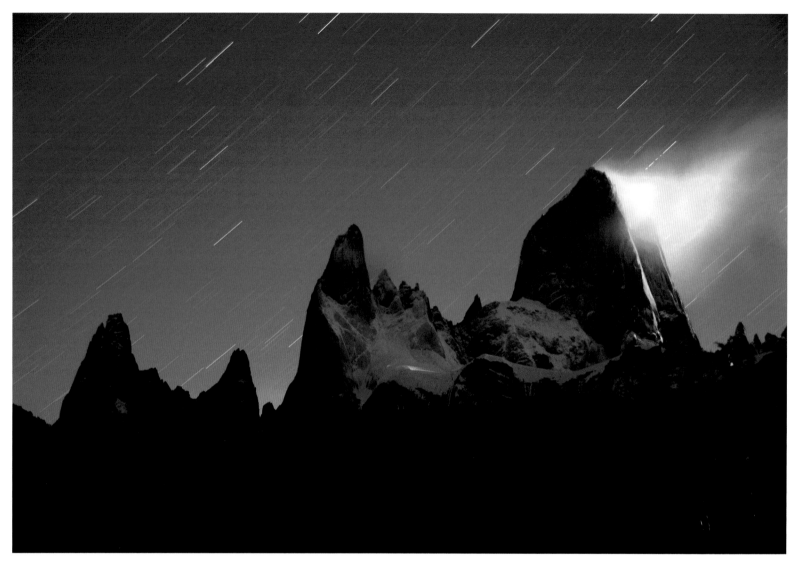

Moon fire on Cerro Chaltén

HIGHLY COMMENDED

Jordi Busqué

SPAIN

The summit of Cerro Chaltén, translated as smoking mountain and also known as Fitz Roy, is nearly always topped by a swirling cloud. But only a few times a year, when the moon is in the right position, can you see it 'on fire' like this. Camping at the foot of the Argentinan side of the huge mountain, Jordi used a six-minute exposure to capture not only the way the wind swirls the fiery cloud but also the star trails in the night sky.

Nikon D70s + AF-S DX VR Nikkor 18-200mm f3.5-5.6G IF-ED lens; 6 mins at 44mm f4.5; ISO 200; cable, mini-tripod.

Midnight eruption

RUNNER-UP

Robert Sinclair

USA

Unlike Old Faithful, which erupts frequently, the Castle Geyser in Yellowstone National Park performs only once or twice a day and has periods of inactivity that can last weeks. Robert arrived to photograph the Castle and discovered it hadn't erupted for more than two days. Confident it would blow soon, he set up his gear and waited. Night fell, the hours went by, and the temperature dropped below freezing. Just after midnight, a deep rumble signalled the start. As water spouted 28 metres (92 feet) into the air, Robert fired his three carefully positioned flash units to light the scene and freeze the motion. By then, it was so cold that the 90°C (194°F) water turned to snow as it fell. The moonlit sky 'was made even more spectacular', says Robert, 'by the simultaneous eruption of Old Faithful beyond the trees'.

Canon EOS 1D Mark II + EF 16-35mm f2.8 USM lens; 55 sec at f4; ISO 400; x3 Speedlight flash units; wireless transmitter; cable release; flashlight, tripod.

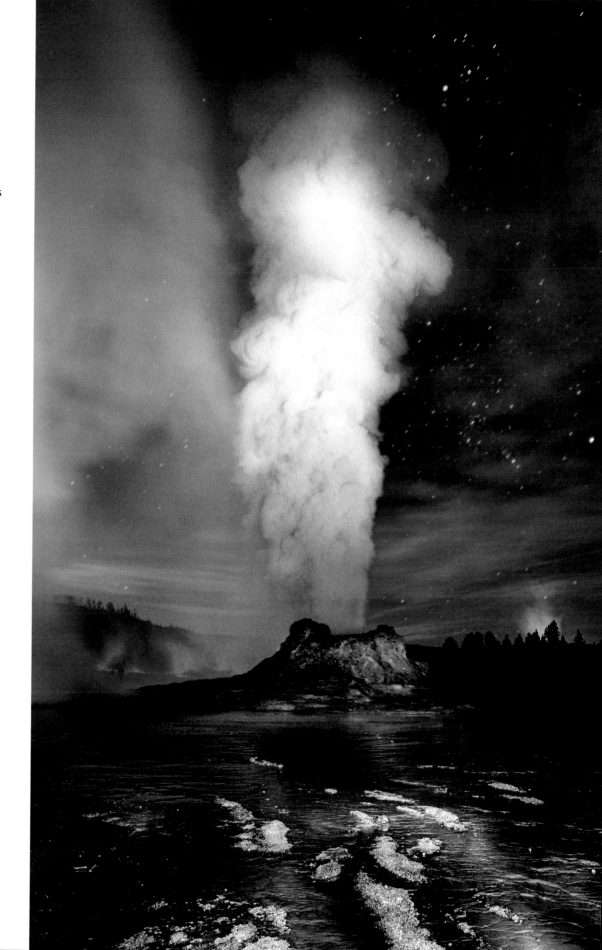

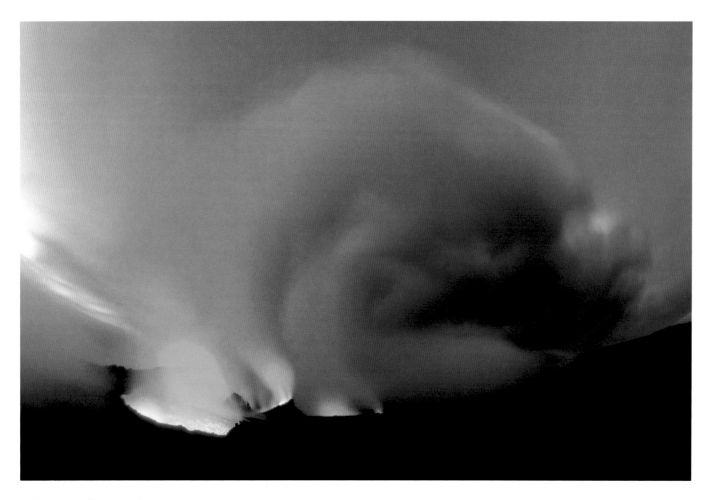

Kilauea dawn display

HIGHLY COMMENDED

Bryan Lowry

USA

Through the night, Bryan walked the trails on the slopes of Kilauea, in Hawaii's Volcanoes National Park, exploring the lava flows and watching the explosions. At dawn, from the north rim of Pu'u O'o vent, Bryan watched the January vent, only 30 or so metres (100 feet) away, shoot super-heated gas some 60 metres (230 feet) into the sky, only to be swirled back down by the cold air and light wind, creating this magnificent dawn display.

Nikon D70 + Nikon 10.5mm f2.8 lens; 30 sec at f22; ISO 200; infrared remote control; tripod.

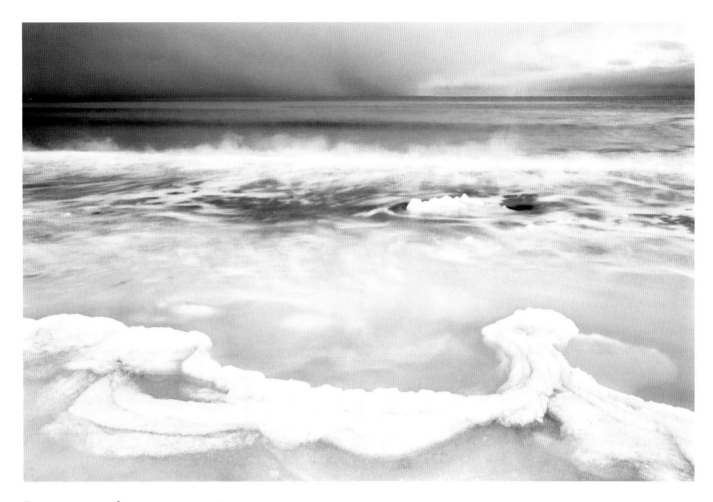

Ice, sea and snow sunset

HIGHLY COMMENDED

Orsolya Haarberg

HUNGARY

'Varanger Peninsula (Norway) is the most dynamic place I know,' says Orsolya, 'where the tundra meets the ocean.' When temperatures plummet – in this case to -20˚C (32˚F) – 'winter wraps thick ice around the ebb-and-flow zone of the sea'. This is a picture of a moment Orsolya will never forget, when the sea broke through the barrage of ice, just as a 'heavy cloud of snow rolled in and the sun set, turning the sky from ice blue to deep plum'.

Nikon D200 + Nikkor 18-70mm f3.5-4.5 G lens; 2.2 sec at f25; tripod.

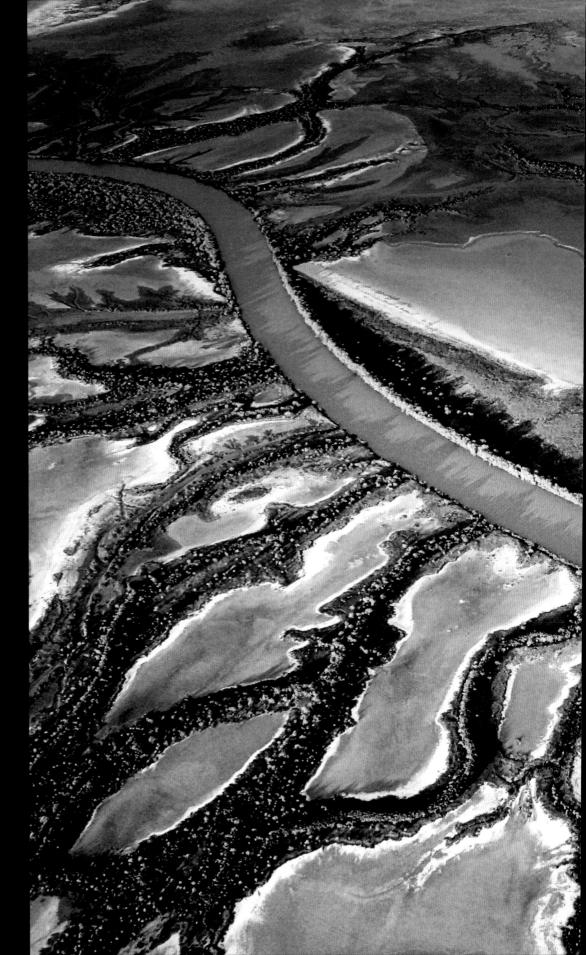

Wetland wilderness

HIGHLY COMMENDED

Damon Smith

AUSTRALIA

This photograph 'represents one of the most elusive' Damon has ever tried to get – and he has been flying and photographing Australian landscapes from light aircraft for the past 30 years. 'The meandering river is typical of many rivers flowing into the Gulf of Carpentaria in the Northern Territory, Australia,' he says. 'Here, at the start of the dry season, temperatures reach 45°C (113°F) and dry out floodplains that were inundated during the 'wet' only a few weeks before.' His quest to find the right ingredients of 'shape, form, colour and remoteness' took years of scouting. All he then had to do was wait for the right time of year and the right weather, fly 2500km (1550 miles) from Sydney and shoot from the air just before sunset 'when the low angle of the sun helps give superb definition and colour'. Circling endlessly over his chosen bend of the river while holding the control column with his knees, he shot through a special photo window in his plane until he had the picture.

Canon EOS 300D + 18-55mm lens at 18mm; 1/320 sec at f8; ISO 400.

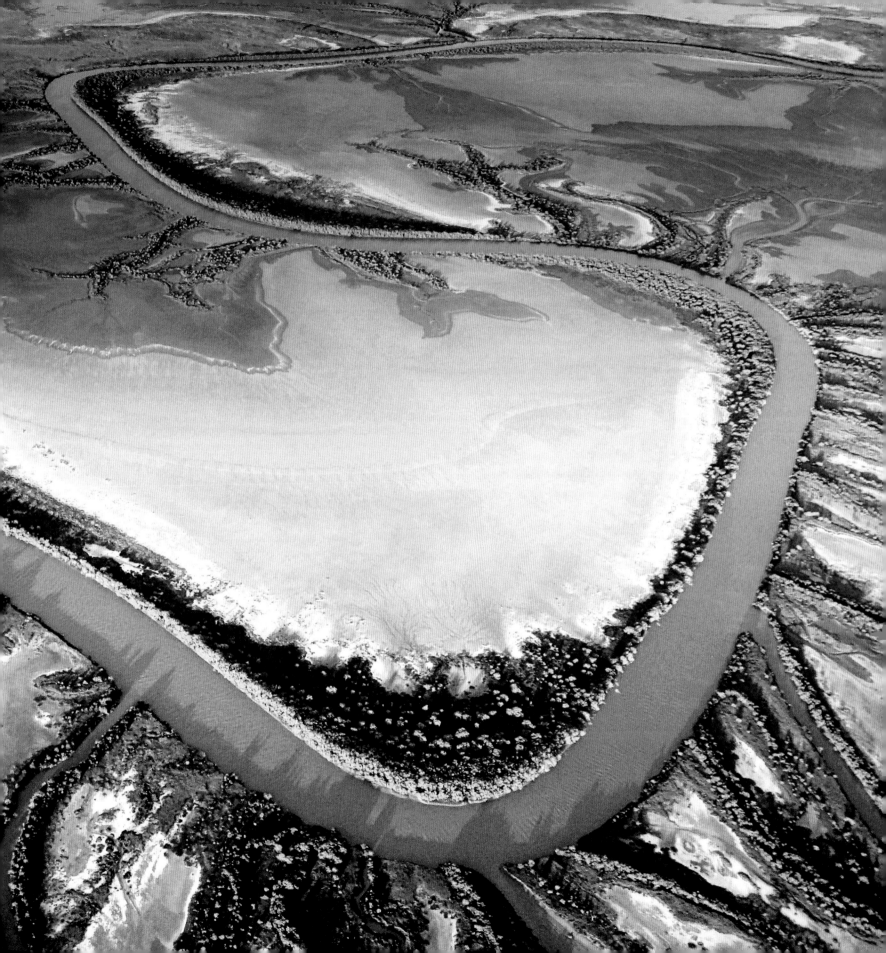

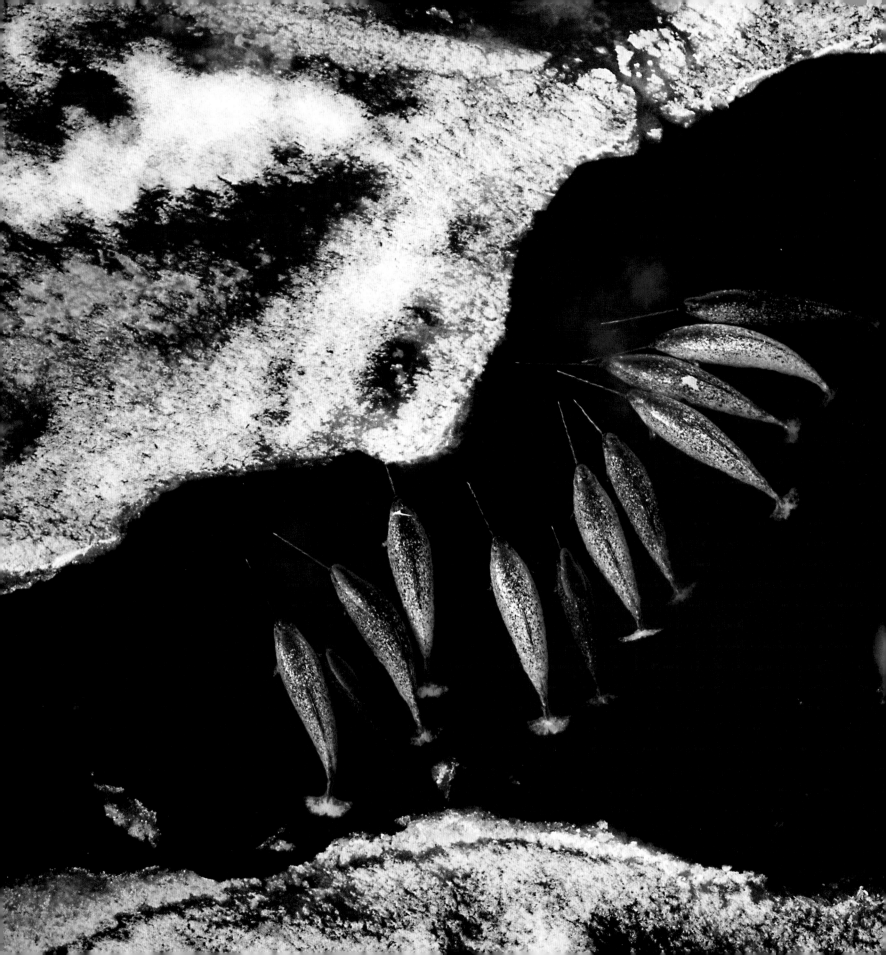

Animals in Their Environment

A winning photograph must convey a sense of the relationship between the animal and where it lives – and the environment must be as important a part of the picture as the subject.

Breath taking

WINNER

Paul Nicklen

CANADA

Flying some 48 kilometres (30 miles) off the Admiralty Inlet ice edge of Northern Baffin Island, Canada, on assignment to photograph narwhals, Paul spotted these males 'feeding under a very large, rotting piece of sea ice – melting in the summer sun and heat'. These Arctic whales swim long distances under the ice, using an advanced system of echolocation, and take advantage of such holes to breathe. 'When groups came to the surface, they were careful to avoid hitting each other with their long tusks,' he says. 'They would take several breaths and then resume fishing under the ice.' The name narwhal is probably derived from an old Norse word *nár*, meaning 'corpse' – a reference to the whale's colour, which seems to blend perfectly with the ice when viewed from below as well as from above.

Canon EOS 1Ds Mark II + 100-400mm IS lens; 1/500 sec at f5.6.

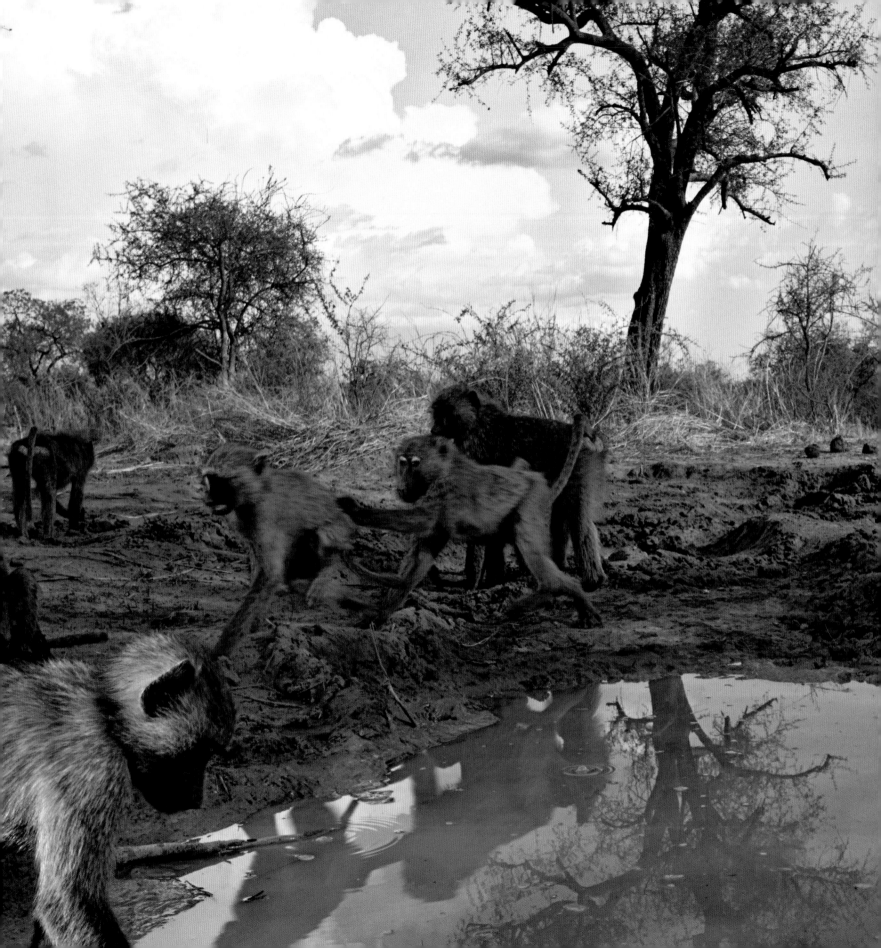

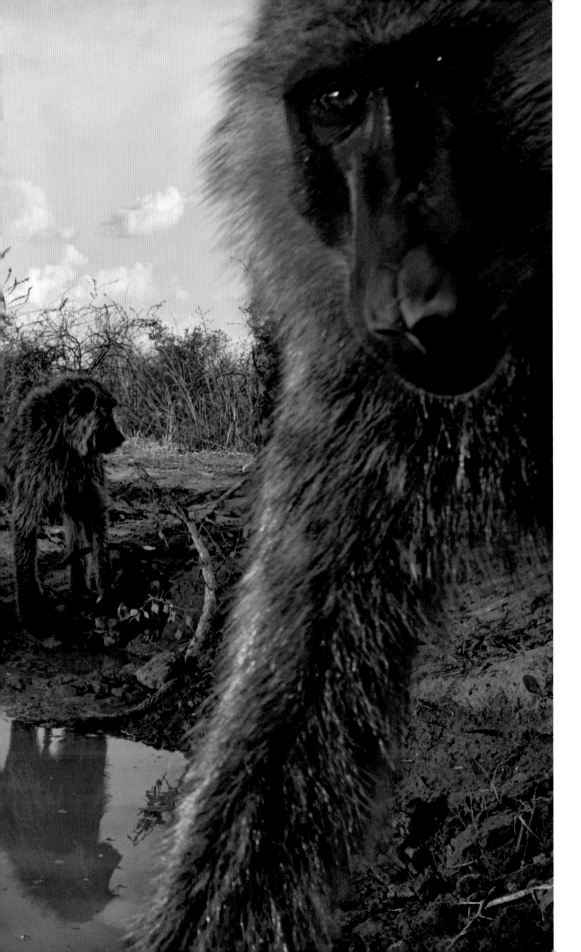

Self-portrait

RUNNER-UP

Michael Nichols

USA

'I was working on an assignment in Zakouma
National Park in Chad,' says Michael, 'on water –
or lack of it.' In fact, the only waterhole for miles
was filled by runoff from the park director's
swimming pool. It attracted animals from far and
wide – baboons, warthogs, serval cats and
elephants would all turn up. 'I'd cast elephants as
my stars, but the baboons had other plans, and
I ended up with this honest and intimate "street
scene" of the troop.' His remote camera, triggered
if an animal crossed the infrared beam, was left up
for the animals to get used to it but became
a magnet for the baboons. 'Most days, after taking
hundreds of photographs of themselves, they
would dismantle the gear.'

**Canon EOS Digital Rebel XT + 10-22mm lens; 1/125 sec at
f11; ISO 100; camera trap.**

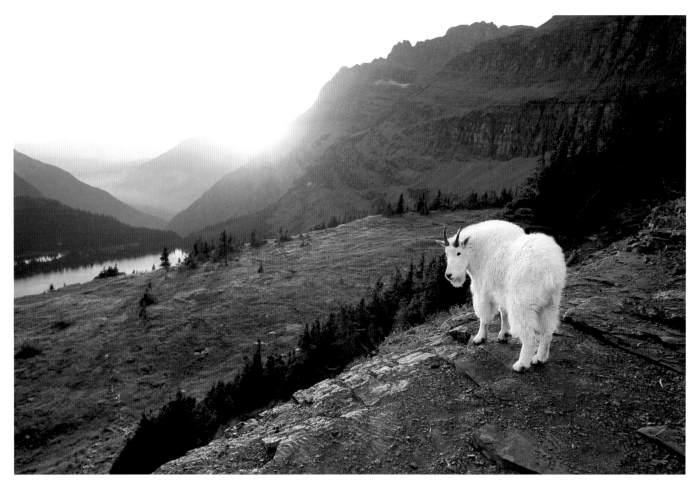

Last light

HIGHLY COMMENDED

Scott McKinley

USA

For Scott, 'few places are more compelling than Montana's Glacier National Park, with its rugged beauty'. He went there specifically to take 'pictures of animals in harmony with their environment', to create 'a sense of place', getting close to his subjects and using wide lenses. Mountain goats are powerful animals, but 'this Billy proved quite accommodating, allowing me to realize my vision.'

Canon EOS 1N + 17-40 f4 lens; 1/50 sec at f16; Fujichrome Velvia 50; flash.

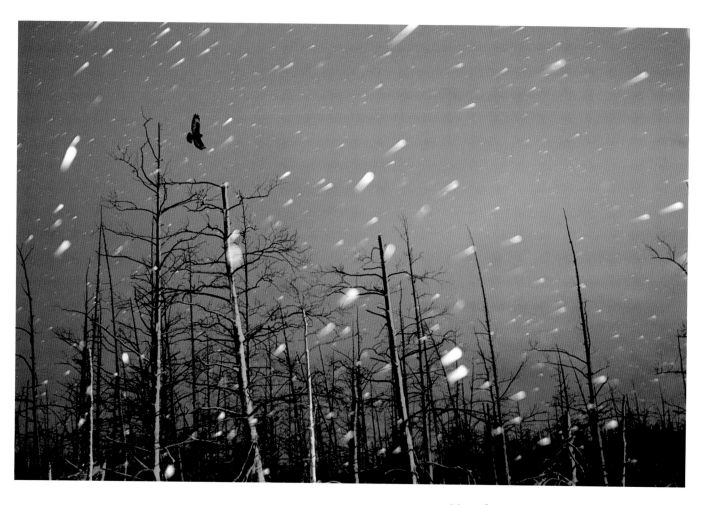

Hawk and passing storm

SPECIALLY COMMENDED

Shane Rucker

USA

The first snow drew Shane out into the Wood County Wildlife Area of Central Wisconsin. As the storm diminished and the sun set, the sky became oddly illuminated. He then began to notice large numbers of raptors flying over the marshes – broad-winged hawks, probably on migration and refuelling by picking off red-winged blackbirds. Here one circles before swooping down on its prey.

Canon EOS 20D + 19-35mm lens; 1/160 sec at f6.3; ISO 400; flash.

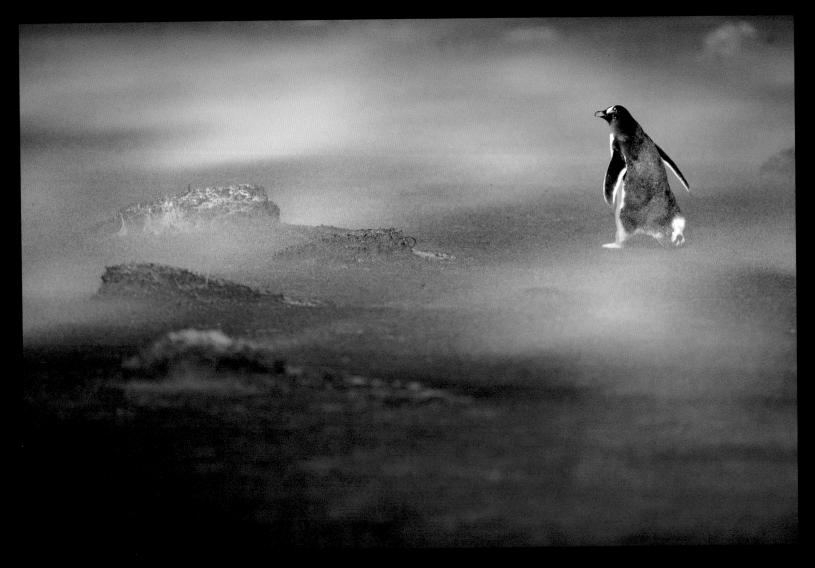

Penguin in a sand storm

HIGHLY COMMENDED

Martin Eisenhawer

SWITZERLAND

The wind whipped up black sand and grit, turning
an uninteresting Falkland Islands day into one rich
with photographic opportunity. Choosing a spot
where the gentoo penguins passed on their way
between the colony and the sea and where the
peaty ground contrasted with the swirling haze,
he composed the frame and waited. 'Finally
a penguin trudged by, eyes partly closed against
the wind – a lonely figure in an unearthly setting.'

**Canon EOS 1Ds Mark II + Canon EF 500mm f4 IS lens;
1/3200 sec at f5; ISO 200; tripod.**

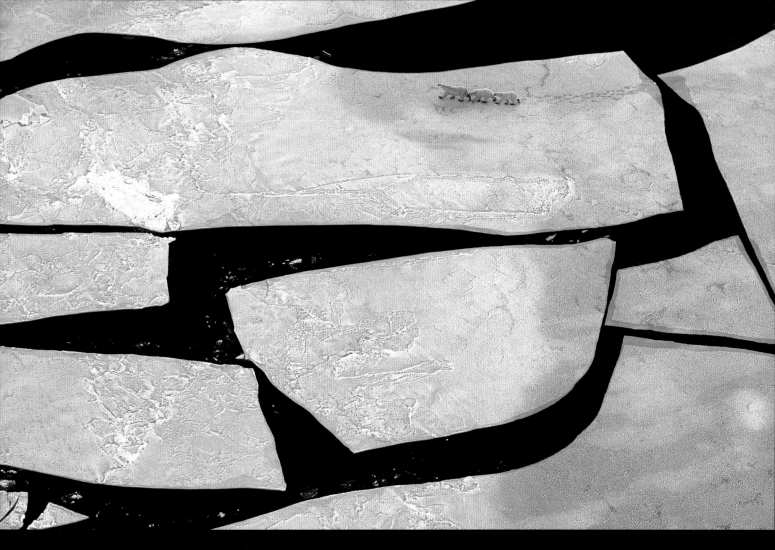

Freezing issues

HIGHLY COMMENDED

Norbert Rosing

GERMANY

One Earth Award

Pictures entered must highlight in a thought-provoking and memorable way our interaction with the natural world and our dependence on it.

The jet trail

WINNER

Csaba Karai

HUNGARY

One summer evening, when the moon was visible in the night sky, Csaba set up his photographic equipment in his backyard in Bicske, Hungary. He wanted to try out his new 500mm telephoto lens, and photographing the moon was an obvious way to start. Thrilled at how clearly he could see the details of the craters, he snapped away. It was only when he uploaded the images onto his computer that he realized the shot he had taken. 'I could hardly believe my eyes,' he says. 'I had no idea the aeroplane had passed by: a chance in a million' – and an image of our times.

Canon EOS 20D + 500mm f4 IS lens and 2x teleconverter; 1/50 sec at f8; ISO 800; tripod.

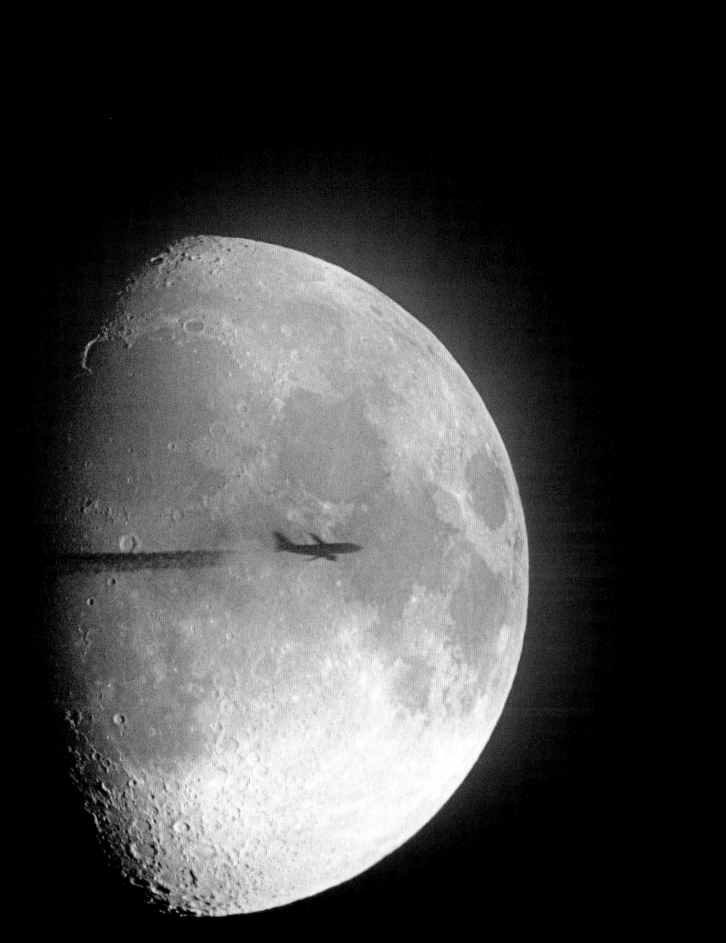

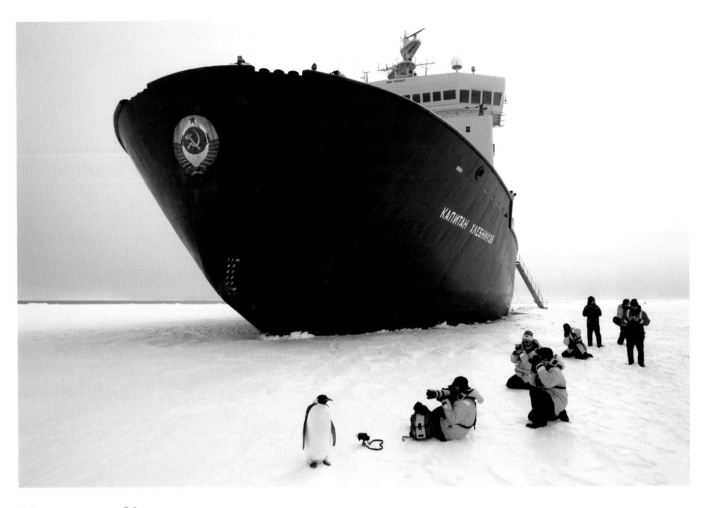

The nature of humans

HIGHLY COMMENDED

Angie Scott

UK

The captain of the Russian icebreaker wedged his ship against the pack ice in Antarctica's Amundsen Sea, so the passengers could step onto the ice. Almost as soon as they did, a young emperor penguin appeared. 'It was curious and unafraid,' says Angie, 'and though we tried to stay the required five metres away, the penguin decided how close it would be. We were probably the first humans it had ever seen.' Every so often, it would give 'a wonderful nasal, reedy cry'. While the other passengers made use of the photographic opportunity, the picture Angie sought was that of the encounter itself – 'a statement on our world, its wild inhabitants and the nature of humans'.

Canon EOS 1D Mark II + Canon EF 17-35mm L USM lens; 1/125 sec at f16.

Polar meltdown

RUNNER-UP

Arne Naevra

NORWAY

Sleeping through an Arctic summer night can be difficult for a photographer, not just because it is never properly dark but also because the night light can be perfect for photography. It was just such a night when Arne took this shot. He had been filming all day for Norwegian tv on a small cruise ship east of Barentsöya Island, in Svalbard, but despite being tired, couldn't resist staying on deck. The boat was far from the nearest pack ice or land, but just before midnight, a strange iceberg came into view. A scan with binoculars revealed its cargo: a young polar bear. When the boat stopped, some distance away, the bear slid off the ice and swam over to investigate, approaching the boat several times, returning intermittently to its slowly thawing life-raft. 'It illustrated so clearly how climate change is affecting the Arctic,' says Arne. When the boat left, the crew stayed on the bridge watching as the bear and its plinth dwindled to a speck on the horizon.

Nikon D2X with AF VR-Nikkor 80-400mm f4.5-5.6D lens at 310mm; 1/180 sec at f5.3; ISO 800.

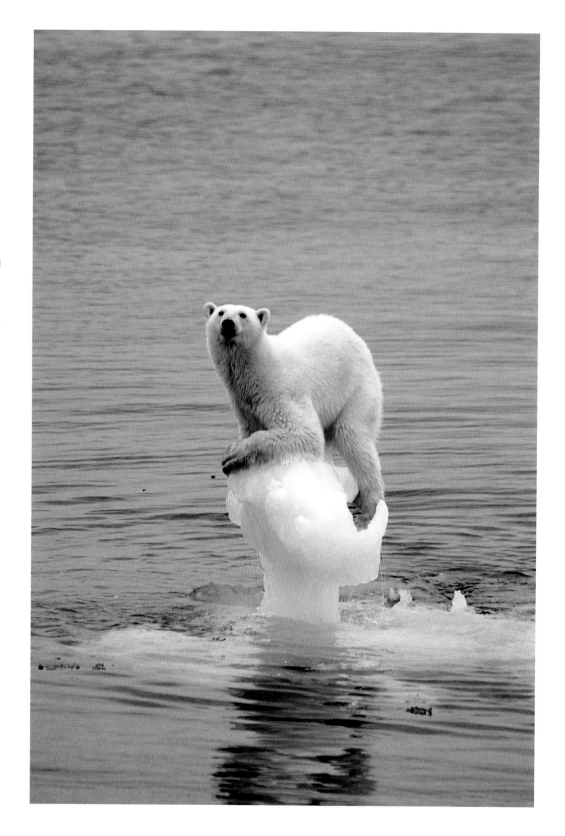

Gerald Durrell Award for Endangered Wildlife

The subjects photographed for this award are species that are critically endangered, endangered, vulnerable or at risk (as officially listed), and its purpose is to highlight the plight of wildlife under threat.

The trophy hunter

WINNER

Roy Toft

USA

A pack of African wild dogs makes short, bloody work of any kill, and the 21-strong the pack that Roy was following had taken just minutes to eat a small male steinbuck, caught in the Linyanti Swamps area of Botswana. As the scrum parted, one wild dog sped away with the head of the steinbuck and disappeared into the surrounding mopane forest. Meanwhile, the rest of the pack, clearly still hungry, reorganized themselves in advance of another hunt. As they trotted off, Roy snapped away from his vehicle, using a slow shutter speed to heighten the sense of movement. Then suddenly the wild dog, still with its trophy gripped in its mouth, reappeared in pursuit of its companions. 'If I'd guessed he might reappear, I'd have gone for a faster shutter speed,' says Roy. In fact, the slow speed proved perfect for capturing the moment. 'It just shows that sometimes it pays *not* to shoot safe.'
African wild dogs once ranged widely throughout sub-Saharan Africa but have declined dramatically because of persecution and habitat loss.

Canon 1D Mark II + Canon 70-200mm f2.8 IS lens; 1/20 sec at f6.3; ISO 800.

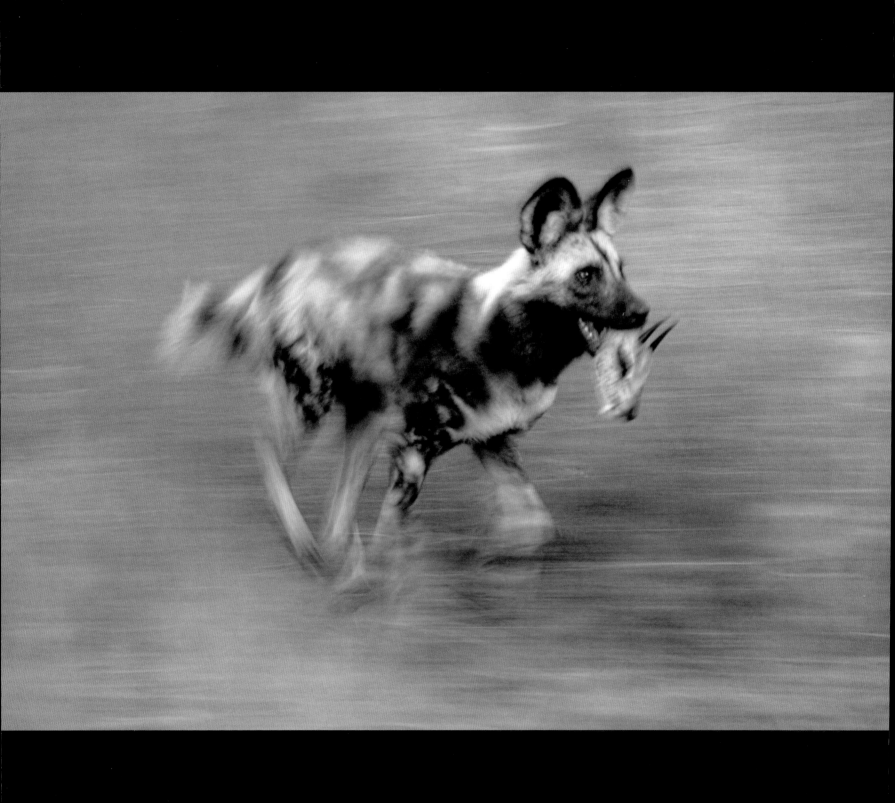

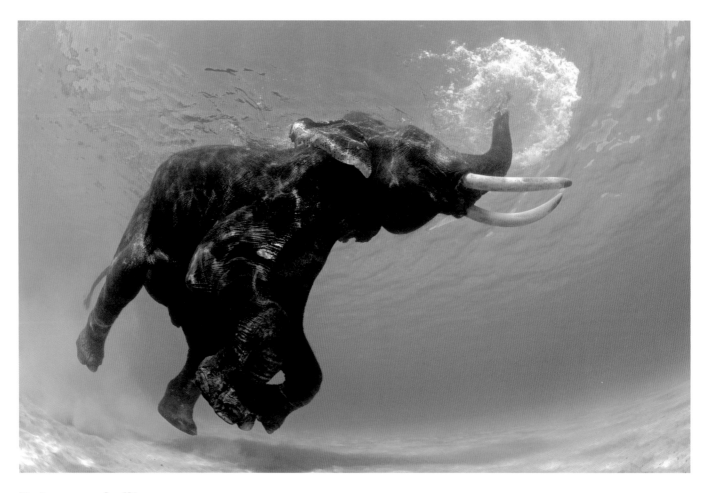

Rajan snorkelling

HIGHLY COMMENDED

Jeff Yonover

USA

'Swimming under water with such a massive land animal', says Jeff, 'was one of those unforgettable life experiences.' The Asian elephant is Rajan, caught as a youngster for the Andaman Islands logging trade – now banned – and a 'retiree' at nearly 60 years old. He takes a daily dip with his handler, who allows scuba-divers in the ocean with him. Jeff captured the moment when Rajan ducked his huge head under water to see what was going on, using his trunk as a snorkel.

Nikon D2X + Nikon 10.5 fisheye lens; 1/100 sec at f10; Subal ND2 housing.

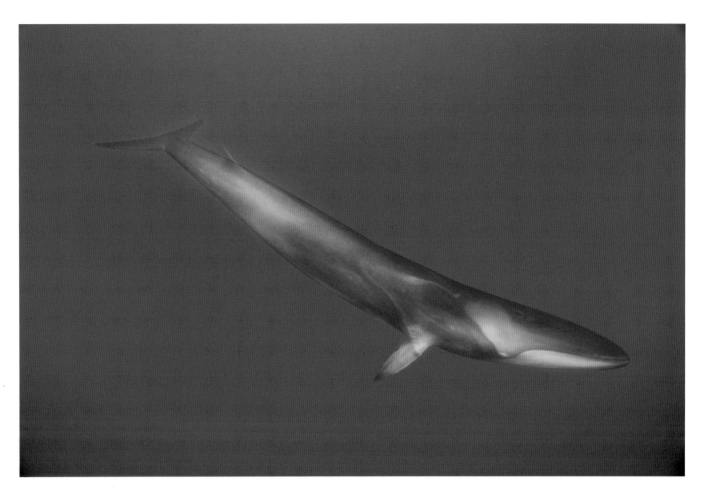

Passing fin

HIGHLY COMMENDED

Wade Hughes

AUSTRALIA

Swift and shy – and hunted almost to extinction in the past – fin whales are difficult to approach. Wade gets close by swimming to a point that might be in the whale's path and then waiting. 'Usually, the whale changes direction or dives,' says Wade. This one, in the Azores, 'turned slightly to approach me and slowed down, perhaps to satisfy its own curiosity, before speeding off, leaving behind three images in my camera and an indelible memory in my mind'.

Nikon D100 + Nikkor 12-24mm lens at 12mm; 1/200 sec at f4; ISO 320; Light and Motion Titan housing.

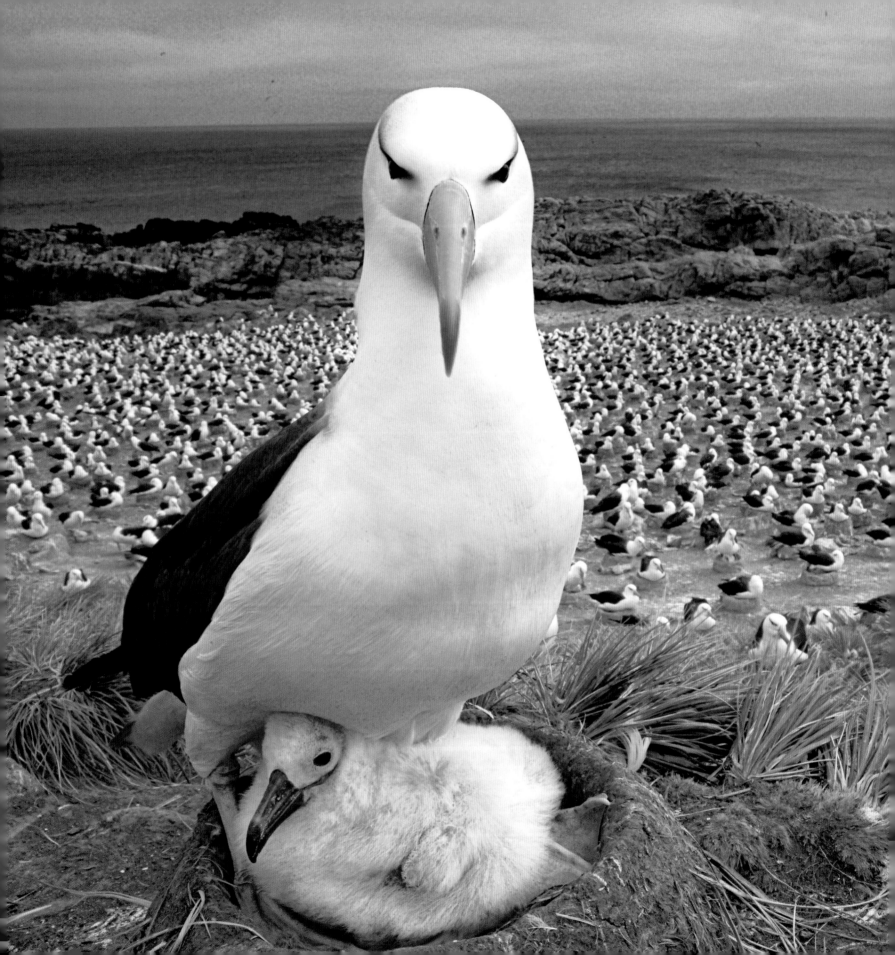

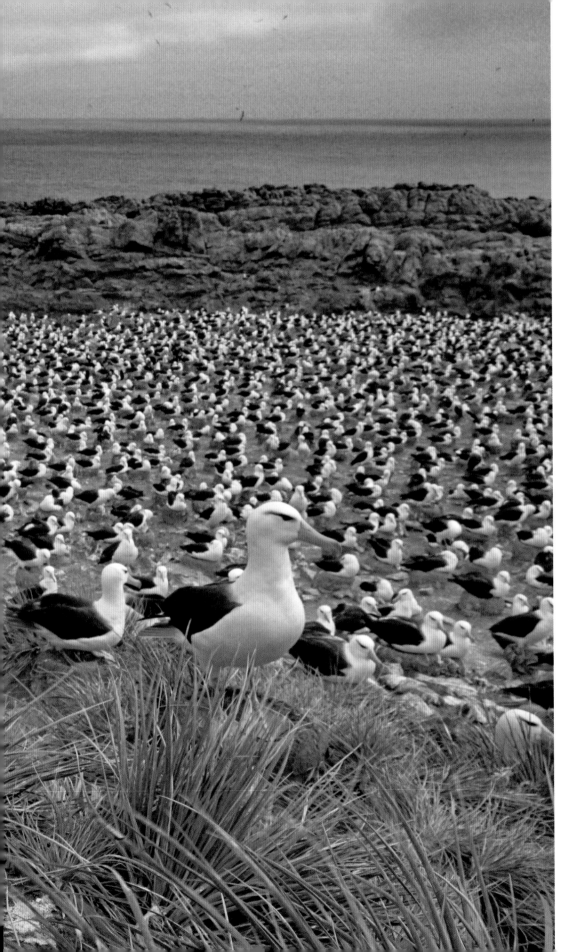

Last of the albatrosses

HIGHLY COMMENDED

Andy Rouse

UK

This is a spectacle few get to see – a massive population of nesting albatrosses on a small uninhabited island in the Falklands. Indeed, Steeple Island has the world's largest breeding colony of black-browed albatrosses, comprising almost a third of the total population of the species. Ten years ago, some 200,000 of the birds bred here, but when Andy visited the island this year, he discovered something disturbing. Albatross pairs usually return year after year to the same nests, but many of the nests on Steeple were empty. Experts calculate that between 1995 and 2000 alone, more than 87,500 breeding pairs were lost at a rate of two albatrosses per hour, and the species is now globally threatened. The main cause of death is the fishing industry. Waste hurled back into the sea by fishing vessels offers rich pickings for the birds, but in the waters around the Falkland Islands, up to 1500 albatrosses perish each season after getting caught on the hooks of long-line fisheries or becoming entangled in fishing equipment.

Canon EOS 1DS Mark II + 24-70mm lens; 1/60 sec at f5.6; ISO 200.

Eric Hosking Award

This award, named after the famous British wildlife photographer Eric Hosking, aims to encourage and promote young photographers aged 18 to 26 and is given for a portfolio that demonstrates their best work. The 2007 winner is Bence Máté from Hungary.

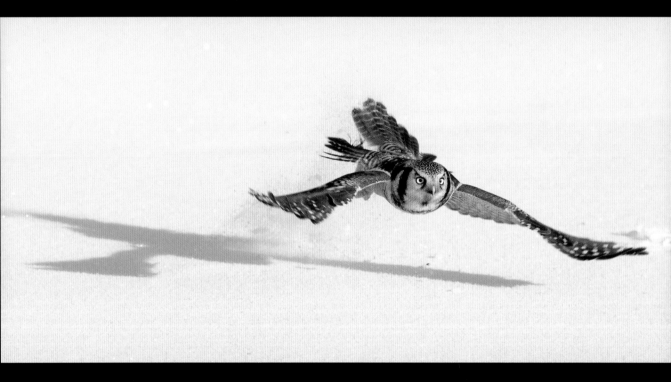

Bence Máté

For the past six years, Bence has been successful in this competition. In 2002, he won the Young Wildlife Photographer of the Year Award, and in 2004, when he was just 19, he became a professional. He now organizes bird photo tours in Hungary so that he can 'spend most of the year in nature'. He loves taking bird-action shots, and he has designed and constructed special hides, in which he spends more than 1000 hours a year. Much of his success is due to his own inventions, such as the use of a semi-translucent one-way glass. In 2005, he became a contributing photographer to National Geographic-Hungary.

Hawk owl swoop

Finland may have many short cloudy days, but it also has many truly wild places. Bence spent eight days with local photographer friends looking for different species of owls living in an area so isolated that many of the birds have little fear of humans. In winter, the owls are also very hungry and therefore bold in daylight. This hawk owl took little notice of Bence as he stood in a clearing photographing it swooping to snatch rodents just under the snow. It came so close that he could hear the whoosh of its wings. But on only one day, after a heavy snowfall, did the sun shine bright enough for Bence to take the shot he was after.

Canon EOS 1D Mark II + Canon AF 300mm f2.8 IS USM lens; 1/2500 sec at f8.

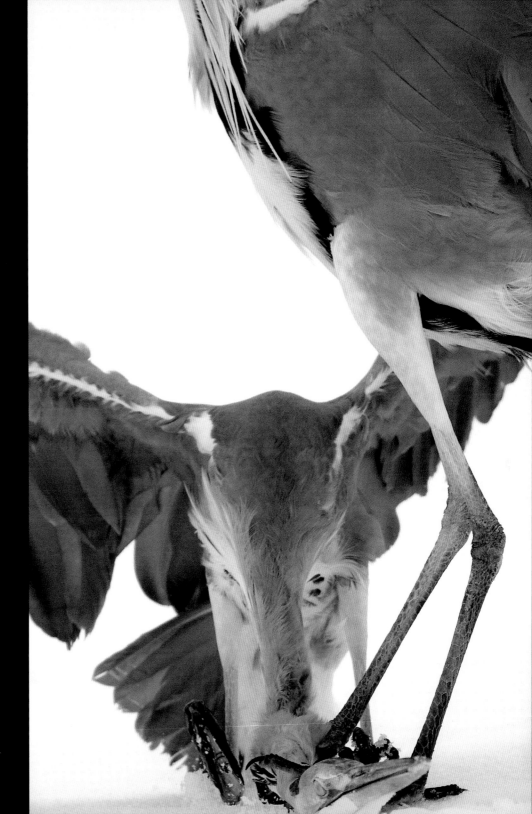

Grey heron mugging

The muggers bide their time. They watch as the more competent grey herons fish around a hole in the ice on Lake Csaj in Kiskunsag National Park, Hungary. Then, as one grabs a fish, the muggers pounce. The lake is one of the biggest nesting sites for herons in central Europe. In winter, competition becomes fierce. Having spent hundreds of hours here in his hide, wrapped in a sleeping bag, Bence knows that, when cold and hunger began to take victims, the herons become desperate. Some abandon fishing and resort to stealing. Bence concentrated on photographing one young heron that was particularly good at fishing. 'Every time it caught a fish, it was mugged,' he says. 'This made a good photo but was hard to watch.'

Canon EOS 300D + Nikon 300mm f2.8 lens and EOS Nikon converter; 1/1000 sec at f2.8; tripod; hide.

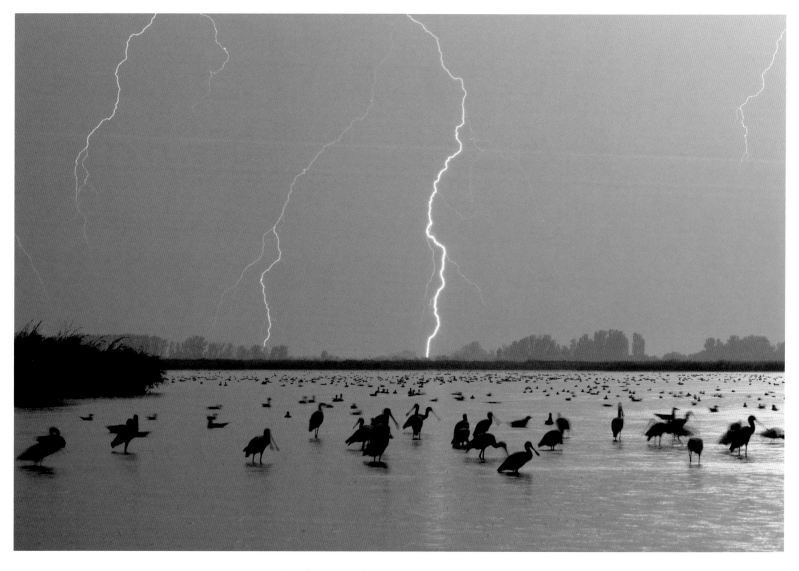

Lightning birds

His tripod shaking from the thunder, and with lightning striking 100 metres (400 feet) away from his hide, Bence's mood was electric: 'It's so rare to get just the right mix of beautiful light, birds and lightning that, when it happens, I'm ecstatic.' Bence constantly monitors the local storm patterns, using an Internet weather map. Usually, the lightning flashes too high up for him to photograph it. This time, though – on Lake Csaj, in Kiskunsag National Park – it forked right to the ground. The wildfowl and gulls merely continued with their evening preparations as the light faded and heavy rain hammered the lake's surface.

Canon EOS 300D + Canon 28-80mm f4 USM lens; 30 sec at f2.8; tripod; hide.

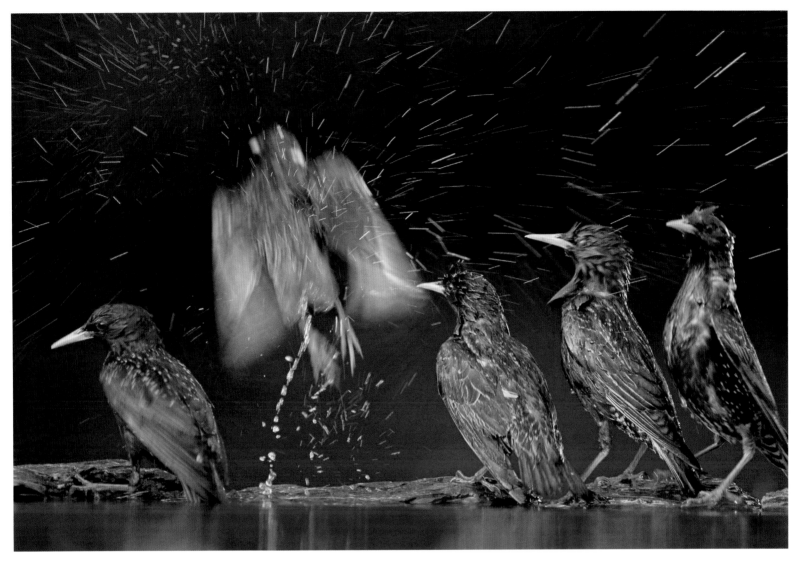

Starling spa

These starlings are jostling for position at the edge of a pool built specially by Bence for the birds in a clearing in Kiskunsag National Park. Sometimes more than 1000 birds of up to 20 species stop by in a single day. Nervous of the sparrowhawks that patrol the area, starlings arrive at dusk and take quick spray-baths. Bence's hide is dug into the ground with his camera at bird's-eye level, and his plan when photographing the starlings was to use a long exposure to create a sense of movement. But the action was so frantic that, only as the last low rays of sun touched the pool, did he manage to create the composition.

Nikon D200 + Nikon MF 300mm f2.8 lens; 1/160 sec at f2.8; tripod; hide.

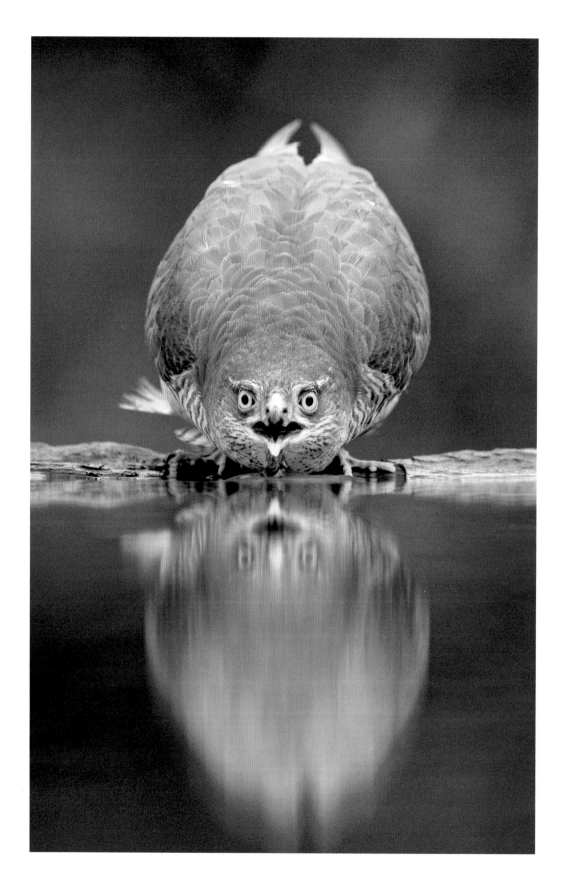

Pool hawk

Movement inside a hide can spook a bird as shy as a sparrowhawk. 'So you can find yourself stuck, unable to adjust or change your lens,' says Bence. 'And if there are several of you fiddling with equipment, it makes it even harder.' So Bence came up with a solution: glass that acted as a one-way 'mirror' when the hide was dark, in this case, fixed to the front of his dugout hide at eye-level with one of his specially created drinking pools. This sparrowhawk spent an hour preening and occasionally leaning forward to sip, relaxed and unaware of his observer. Bence composed the shot he wanted, focused the camera in advance of the bird bending down to drink and caught the moment. The one-way 'mirror' is now an essential part of his photographic kit.

Nikon D200 + Nikon MF 300mm f2.8 lens; 1/1000 sec at f2.8; tripod; hide.

Warbler and its cuckoo

Up to his chest in water, Bence watched a pair of reed warblers desperately trying to fill the belly of the young chick they mistakenly thought was theirs. Cuckoos thrive in Hungary, and a single pair can lay up to 30 eggs each season in other birds' nests. When the single chick hatches, its first job is to shove any other eggs out of the nest, thus ensuring that it has the undivided attention of its adoptive parents. This massive chick, by the Pacsmag fish-ponds in western Hungary, urged on its hoodwinked parents with strong, high-pitched begging calls. 'They worked hard and came back with food every ten minutes or so,' says Bence. 'But the cuckoo still wanted more.'

Nikon D200 + Nikon MF 300mm f2.8 lens and Nikon TC-301 extender; 1/1000 sec at f5.6; tripod; hide.

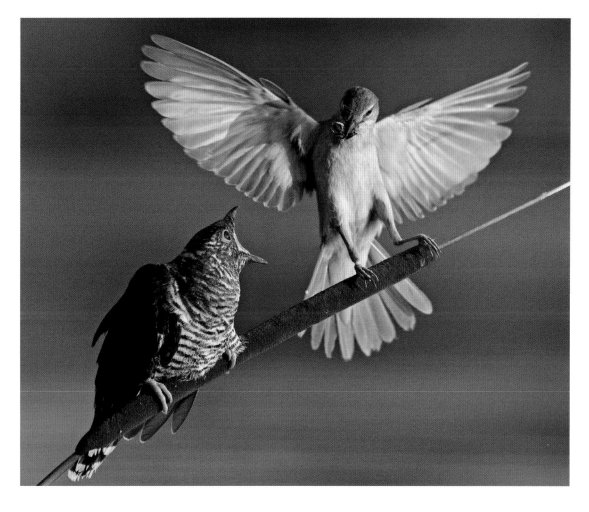

The Shell Young Wildlife Photographer of the Year Award

This award, a cash prize and the title Shell Young Wildlife Photographer of the Year 2007 goes to Patrick Corning — the young photographer whose image has been judged to be the most memorable of all the pictures by young photographers aged 17 or under.

Patrick Corning

Patrick was nine when he took his award-winning shot, which is also the winning picture in his age category — ten and under. His best-ever birthday present was a proper SLR camera, which his parents gave him when he was eight. His favourite subject at school is science, and he is a very keen birdwatcher, taking photographs of the birds in his garden and around his home in Surrey in the UK. He has recently obtained his open-water scuba-diving certificate, which will open up the world of underwater photography for him.

Monkey moment

Last year Patrick went on holiday with his parents to Costa Rica. They stayed in Quepos, which is near Manuel Antonio National Park, but an ideal place for watching wildlife turned out to be the balcony of their villa. All around were fruiting trees, to which a host of visitors came at least twice a day. These included mantled howler monkeys, white-faced capuchins and these endangered red-backed squirrel monkeys. One day, the squirrel monkeys stayed for a long time after feeding, playing and resting. 'They didn't mind me watching,' says Patrick, 'and even climbed on the balcony rails.' These three individuals lined up on a branch, messing around and giving Patrick the chance to catch the moment when one tugged its playmate's ear.

Nikon D50 + 75-300mm f4.5-5.6 lens; 1/40 sec at f5.6; ISO 200; tripod.

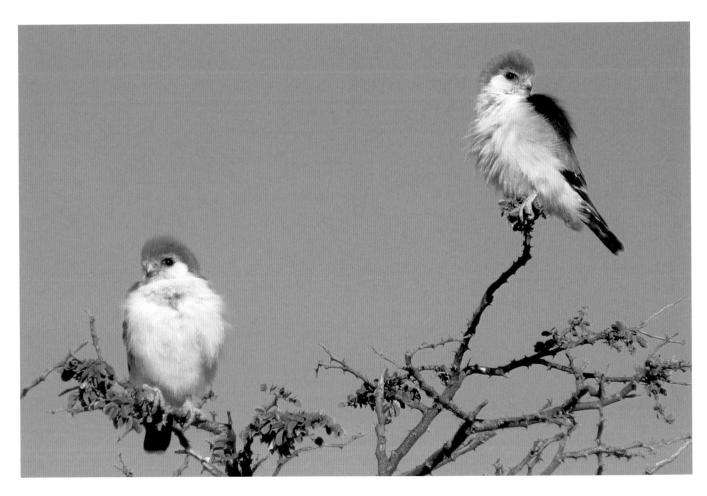

Pygmy pair

SPECIALLY COMMENDED

Gregor Tims

UK

Gregor's passion is birdwatching, and he uses photography to 'collect as many pictures of different birds' as he can. On holiday with his family in Namibia's Etosha National Park, he spotted these African pygmy falcons (the female to the right, with the brown back) on the lookout for prey. To get the best image, he knew he needed his mother's camera and zoom. 'It took a bit of persuasion,' he says, 'but she eventually passed it over,' allowing just enough time to take the shot before the birds flew away.

Panasonic Leica DMC-FZ7 + 12x 35mm lens.

Puma up close

RUNNER-UP

Tom Godwin

UK

Last year, Tom travelled with his family to Los Llanos, a vast, wildlife-rich plain in central Venezuela, staying at Hato El Cedral, which is a working ranch and nature lodge. It's the perfect place for a budding naturalist, but Tom never imagined he would see a wild puma. The family was on a drive to look at wildlife when they spotted this young one in a small tree beside the raised track. 'The puma was calm', says Tom, 'and not at all aggressive. It even yawned and stretched before looking directly at me.' Tom slowly approached and positioned himself under the tree, from where he took this intimate shot.

Sony Cyber-Shot DSC-W1 + Carl Zeiss Vario-Tessar 7.9-22.7mm f2.8-5.2 lens; automatic speed and exposure.

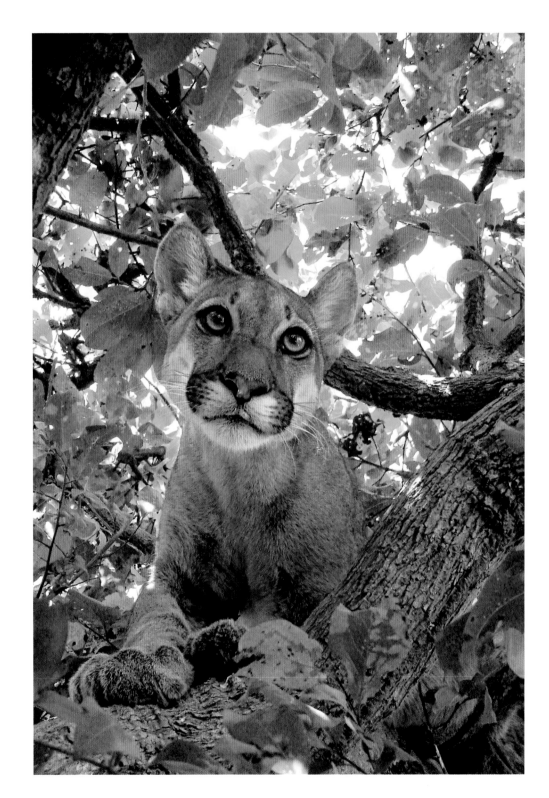

Sparrowhawk on the lookout

WINNER

Fergus Gill

UK

Last summer, after school, Fergus would camp out in a hide in his back garden. He is an experienced photographer and had erected the hide near a rowan tree, making sure he had a clear view of one particular branch – the favourite perch of a male sparrowhawk. In the 1960s, sparrowhawks became rare because of the effects of toxins such as DDT, which moved up the food chain into insects, then small birds and then their predators. These chemicals are now banned, and sparrowhawks are once again thriving. Many are now living and hunting not just in woodlands but also in urban areas. 'This one came to our garden several times a day to hunt the newly fledged house sparrows,' says Fergus.

Nikon D200 + Nikon 200-400mm f4 lens; 1/15 sec at f4; ISO 400; tripod; dome hide.

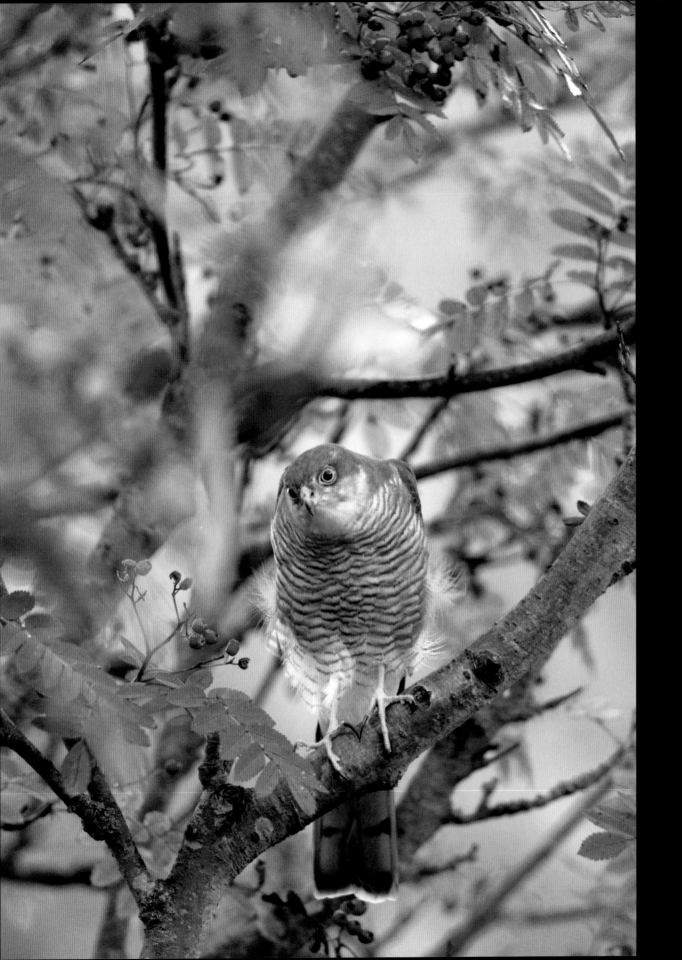

Redshank reflection

HIGHLY COMMENDED

Alberto Fantoni

ITALY

A migrating spotted redshank in transit spent several days on the Adda River, near Alberto's home in Lombardy, northern Italy. Spotted redshanks breed in the Arctic circle and travel to the Mediterranean or Africa for the winter, and although they do stop to rest or refuel, Alberto had never seen one in his home region. For several days, he was able to watch and photograph this spotted redshank feeding along the shallow river edges. 'One evening, a beautiful sunset was reflected in the water. I knew then I could take a very special shot.' Soon after, the bird recovered its strength enough to resume its epic journey.

Nikon D70s + Nikon 300mm f4 lens; 1/80 sec at f5.6.

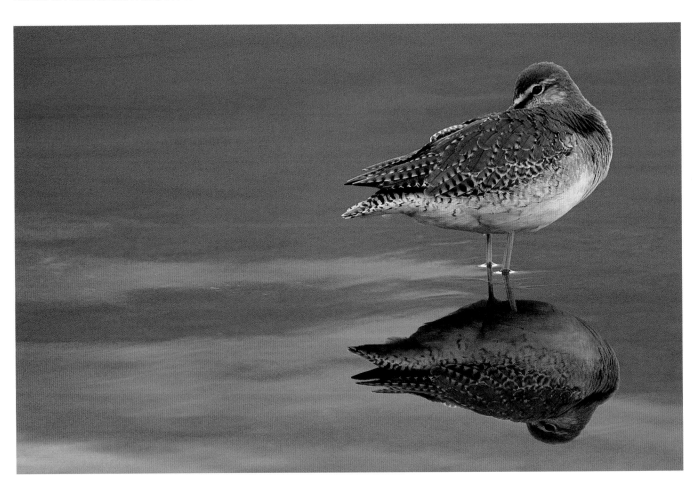

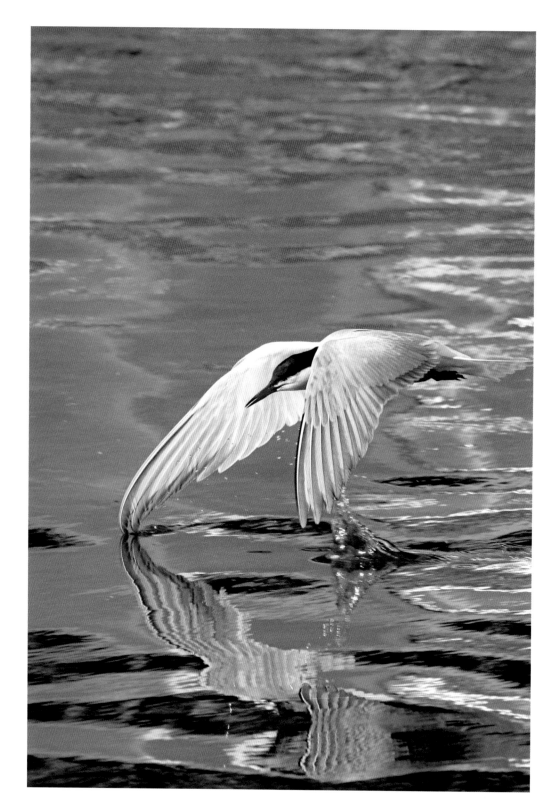

London tern

RUNNER-UP

Jack Chapman

UK

Having just bought his first digital SLR camera, Jack borrowed his uncle's 400mm lens for a couple of weeks and went on the hunt for photographic opportunities. One of the best spots proved to be the River Lee Navigation canal, close to his home in London. Here he discovered common terns (nesting on the neighbouring reservoirs) flying in to drink and feed. Most of the food they were scooping out was bread thrown in for the ducks – 'not good for the birds or the canal', says Jack. 'Most of it joins the rest of the pollution.' After observing the terns for a while, he worked out where best to position himself to photograph them as they zigzagged up the canal. 'I caught this particular tern as it passed the reflection of a scarlet canal boat, its wings skimming the surface.'

Canon EOS 350D + 400mm f5.6 lens; 1/400 sec at f5.6; ISO 100.

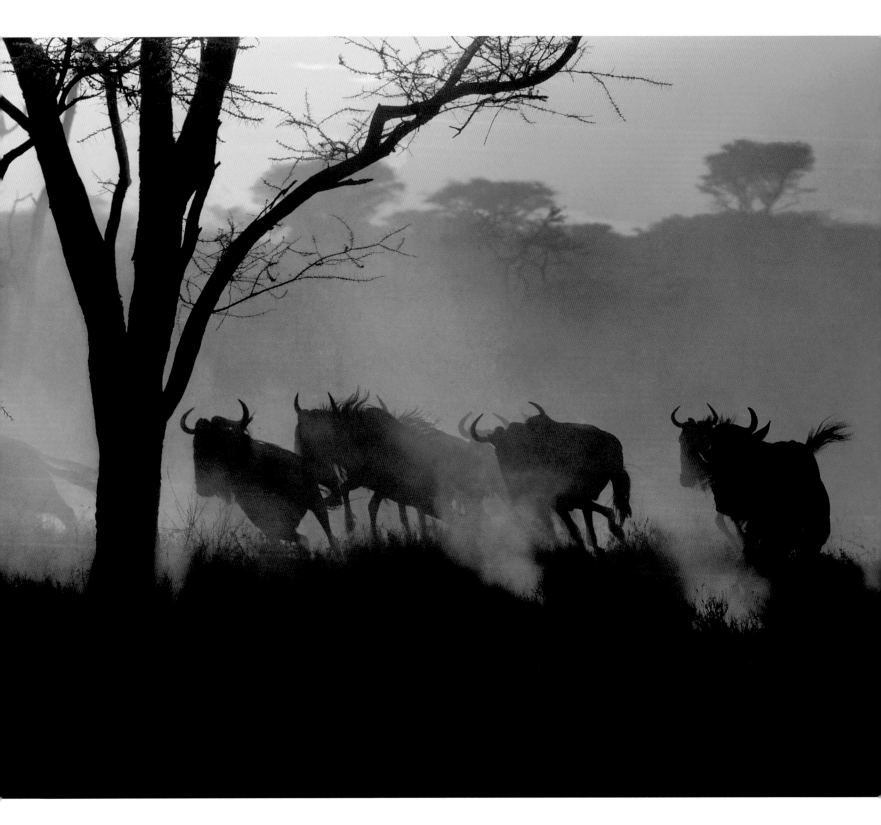

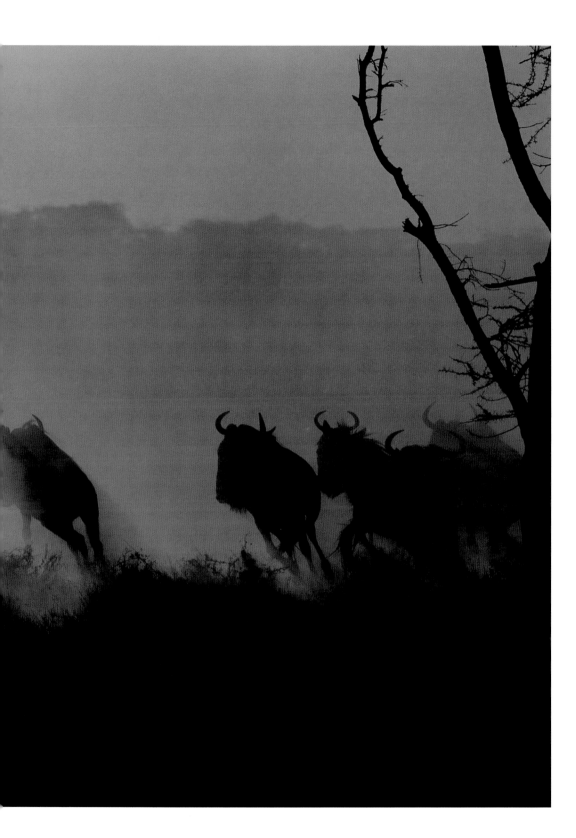

Serengeti stampede

HIGHLY COMMENDED

Liisa Widstrand

SWEDEN

In an endless pilgrimage, 1.5 million wildebeest follow the seasonal African rains in search of water and fresh grazing grounds. The round trip between Tanzania's Serengeti National Park and Kenya's Masai Mara is nearly 3000 kilometres (1860 miles), and the seemingly never-ending trails of wildebeest rank as one of the world's greatest wildlife spectacles. Wildebeest are nervous and will run or even stampede at the slightest threat. When this small group in the Serengeti started to run, it was dusk, and the effect was impressive, remembers Liisa. 'Their hooves kicked up clouds of dust that radiated in the evening light.'

Nikon D200 + Nikkor VR 70-200mm f2.8 lens; 1/1000 sec; ISO 100.

Forest of the fog

HIGHLY COMMENDED

Michal Budzyński

POLAND

Michal's first outing with the Polish Nature Photographers' Union, to the Beskidy Mountains, was nearly a disaster. 'We were surrounded by thick mist. What's more, it was freezing cold,' and 'everything looked grim'. But when he entered the forest, he discovered another world and 'a stunning scene for a picture', the debarked tree adding a point of colour. Next day was sunny and the views were great, but the atmosphere had evaporated.

Nikon D80 + AF-S Nikkor 18-70mm f3.5-4.5 G ED DX lens; 1/30 sec at f9; ISO 160; Velbon tripod.

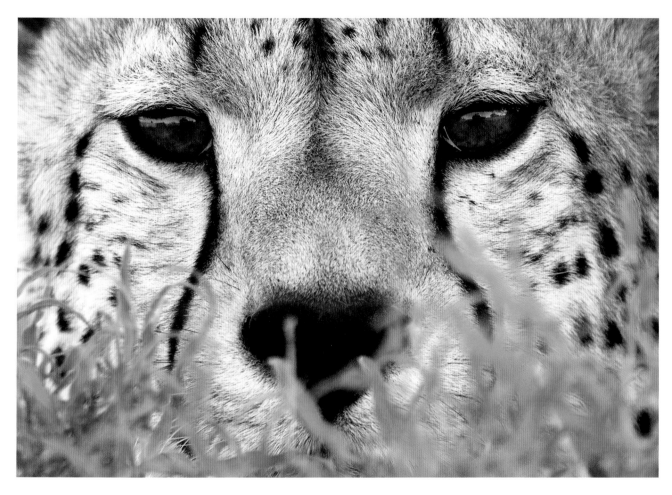

Eye to eye

HIGHLY COMMENDED

Liisa Widstrand

SWEDEN

Distinctive black 'tear streaks' run from the inside
corner of the cheetah's eyes to its mouth.
Even without a zoom, Liisa could see these clearly,
because the cheetah had strolled so close.
As she began photographing it, she realized that
she could see a panorama of the Serengeti,
including the vehicle with her in it, reflected in
the cat's eyes – a reminder of the cheetah's
phenomenal field of vision.

**Nikon D200 + Nikkor 600mm f4 lens and TC14B extender;
1/500; ISO 200; beanbag.**

Snow bird

HIGHLY COMMENDED

Alberto Fantoni

ITALY

'I couldn't believe my eyes,' says Alberto when he first saw this white blackbird near his home in Lombardy. Blackbirds often have the odd patch of white, but nearly all-white birds are not common and don't usually survive long. Alberto first saw this one in summer. It seemed 'a little bit edgy – perhaps it knew it looked very conspicuous'.
He started to feed the white bird, finally enticing it close enough to get a decent photograph.
By then, winter had arrived, providing the perfect background for the white bird's survival and the perfect backdrop for a picture.

Nikon D70s + Nikon 300mm f4 lens; 1/640 sec at f5.6.

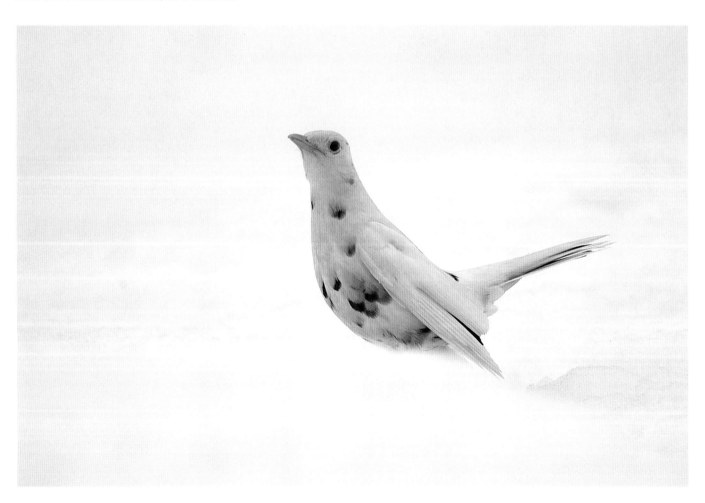

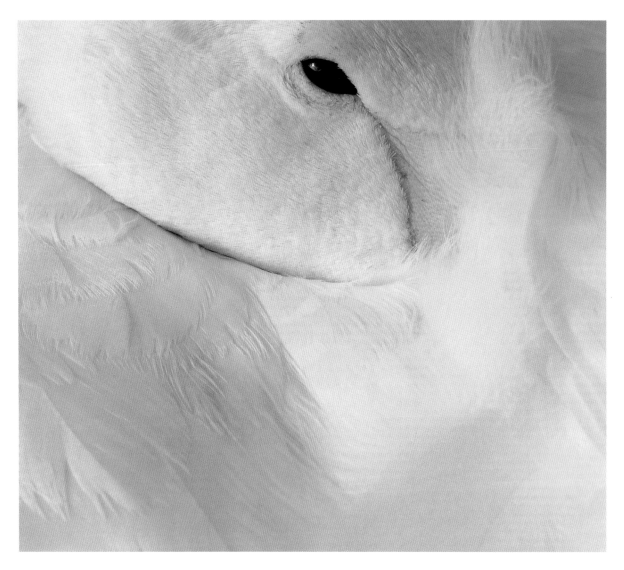

Whooper repose

HIGHLY COMMENDED

Sam Rowley

UK

Sam had spent a day at the London Wetland Centre taking photos of the wildfowl. Fed up with his results, he was heading out when he spotted a resting whooper swan, the last rays of the winter sun just catching its plumage. Sam crouched down a few metres away and composed his image – focusing on the whooper's soft white feathers and the contrasting distinctive yellow bill. The swan opened its eyes briefly to check him out, and Sam took this shot just as it was closing them again.

Nikon Coolpix 8800; 1/138 sec at f5.8.

Skimmers on show

WINNER

Evan Graff

USA

Evan ranks black skimmers as among his favourite birds. So he was delighted to see a big flock resting in a pull-off along a stretch of water on Merritt Island, Florida, all facing in the same direction. Dropping to the ground so as not to spook them, Evan inched closer on his stomach, positioning himself so that he could photograph several birds lined up behind one another. Skimmers are the only birds whose lower bill is longer than the upper one. Flying just above the water with their beaks wide open, they use their lower bills to trawl for fish. 'Their bills look really large from the side,' Evan says, 'but what I wanted to show was how extremely thin and delicate they really are.'

Nikon D200 + Sigma 50-500mm EX lens; 1/320 sec at f6.3; ISO 400; tripod.

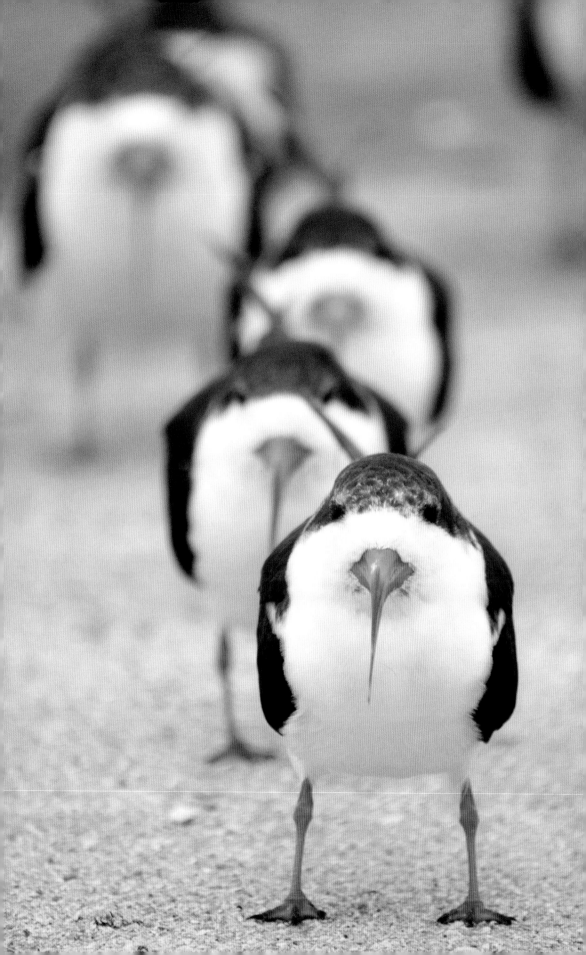

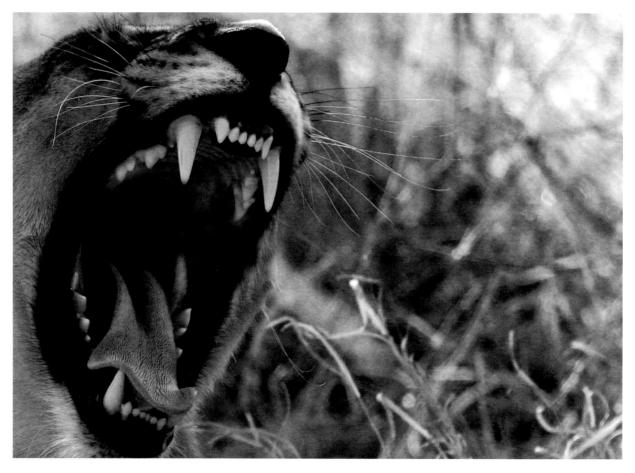

The yawn

RUNNER-UP

Mark Fernley

UK

Waiting just 9 metres (30 feet) away, Mark was so close to the pride, he could 'smell they had eaten and see flesh and blood on their mouths'. Their flies also became his flies. The lions had spent most of the day resting in South Africa's Madikwe Game Reserve, and so it seemed appropriate to set himself the task of photographing a yawn in a creative way. He got his shot as the sun was going down – one to add to his lion portfolio (Mark's aim is to become a professional wildlife photographer).

Canon EOS 30D + Canon EF 100-400mm lens with image stabilizer; 1/800 sec at f5.6; ISO 400.

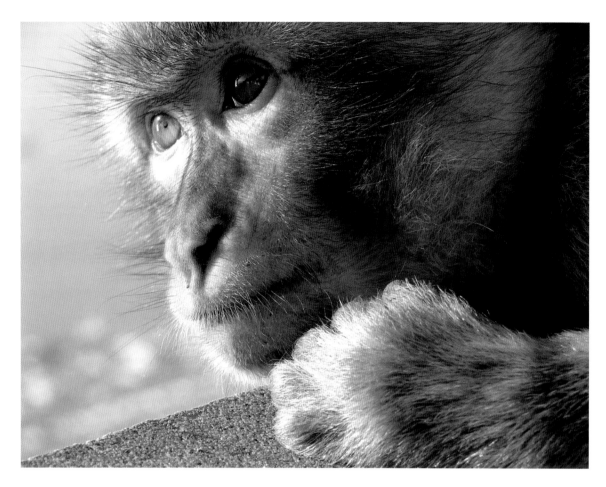

Urban primate

Christopher Buttigieg

GIBRALTAR

Strolling through Gibraltar's Upper Rock Nature Reserve, Christopher spotted this macaque settling down for a siesta in the afternoon sun. Barbary macaques are thriving on Gibraltar (unlike those in North Africa), with about 230 in 6 troops. 'This individual was indifferent to me,' says Christopher, 'as if reflecting on something, which allowed me to get quite close. But I didn't want to make even indirect eye contact, as this would have resulted in an attempt to snatch the camera!'

Sony Cyber-shot DSC H2 + Carl Zeiss Vario-Tessar 36-432mm lens; 1/250 sec at f4; ISO 80; lens hood.

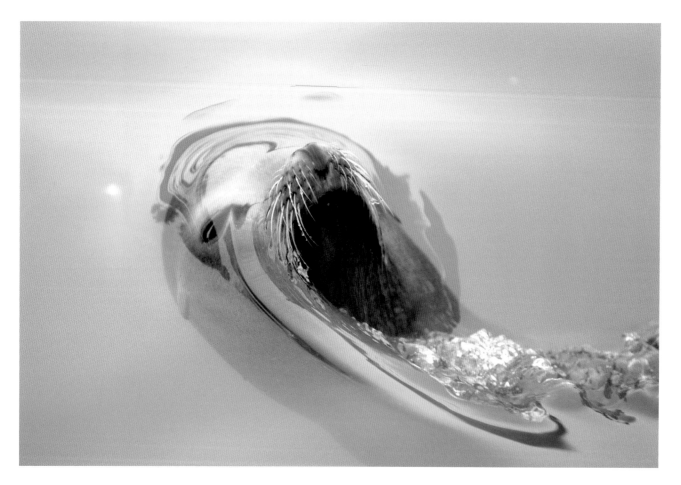

The emergence

HIGHLY COMMENDED

Tom Steele

UK

Planning to photograph a captive wild animal and to explore whether it was still wild at heart, as part of his BA (Tom was only 16 when he was accepted on the course), he spent a day at Blackpool Zoo. 'I picked a moving animal', says Tom, 'to give the picture creative edge. This California sealion emerged swimming on its back. It looks as if its mouth is open, but that's an illusion.' Is it still 'wild at heart'? That, too, might be an illusion, but the beauty of the animal as it moved was real.

Canon EOS 1D Mark II N + Canon EF 70-200mm IS f2.8 lens; 1/1000 sec at f2.8; ISO 400 (-0.3 compensation).

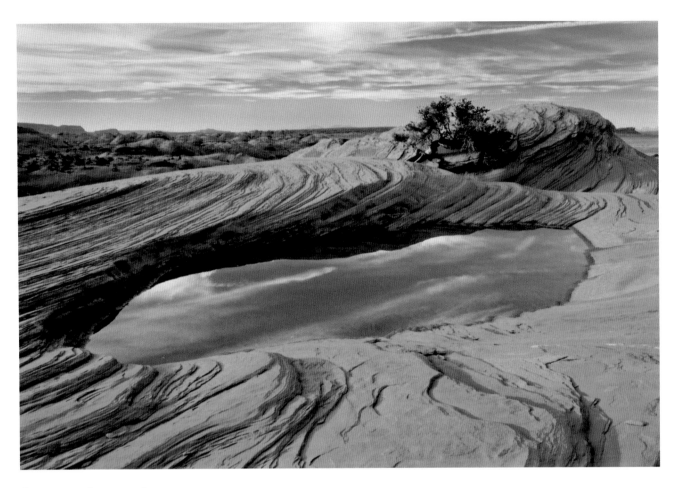

Desert sky-pool

HIGHLY COMMENDED

Nick Burden

USA

The backdrop for countless Western movies, Monument Valley Navajo Tribal Park in Arizona, USA, was once a vast plateau. For 50 million years, wind and rain have eroded away the layers of soft and hard rocks to create dramatic sculptures. Nick visited Mystery Valley with his dad and a Navajo guide a week after a downpour had drenched the desert and came across this rain-pool. 'I wanted to capture the sky reflected in the water', says Nick, 'and shot till I filled up my memory card.'

Nikon D100 + Sigma 28-200mm f4/5.6 lens; 1/6 sec at f22; Silk U212 tripod.

Index of Photographers

23
Elaine Argaet (Australia)
elainea@hotkey.net.au

20
Ingo Arndt (Germany)
info@ingoarndt.com
www.ingoarndt.com
Agents
www.naturepl.com
www.mindenpictures.com

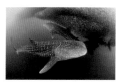

16
Laurent Baheux (France)
laurentbaheux@hotmail.com
www.laurentbaheux.com

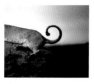

54
Felipe Barrio (Spain)
info@uf-photo.com
www.uf-photo.com

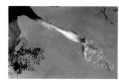

96
Jordi Bas Casas (Spain)
jbas1@pie.xtec.es
www.jordibas.net
Agents
www.nhpa.co.uk
www.photoshot.com

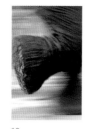

19
Kurt Jay Bertels (South Africa)
kurtbertels@hotmail.com
www.africangraphic.com

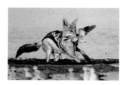

36
Johan J. Botha (South Africa)
johan.botha@sasol.com

146
Michal Budzyński (Poland)
michal.fp@gmail.com
www.michalbudzynski.win.pl

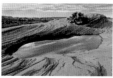

155
Nick Burden (USA)
rburden@ecentral.com

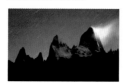

106
Jordi Busqué (Spain)
info@jordibusque.com
www.jordibusque.com

22
Adam Butler (UK)
adam@BigSplashPictures.com
www.BigSplashPictures.com

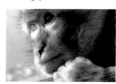

153
Christopher Buttigieg (Gibraltar)
c.buttigieg1510@gmail.com

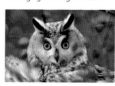

93
Régis Cavignaux (France)
rcavignaux@wanadoo.fr
www.regiscavignaux.com

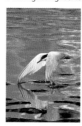

143
Jack Chapman (UK)
jackpbchapman@tiscali.co.uk

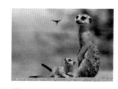

43
Shem Compion (South Africa)
shem@shemimages.com
www.shemimages.com

64
Alec Connah (UK)
alec.connah@virgin.net
www.latentlight.com

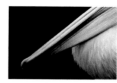

81
Wesley Cooper (Australia)
wes.cooper@gmail.com

136
Patrick Corning (UK/USA)
patrick@kcorning.com

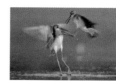

35
George Decamp (USA)
gdecamp@gmail.com
www.decamp.net

62
Len Deeley (UK)
len.deeley@btinternet.com
www.image-photography.co.uk

68
Charlene deJori (USA)
oceanica@sbcglobal.net

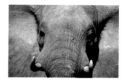

80
Michel Denis-Huot (France)
mcdh@denis-huot.com
www.denis-huot.com
Agent
bios@biosphoto.com

66
Jack Dykinga (USA)
jack@dykinga.com
www.dykinga.com
Agents
pete@dykinga.com
www.naturepl.com

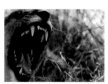

86
Graham Eaton (UK)
graham@eatonphotography.co.uk
www.eatonphotography.co.uk
Agent
www.splashdowndirect.com

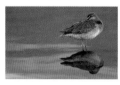

118
Martin Eisenhawer (Switzerland)
martin@eisenhawer-
naturephotography.com
www.eisenhawer-
naturephotography.com

142, 148
Alberto Fantoni (Italy)
fantoniluca4@alice.it

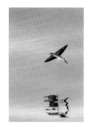

152
Mark Fernley (UK)
davefernley@aol.com
www.pbase.com/mark_fernley

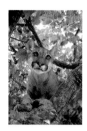

48
Marguerite Fewkes (UK)
mags@fewkes.demon.co.uk
www.magsimages.com

88
Angel M. Fitor (Spain)
seaframes@seaframes.com
www.seaframes.com

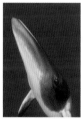

89
Jürgen Freund (Germany)
freundfactory@gmail.com
www.jurgenfreund.com
Agent
www.naturepl.com

140
Fergus Gill (UK)
fergus@wolfhill.free-online.co.uk

139
Tom Godwin (UK)
alan@reefandrainforest.co.uk
www.reefandrainforest.co.uk

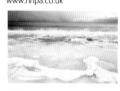

32
Chris Gomersall (UK)
chris@c-gomersall.demon.co.uk
www.chrisgomersall.co.uk
Agents
www.naturepl.com
www.alamy.com

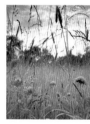

84
Sergey Gorshkov (Russia)
gsvl@mail.ru
www.gorshkov-photo.com

150
Evan Graff (USA)
egraff89@yahoo.com
www.philzworld.com/evanzworld/

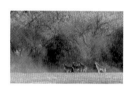

94
Danny Green (UK)
danny@dannygreenphotography.com
www.dannygreenphotography.com
Agents
www.rspbimages.com
www.nhpa.co.uk

109
Orsolya Haarberg (Hungary)
orsolya.haarberg@freemail.hu
www.haarbergphoto.com

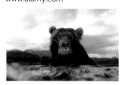

74
Rupert Heath (UK)
info@rupertheath.co.uk
www.rupertheath.co.uk

83
Anna Henly (UK)
anna.photography@btinternet.com
www.annahenly.com

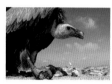

90
Juan Manuel Hernández López
(Spain)
luluson@teleline.es
www.juanmanuelhernandez.com

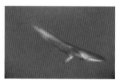

127
Wade Hughes (Australia)
aussiesabroad@aol.com
www.thirteenthbeach.com

45
Cathy Illg (USA)
gorden@advenphoto.com
www.advenphoto.com

120
Csaba Karai (Hungary)
cskarai@t-online.hu
www.karaicsaba.hu

Index of Photographers

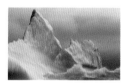

104
Robert Knight (USA)
info@robertknightgallery.com
www.robertknightgallery.com

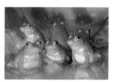

50
Ines Labunski Roberts (UK/USA)
inesr@cox.net

108
Bryan Lowry (USA)
bryanlowry@lavapix.com
www.lavapix.com

52
David Maitland (UK)
dpmaitland@googlemail.com
www.davidmaitland.com
Agent
www.gettyimages.com

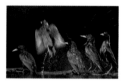

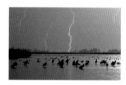

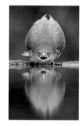

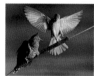

130-5
Bence Máté (Hungary)
bence@matebence.hu
phototours@matebence.hu
www.matebence.hu

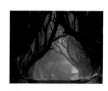

70
Bob McCallion (UK)
mccallion@onetel.com

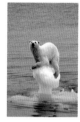

29
Kristin McCrea (Canada)
redwing@xplornet.com
www.digitalfarm.ca

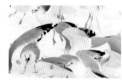

116
Scott McKinley (USA)
srmfilms@bresnan.net
www.wildexposuresgallery.com

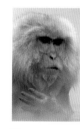

82
Alexander Mustard (UK)
alex@amustard.com
www.amustard.com

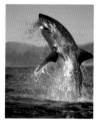

46
Amos Nachoum (Israel/USA)
amos@BigAnimalsphotography.com
www.biganimals.com

123
Arne Naevra (Norway)
post@naturbilder.no
www.naturbilder.no

51
Béla Násfay (Hungary)
nasfay@t-online.hu
www.korallbuvar.hu

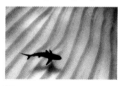

92
Ian Nelson (UK)
irnelson@mac.com
www.iannelsonwildlife.com

114
Michael Nichols (USA)
jpirog@ngs.org
www.michaelnicknichols.com
Agent
www.ngsimages.com

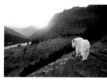

56, 58, 60, 112
Paul Nicklen (Canada)
nicklen@northwestel.net
www.paulnicklen.com
Agent
www.ngsimages.com

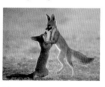

44
Helmut Niebuhr (South Africa)
helmutn1@worldonline.co.za

14
Ben Osborne (UK)
ben@benosbornephotography.co.uk
www.benosbornephotography.co.uk
Agents
www.gettyimages.com
www.naturepl.com

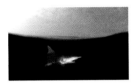

78
Thomas P. Peschak (South Africa)
tpeschak@iafrica.com
www.currentsofcontrast.com

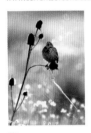

33
Gastone Pivatelli (Italy)
crex@libero.it

102
Stephen Powles (UK)
s.powles@ukf.net

26
Louis-Marie Preau (France)
photo@louismariepreau.com
www.louismariepreau.com

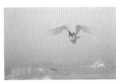

119
Norbert Rosing (Germany)
rosingbear@aol.com
www.rosing.de
Agents
www.ngsimages.com
www.mauritius-images.com

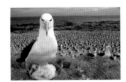

128
Andy Rouse (UK)
sales@andyrouse.co.uk
www.andyrouse.co.uk

149
Sam Rowley (UK)
baby_sam_123@hotmail.com

117
Shane Rucker (USA)
photography@shanerucker.com
www.shanerucker.com

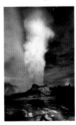

103
Jonas Salmonsson (Sweden)
jsalmonsson@hotmail.com
www.salmonsson.fotosidan.se
Agent
www.pixonnet.com

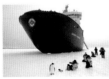

122
Angie Scott (UK)
jonathan@jonathanangelascott.com
www.jonathanangelascott.com
Agents
www.gettyimages.com
www.imagestate.com
www.naturepl.com
www.nhpa.co.uk

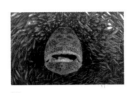

65
Douglas David Seifert (USA)
douglasseifert@mac.com
www.douglasseifert.com

42
Cristóbal Serrano Pérez (Spain)
cristobal@cristobalserrano.com
www.cristobalserrano.com

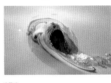

40
Anup Shah (UK)
sneh_shah_uk@yahoo.com
www.shahimages.com
Agent
www.naturepl.com

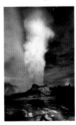

107
Robert Sinclair (USA)
rob@imagesfromthewild.com
www.imagesfromthewild.com

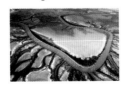

110
Damon Smith (Australia)
information@damonsmith.com
www.damonsmith.com

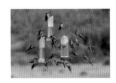

99
Mark Somogyi (Hungary)
somogyimark@sm-art.hu
www.somogyimark.hu

154
Tom Steele (UK)
tom@tomsteelewildlife
photography.com
www.tomsteelewildlife
photography.com

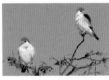

24
Gary Steer (Australia)
gary@wildvisuals.com.au
www.garysteer.com.au

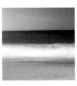

30
Maria Stenzel (USA)
mariastenzel@mac.com
www.mariastenzel.com
Agent
www.ngsimages.com

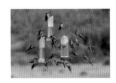

98
Yuichi Takasaka (Japan)
info@blue-moon.ca
www.blue-moon.ca

101
Ari Tervo (Finland)
ari.tervo@kajaani.net

138
Gregor Tims (UK)
rachel@timsfamily.co.uk

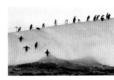

28, 34
David Tipling (UK)
dt@windrushphotos.demon.co.uk
www.davidtipling.com

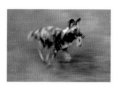

124
Roy Toft (USA)
roy@toftphoto.com
www.toftphoto.com

53
Philippe Toussaint (Belgium)
philippe_toussaint@skynet.be
www.philippetoussaint.com

72
Maurizio Valentini (Italy)
mauvalentini@tiscali.it
www.mauriziovalentini.it
Agent
www.nhpa.co.uk

76
Werner Van Steen (Belgium)
info@boulder.be
www.wernervansteen.com

17, 18
Jan Vermeer (The Netherlands)
janvermeer.foto@planet.nl
www.janvermeer.nl
Agent
www.fotonatura.com

100
Andrew Walmsley (UK)
a-walmsley@care2.com
www.awimages.net

63
Patrick Weir (UK)
digitaldiver@gmail.com

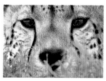

144, 147
Liisa Widstrand (Sweden)
liisa.widstrand@telia.com

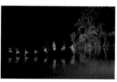

126
Jeff Yonover (USA)
jeff@jeffyonover.com
www.jeffyonover.com

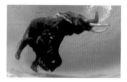

38
Christian Ziegler (Germany)
zieglerphoto@yahoo.com
www.naturphoto.de
Agents
www.mindenpictures.com
www.danitadelimont.com